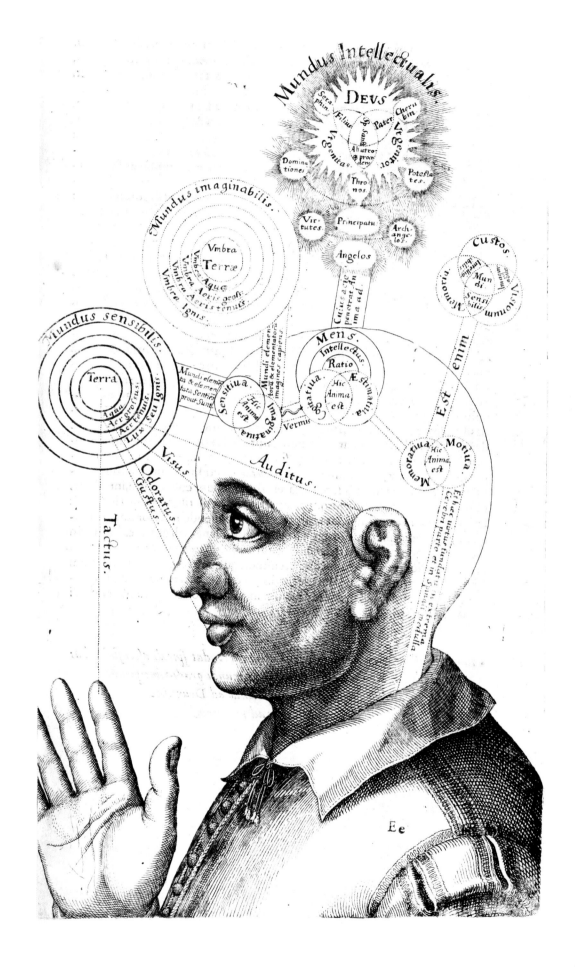

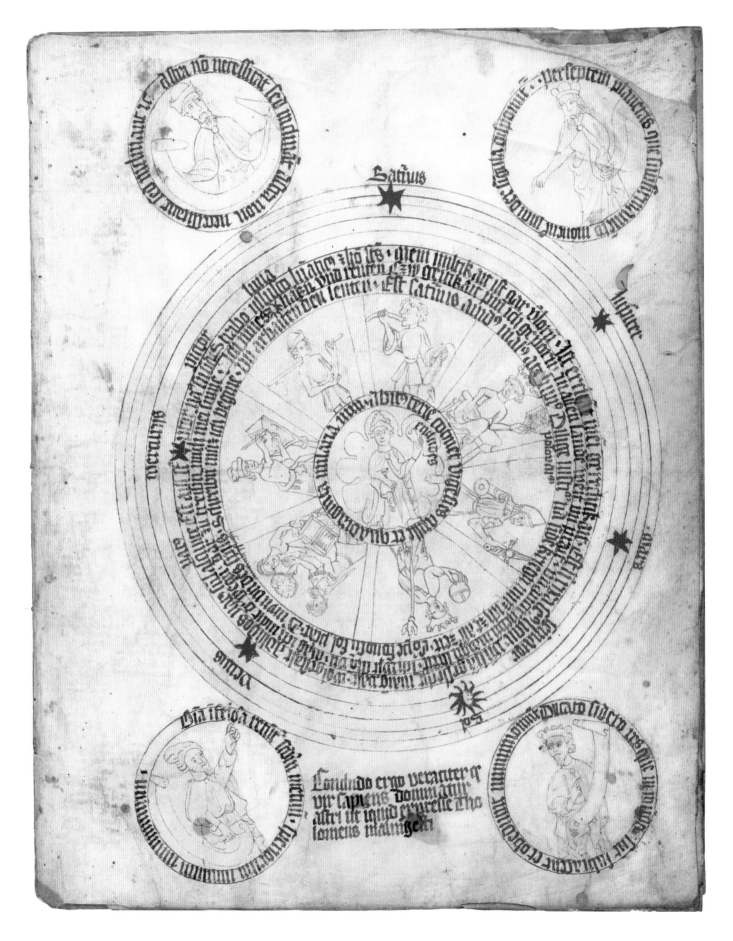

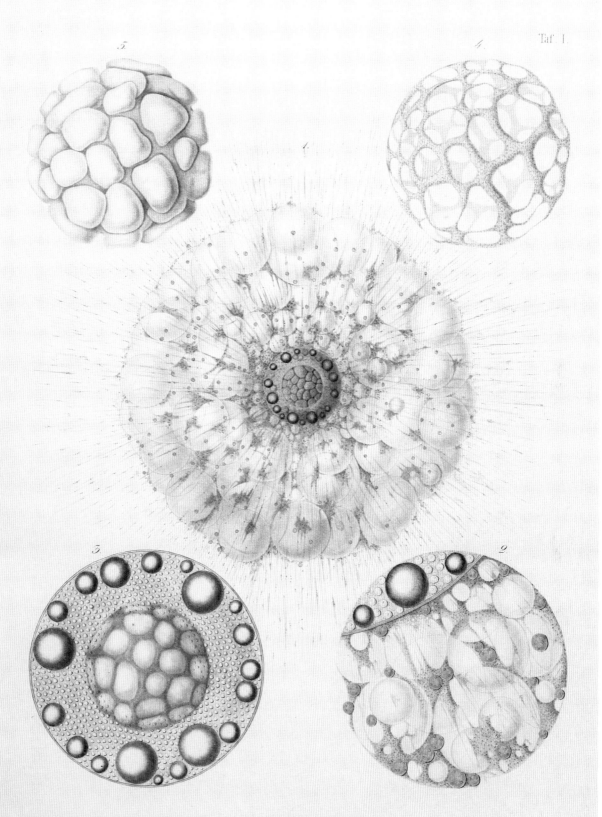

1—5. Thalassicolla pelagica, Hkl.

E. Haeckel del.

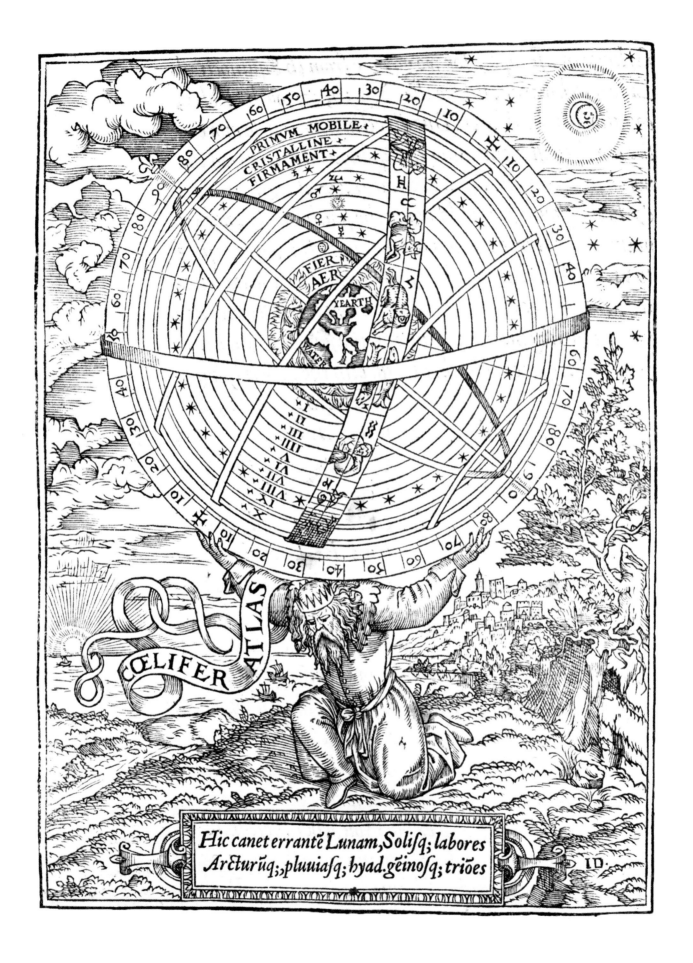

PRIMVM MOBILE

CRISTALLINE
FIRMAMENT

FIER
AER

YEARTH

CŒLIFER ATLAS

Hic canet errantē Lunam, Solisq; labores
Arcturūq;, pluuiasq; hyad.gēinosq; triões

ID.

THE BOOK OF CIRCLES

Visualizing Spheres of Knowledge

Manuel Lima

Princeton Architectural Press
New York

Frontispieces

(page 1)
Robert Fludd
Mental faculties
1617

A diagram of the mind from the noteworthy encyclopedia of medieval science and mystical philosophy *Utriusque cosmi maioris et minoris metaphysica, physica, atque technica historia* (The greater cosmos and the lesser metaphysics, physics, and the history of technology), 1617. English polymath Robert Fludd depicts the three types of vision associated with specific ventricles of the brain: sensible or corporeal (*mundus sensibilis*), spiritual or imaginary (*mundus imaginalis*), and intellectual or cognitive (*mundus intellectualis*).

(page 2)
Anonymous
Earth and the seven planets
ca. 1410

An illustration from an early fifteenth-century manuscript containing several allegorical and medical drawings, with specific instructions on common medieval practices, including the now appalling procedure of bloodletting. Some of the charts include instructions for when and from where to draw blood and how the movement of celestial bodies such as the moon could influence such an operation. Depicted here is the Earth, surrounded by seven planets, the sun, and the moon.

(page 3)
Ernst Haeckel
Thalassicolla pelagica
1862

Illustration from a richly illustrated book that the German biologist Ernst Haeckel published in 1862; its thirty-five plates reveal the elaborate structures of tiny (0.1 to 0.2 millimeters in diameter) unicellular eukaryotic organisms called radiolaria. The vivid drawings of their ornate silica skeletons were the result of months of attentive observation and sketching in front of a microscope. Shown here is the first plate of the book, depicting the species of radiolaria that Haeckel labeled *Thalassicolla pelagica*.

(page 4)
William Cuningham
Coelifer Atlas
1559

Illustration from English physician and astrologer William Cuningham's *The Cosmographical Glasse*. It shows Atlas, the Greek god of astronomy, in the role of the *coelifer* (in Latin, bearer of the heavens), sustaining an armillary sphere of the Ptolemaic system (geocentric model). Earth is at the core, comprising the elements of earth and water and enclosed by the elements of air and fire. Also depicted are different planets, the firmament of stars, the crystalline band, and *primum mobile* (the outermost sphere, first introduced by Ptolemy).

To my new, ever-expanding circle of love: Chloe

And to my childhood circles of affection: José Maria, who showed me the beauty and power of nature, and Walter, who imparted to me a passion for science and discovery

CONTENTS

Family 1
RINGS &
SPIRALS
65

66

74

82

Family 2
WHEELS &
PIES
91

92

100

110

Family 3
GRIDS &
GRATICULES
119

120

130

138

Family 4
EBBS &
FLOWS
147

148

156

164

Family 5
SHAPES &
BOUNDARIES
175

176

184

192

Family 6
MAPS &
BLUEPRINTS
201

202

210

218

Family 7
NODES &
LINKS
229

230

238

246

PREFACE

It was February 2011, and I had just finished giving a lecture at the Image in Science and Art Colloquium, organized by the University of Lisbon's Center for Philosophy of Sciences. After I'd answered a few questions from the audience, one of the many professors in the auditorium stood up and asked, "Why do most of the visualization models you showed tend to follow a circular layout?" As the chair of the session, entitled *The Emergence of Information Visualization*, I was not only intrigued by her question but also somewhat vexed that this plainly evident observation had never occurred to me. "That's a great question," I said, pausing, and followed with a candid reply: "I don't exactly know why." At the end of the session, we exchanged a few more thoughts on the matter, but it soon became clear that I would need to leave her query unanswered. To say this question lingered with me for quite some time would be an understatement.

Later that same year, in September 2011, while presenting my first book at the New York Public Library and retelling this story in private to an audience member, I became enthralled by the mention of an experiment that established a correlation between circular shapes and happy faces. From that point on, I became consumed by this topic.

It took me some time to articulate my thoughts, but in many ways, this book constitutes an answer to that original intriguing question. As I delved into more and more visualization methods and approaches, the omnipresence of the circular layout became utterly overwhelming. For example, out of 1,000 projects indexed on my website, VisualComplexity.com—a ten-year online archive of visualization projects from domains as disparate as art and biology, computer systems and transportation networks—roughly 302 projects (about 30 percent) are based on some type of radial construct.

Of all possible models and configurations—with endless possibilities for constructing diagrams and charts—why is the circular layout such an exceptionally popular choice for depicting information? This book aims to answer this question in three distinct ways: first, by providing a context for the universality of the circular shape as a cultural symbol in all domains of human knowledge, across space and time; second, by describing a set of perceptual biases, identified by cognitive science in recent years, that explain our innate preference for all things circular; third, by developing a comprehensive taxonomy of twenty-one distinct patterns, which showcases the diversity and flexibility of the circular layout. With more than three hundred images, this book is a celebration of the enduring appeal of the circle, not just in the realm of information design, but in every sphere of human expression.

For my previous book, *The Book of Trees*, the task of gathering and curating such a large sample of projects was daunting; for this volume, due to the breadth of the topic, the task seemed paralyzing at times. Faced with such a demanding goal, one can either become too frightened to act or simply move forward in the hope of advancing our evolving collective knowledge by at least a single step. As Dominican friar Vincent of Beauvais expressed in his *Speculum Maius* (1244–55), the largest and most popular encyclopedia in the West before 1600, comprising 4.5 million words in 80 books and 9,885 chapters, "I know that I was not able to find or read everything that has been written. And I do not claim that I expressed everything that was noteworthy even from what I was able to read, otherwise I would have had to add an enormous volume. But of good things I gathered, I think, the better ones and certainly of the better things, a few of them."[1]

Manuel Lima
New York, March 2016

Note

1 Blair, *Too Much to Know.*

ACKNOWLEDGMENTS

Whenever one aspires to compile such a diverse body of work, spanning several centuries, establishing a plan of action is never a straightforward task. To make it more manageable, I divided this extensive research enterprise into two categories of projects: *contemporary*—produced in the last twenty-five years—and *historical*—dating as far back as the High Middle Ages (ca. 1000), with a few older examples.

Exploring contemporary projects is seemingly easier, as many of them are well publicized online and indexed by multiple sources. It is also quite satisfying, as one gets to communicate directly with the people behind the work. My first wave of recognition goes to the dozens, if not hundreds, of individuals, studios, agencies, laboratories, universities, and companies who have kindly shared their images, some spending many hours re-creating their original pieces especially for this undertaking. This book wouldn't exist without you.

If contemporary projects are, as the modern adage says, just a click away, historical ones are considerably harder to find. Not only does one have to know the right resources and tools, but also be willing to spend long hours browsing through countless manuscript pages, only to encounter a single relevant illustration among many dead ends. The second wave of recognition goes to a growing number of institutions, libraries, collections, galleries, and museums that are making available online a large number of digitized manuscripts and rare books. The broad accessibility of their collections has been instrumental in the making of this volume.

These are some of the resources that were invaluable in my research on older material: the Library of Congress; the Wellcome Library and its online resource, Wellcome Images; the British Museum; Yale University's Beinecke Rare Book & Manuscript Library; the World Digital Library, a fruitful partnership between the Library of Congress and the United Nations Educational, Cultural and Scientific Organization (UNESCO); the Digital Walters, a collection of more than nine hundred rare books and manuscripts hosted by the Walters Art Museum, in Baltimore; the Public Domain Review, an online project by the Open Knowledge Foundation; the Internet Archive, a growing collection of digitized works; Wikimedia Commons, a large database of public domain imagery; Europeana, a gathering of items from many of Europe's libraries, archives, and museums; the Biodiversity Heritage Library, a consortium of natural history libraries; the David Rumsey Historical Map Collection, one of the largest private collections of historic maps; the Digital Bodleian, the online collection of the Bodleian Libraries at the University of Oxford; the Houghton Library at Harvard University; the John Carter Brown Library at Brown University; and the Kislak Center for Special Collections, Rare Books and Manuscripts at the University of Pennsylvania Libraries.

I would also like to thank Anna Ridler for her priceless help with many of the captions across the twenty-one models of the book. Finally, and most warmly, my caring gratitude goes to my wife, Joana, and daughter, Chloe, for their unwavering patience through all the hours this book kept me away from them.

The eye is the first circle; the horizon which it forms is the second; and throughout nature this primary figure is repeated without end. It is the highest emblem in the cipher of the world.

—Ralph Waldo Emerson

Never, never rest contented with any circle of ideas, but always be certain that a wider one is still possible.

—John Richard Jefferies

Round and perfect like vast space, nothing lacking, nothing in excess.

—Chien-chih Seng-ts'an

INTRODUCTION

Among the natural shapes primitive humans were exposed to, the bright, circular silhouettes of celestial bodies must have been the most impressive ones. Witnessing the power of the hot, curved sun or the gleaming light of a full moon /*fig.*1, our ancestors must have been engrossed by the beauty, perfection, and strength of these shapes. Such reverence for celestial bodies is shared by almost every animist culture, as we can observe from the countless variations of solar deities that emerged independently at different times across the globe. Our late ancestors couldn't, of course, grasp the truly ubiquitous nature of the circle. They couldn't attest to the circularity of cells, bacteria, and microscopic organisms /*fig.* 2 or the spherical structure of faraway planets and stars—objects either too small or too distant for the naked eye to spot. Nevertheless, the prevalence of this shape was already overwhelming. They could see it in earth formations such as mounds, craters, and small lakes; in the sections of tree trunks and plant stems /*fig.* 3 /*fig.* 4; in the moving ripples on the surface of water; and in a variety of leaves, fruits, shells, rocks, and pebbles. Under the right light, they could even glimpse some neighboring planets, such as Mars, Jupiter, and Venus (the third brightest natural object in the sky) /*fig.* 5. Perhaps most important to our inherent social nature, they saw it recurrently in the eyes of their closest relatives, friends, acquaintances, and extended community /*fig.* 6. Such an omnipresence of circular shapes in nature must have been, if nothing else, a source of wonder and admiration.

The circularity exhibited in nature turned out to be much more than a source of wonder. It soon became a chief guiding principle of human culture, emulated and reinvented in art, religion, language, technology, architecture, philosophy, and science /*fig.* 7 /*fig.* 8. Used to represent a wide range of ideas and phenomena pertaining to almost every domain of knowledge, the circle became a universal metaphor embraced by virtually every civilization that has ever existed. A closer look at human appropriations of the circle shows a continuous order, from the towns and urban areas we have built over the centuries to the household articles and tools we have designed to the written signs and symbols we have created to communicate with each other.

fig. 1

Galileo Galilei
Moon drawing
1610

Pen-and-ink portrayal of the moon, part of a series of drawings and watercolors that were showcased in a small astronomical pamphlet published in Venice in March 1610, entitled (in short) *Sidereus Nuncius* (The starry messenger). It was the first time telescopic observations of the moon were documented in a scientific treatise. The drawings revealed numerous craters and mountains on the surface of Earth's natural satellite, contradicting the established notion of the moon as a smooth, perfect sphere.

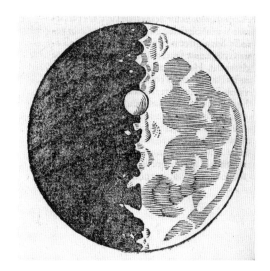

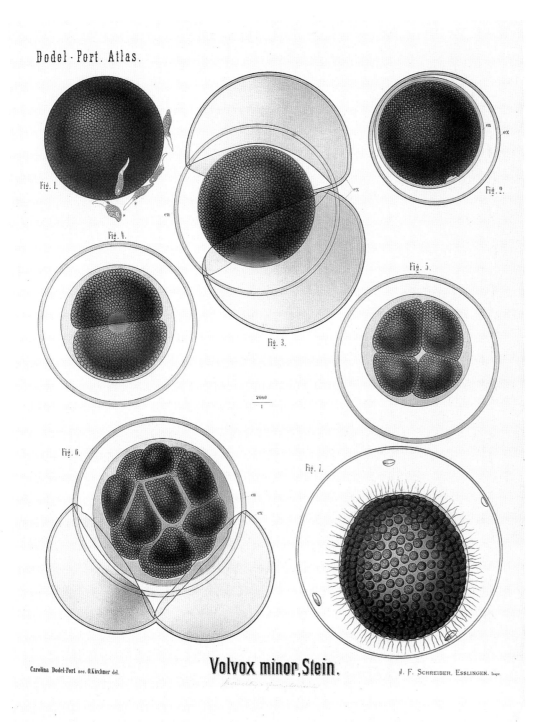

Fig. 1.

Fig. 2.

Fig. 4.

Fig. 3.

Fig. 5.

Fig. 6.

Fig. 7.

Carolina Dodel-Port sec. O.Kirchner del.

Volvox minor, Stein.

J. F. Schreiber, Esslingen. Impr.

fig. 2

Arnold and Carolina Dodel-Port
Volvox minor
1878–83

An illustration of the different stages of *Volvox minor* F.Stein, a species of tiny green algae (belonging to the Volvocaceae family) that inhabits spherical colonies of up to fifty thousand cells. Each cell of a Volvox measures between 0.004 and 0.008 millimeters. This plate is part of a collection of forty-two botanical charts collectively known as the Dodel-Port *Atlas*, created by Swiss botanist Arnold Dodel-Port and his wife, Carolina.

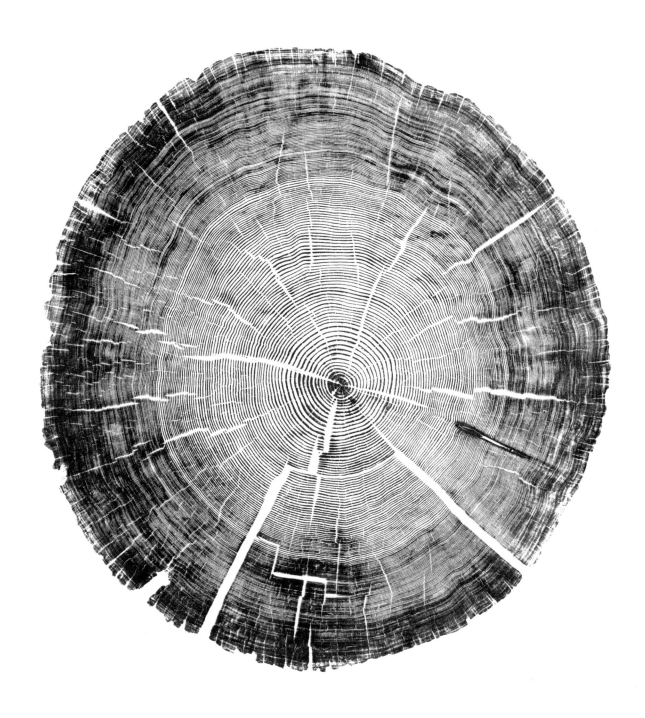

fig. 3

Bryan Nash Gill
Cedar Pole
2011

Relief print on paper, 23.5 ×
22.125 inches (59.69 × 56.2
centimeters). Print taken
from the crosscut of a retired
telephone pole in 2011. From

2004 until his death in 2013,
the American artist Bryan
Nash Gill collected dead tree
sections and parts, which he
used for various types of relief
printing. Many of these pieces
were featured in his 2012
series *Woodcut*. This particular
print shows a well-defined
range of concentric rings with
noticeable cracks.

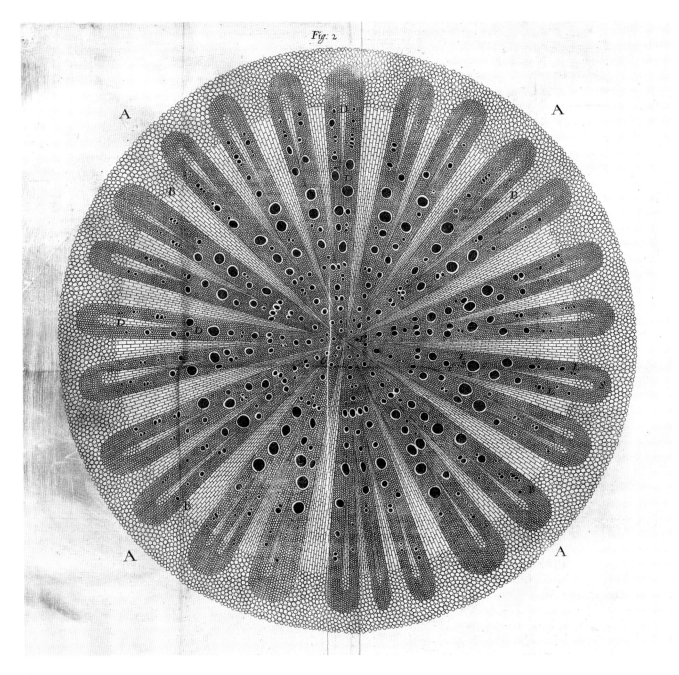

fig. **4**

Nehemiah Grew
Vine root
1682

A microscopic drawing showing
a transversal cut of a vine root.
This illustration is part of a set

of eighty-two illustrated plates
featured in the English botanist
Nehemiah Grew's *The Anatomy
of Plants* (1682), a significant
work on plant anatomy that
brought to light the intricate
structure and morphology
of plants via the recently
developed modern microscope.

THE BOOK OF CIRCLES

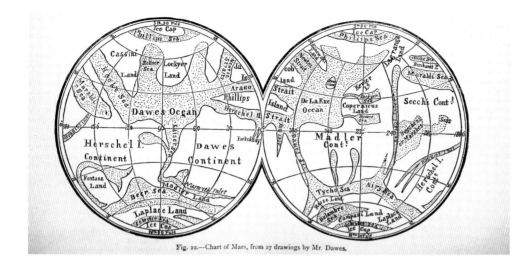

Fig. 22.—Chart of Mars, from 27 drawings by Mr. Dawes.

fig. 5

Richard Anthony Proctor
Chart of Mars
1879

One of the first maps of Mars, created by the English astronomer Richard Anthony Proctor and published in his book *Flowers of the Sky* (1879). As described by the author, the chart "presents the whole surface of Mars divided into lands and seas and polar snows, with the names attached of various observers who have at sundry times contributed to our knowledge of the planet's features." The chart was based on twenty-seven drawings by the English observer William Rutter Dawes as well as other sketches, some dating back to 1666, from astronomers such as William Herschel, Wilhelm Beer, and Johann Heinrich von Mädler.

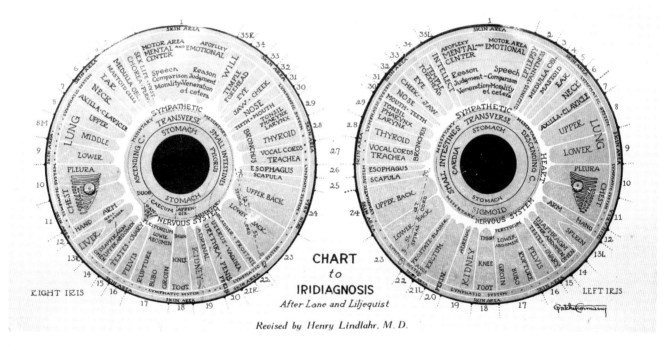

CHART
to
IRIDIAGNOSIS
After Lane and Liljequist

Revised by Henry Lindlahr, M. D.

fig. 6

Henry Lindlahr
Chart to Iridiagnosis
1919

Frontispiece to the book *Iridiagnosis and other Diagnostic Methods* (1919), by the American naturopathic physician Henry Lindlahr. This chart illustrates the various zones of a human iris that are studied by proponents of iridology—an alternative medicine technique born in the seventeenth century. Generally seen as a pseudoscience, iridology associates regions and patterns of the iris with the health condition of specific areas of the human body.

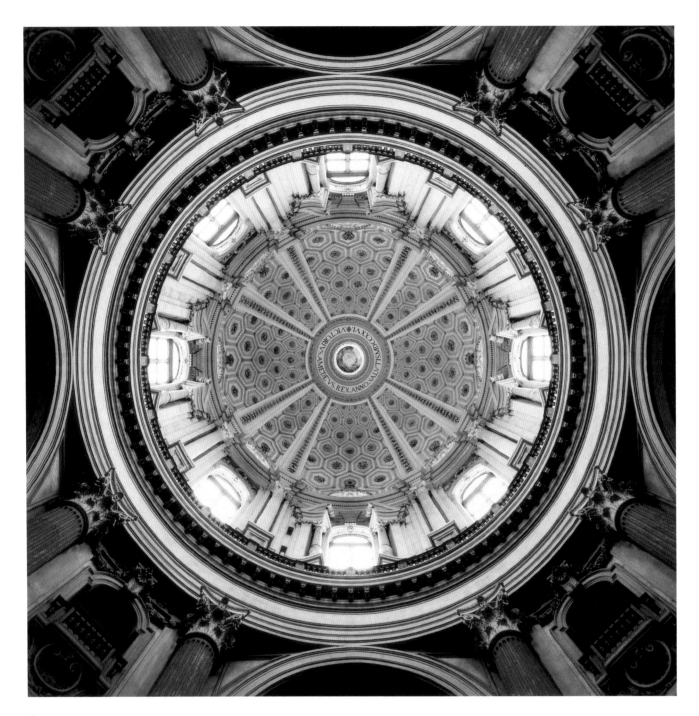

fig. 7

Dome of the Basilica of
Superga, Turin, Italy
ca. 1717–31

Photograph by David
Stephenson, from his book
Visions of Heaven (2005).

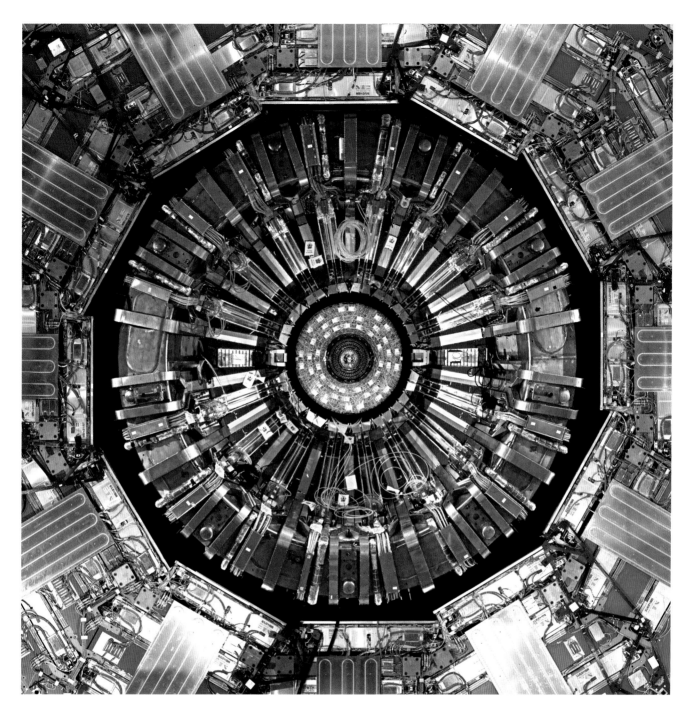

fig. 8

Compact Muon Solenoid, Large Hadron Collider, Cessy, France
2008

The Compact Muon Solenoid (CMS), a particle detector that observes a gamut of particles resulting from high-speed proton collisions at the Large Hadron Collider in Cessy, France. This photo shows a cross section of the open CMS detector, which is installed in a cavern 100 meters underground. With an approximate weight of 14,000 tons, the CMS measures 21.6 meters in length and 15 meters in diameter. Photograph by Maximilien Brice and Michael Hoch, the European Organization for Nuclear Research.

1. CITIES AND ARTIFACTS

Since the early days of human sedentism, most settlements, villages, and cities have followed some type of circular arrangement, normally enclosing a primary area bustling with important economic, social, and political activities. A circular layout provides a strong sense of unity among households and protects individuals from potential dangers coming from any direction. Such a planning logic can be found in ancient cities such as Arkaim in the Southern Urals (ca. 1700 BC), Ectabana in what is now Iran (ca. 700 BC), or in the Mesoamerican Teuchitlan tradition (ca. AD 200). As settlements grew and became more complex, their most valued area naturally remained the core, protected by an ever-expanding peripheral area. Throughout history, this general organizing principle emerged in an organic fashion, without any high-level planning. An intentional circular plan did surface at times (in Ancient Greece and the Roman Empire, notably in Roman military camps), but it was during the High Middle Ages and the Renaissance that the idealized circular order of cities was broadly adopted across Europe. Such was the prevalence of this practice, exemplified by the French *circulade* (a traditional medieval village organized in concentric circles), that many modern-day cities of the Old World, some with large urban sprawls, still maintain a general circular plan / *fig*. 9 / *fig*. 10. This model could even be witnessed in some North American towns, such as the well-known Circleville, Ohio, until the early nineteenth century, when the convenience of the orthogonal grid was widely adopted.

For increased security against human and natural threats, towns and cities often encircled the key areas of a commune with a physical boundary. Predominantly circular, fortifications exhibited different styles and constructs, such as the simple wooden palisade (popular among the Celts and in pre-Columbian Mississippian culture) / *fig*. 11, the earth rampart and hill fort, the Celtic castro, the stone ringfort, the Renaissance star fort, and the imposing stone-walled medieval fort. The omnipresence of these planning arrangements, particularly in the case of the primeval circular earthwork, makes it reasonable to imagine they have been popular since long before recorded history. Perhaps the most intriguing of all prehistoric circular structures are the hundreds of stone arrangements erected across the British Isles, the earliest dating back to the Late Neolithic and Early Bronze Age (ca. 3200 BC). Among these intriguing structures is the best known of all, Stonehenge / *fig*. 12. Thought to be a large solar calendar used to celebrate different events throughout the year, Stonehenge was constructed in multiple stages starting around 3100 BC, and it appears to have been rearranged several times until 1600 BC. As impressive as it is, Stonehenge is just one of more than thirteen hundred sites across the British Isles that consist of similar rings of stones, from Avebury in southern England to the Orkney Islands in northern Scotland.

Whenever humans gather around a particular scene or object, they instinctively form a circle. This universal behavior underlies the shape of many ancestral entertainment structures, such as circuses, arenas, theaters, coliseums, concert halls, and stadiums. More than an organizing principle for entertaining, circularity has been incorporated into numerous religious, political, commercial, and residential edifices in ancient and modern times, most notably Buddhist stupas, Christian baptisteries, rotundas, planetariums, lighthouses, tower houses, windmills, shopping malls, libraries, and hotels / *fig*. 13. The vestiges of this ancestral principle are recognizable in the huts of the Matakam people in Cameroon, the *trulli* of Alberobello in southern Italy, the tepees built by North America's indigenous people, or the igloos erected by some

fig. 9

Pasquale Cicogna and
Georg Braun
**Plan of the city of Palmanova,
Italy**
1593

Engraving of the idealized
circular plan of Palmanova,
in northeastern Italy, with a
star-fort layout typical of the
late Renaissance. Founded
to commemorate the early
Christian martyr Saint Justine
of Padua, as well as the
anniversary of the 1571 victory
of the Christian forces of the
Holy League over the Ottoman
navy in the Battle of Lepanto,
Palmanova is the embodiment
of the utopian city arrangement
that proliferated across Europe
during the Renaissance.

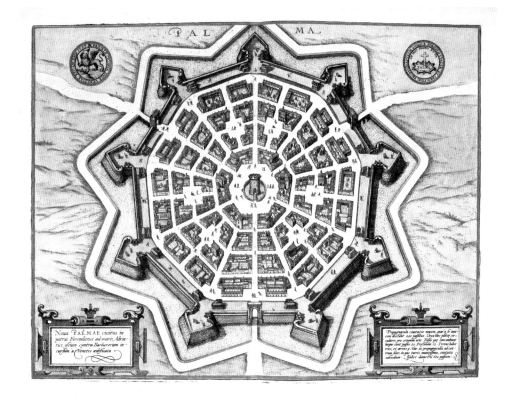

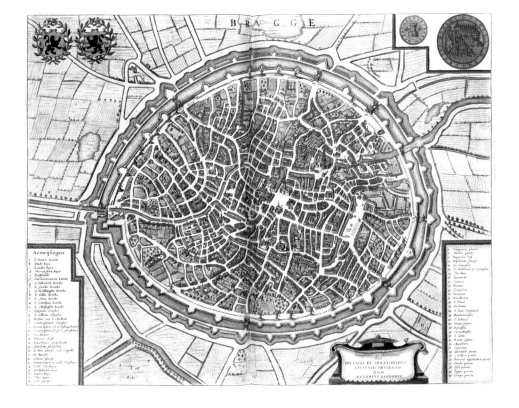

fig. 10

Anonymous
Map of Bruges
1649

Map showing the circular plan
of the medieval Flemish town of
Bruges, in modern-day Belgium.
It is featured in the *Atlas van
Loon*, a collection of eighteen
extant volumes (out of twenty-
four original ones) of world
and city maps, commissioned
by the banker and member
of Amsterdam's town council
Frederik Willem van Loon in the
latter half of the seventeenth
century. The opulent *Atlas*
includes the Dutch edition
of Joan Blaeu's famous nine-
volume *Grooten Atlas* (1662–65),
as well as numerous other
celebrated volumes of maps.

fig. 11

Theodor de Bry
Indian village of Pomeiooc
1590

Colored version of Flemish engraver Theodor de Bry's depiction of the American Indian village of Pomeiooc, originally published as an illustration in Thomas Hariot's book *A Briefe and True Report of the New Found Land of Virginia* (1588), based on a watercolor by colonist John White. It depicts an Algonquian village consisting of a small group of buildings bounded by a circular palisade. Located in present-day North Carolina, this settlement was typical of those built by many Native American tribes, from the Arawak in the West Indies to the Algonquian in the eastern United States and Canada.

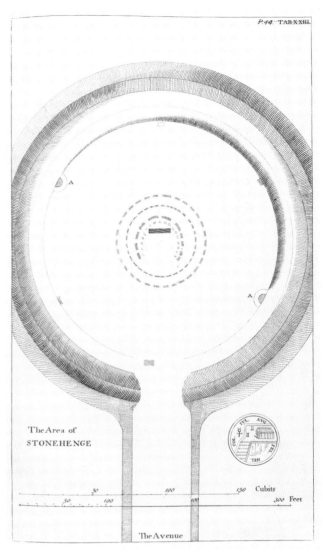

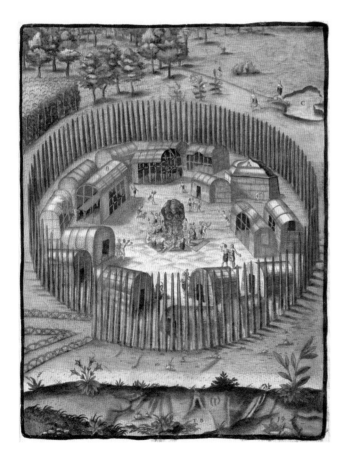

fig. 12

William Stukeley
The Area of Stonehenge
1740

Drawing of the outer and inner circles of Stonehenge by the English vicar and antiquarian William Stukeley, who spearheaded the survey of important British prehistoric sites such as Stonehenge and Avebury. It shows the outer circular earth bank and ditch—believed to be the first structure built at Stonehenge, in around 3100 BC—enclosing the central ringed stone structure, erected around 2400 BC.

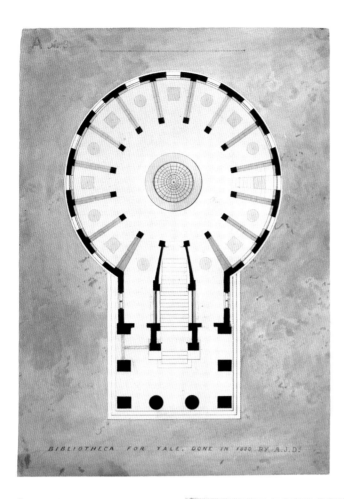

BIBLIOTHECA FOR YALE. DONE IN 1830 BY A.J.D.

fig. 13 (left)

fig. 13 (left)

Alexander Jackson Davis
Yale Library
1830

Architectural drawing of a proposed Yale University library building by the American architect Alexander Jackson Davis.

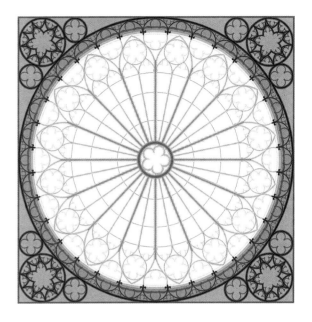

fig. 14 (right)

Gustave de Beaumont
Plan of Cherry Hill Penitentiary
1833

Architectural drawing of the radial plan of the Eastern State Penitentiary, also known as Cherry Hill, in Philadelphia, designed by the English architect John Haviland. In operation from 1829 to 1971, the penitentiary's design was influenced by the idea of the Panopticon, developed by the English law reformer Jeremy Bentham in 1791. Its circular structure allowed for totalitarian control via a centralized guard who could oversee all the cell doors of its radiating wings. Cherry Hill Penitentiary's radial layout soon became the model for many other prisons in countries including England, Spain, France, and Cuba.

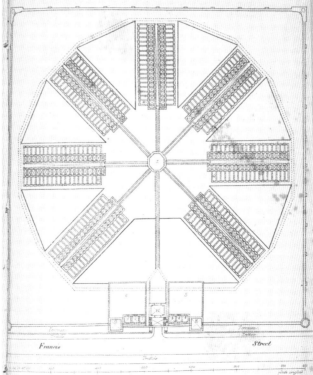

fig. 15 (above)

Erwin von Steinbach
West facade rose window of Strasbourg Cathedral
1176–1439

Architectural drawing by Sansculotte of the highly detailed Gothic rose window measuring 45 feet (13.6 meters) in diameter. This window is a central element of the Strasbourg Cathedral in France, the sixth tallest church in the world, for which construction started in 1015. Popular in medieval Europe, particularly during the Gothic period, rose windows likely have their origin in Byzantine architecture and the Roman oculus, a circular opening whose origins might in turn predate recorded history.

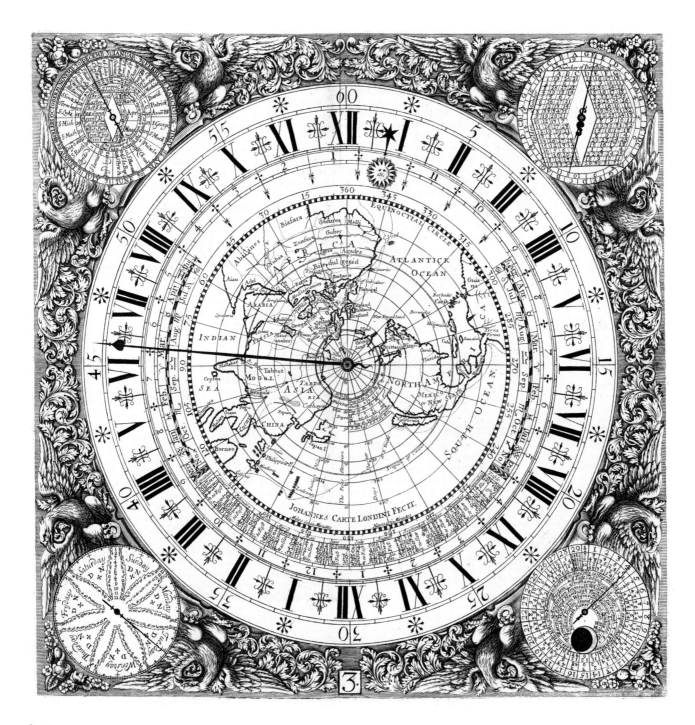

fig. 16

John Carte
The Frontispiece of "The Cosmographical Clock"
1700

This diagram was featured on a broadside advertisement representing various phenomena as occurring on Tuesday, December 3, 1700, at three quarters past twelve. It was produced by John Carte, an enigmatic and influential British clockmaker who was known for his cosmographical clocks that calculated cyclical events such as tides and feast days.

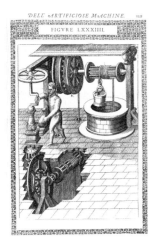

fig. 17

Agostino Ramelli
Dell Artificiose Machine
(The ingenious machine)
1588

Illustration showing an
operating water-well machine,
part of an instructional book, by
the Italian engineer Agostino
Ramelli, entitled *Le diverse
et artificiose machine del
Capitano Agostino Ramelli*
(The diverse and ingenious
machines of Captain Agostino
Ramelli). The book includes 195
engineering designs for several
types of machinery, including
mills, pumps, and wells, many
featuring circular components.

Inuit tribes. In the late eighteenth century, English philosopher Jeremy Bentham famously epitomized the notion of centralized control with the Panopticon, a circular penitentiary with a surveillance booth at its epicenter /*fig.* 14. More recently, geodesic domes, popularized by the American architect Buckminster Fuller in the twentieth century, came to symbolize a new circular modernity in architecture. Finally, often for its strengthening capability, circularity is employed in various architectural structures, features, and ornaments, such as the bridge, dome, arch, staircase, rose window, tracery, and volute /*fig.* 15.

On a smaller scale, we can observe circles everywhere in our contemporary daily routine, from manholes on the ground to traffic signs, antennae, umbrellas, tires, gears, tableware, music records, watches, coins, rings, and the numerous dials and buttons integral to modern technology's digital interfaces. Historically, the circle has been the dominant shape of devices for measuring time, geographical location, or the position of stars, such as the sundial, compass, astrolabe, and astronomical clock /*fig.* 16. But one of the most enduring manifestations of the circle—and of human invention—has undoubtedly been the wheel. Initially used by potters in ancient Mesopotamia around 4500 BC, the wheel was soon embraced by chariot makers in Sumer, Central Europe, Egypt, and ultimately China. Wheeled vehicles enabled major advances in agriculture, transportation, and the military, becoming a major catalyst for the progress of human civilization. The wheel again played a pivotal role in the Industrial Revolution and the mechanization of modernizing societies across the world. While wheeled machinery had been used for centuries in mining, milling, and irrigation /*fig.* 17, it was during the Industrial Revolution that the wheel became the primary engine of a new world order, underpinning a range of industries, from steam power to textile manufacture. As we will see, the universal use of the wheel as a power generator meant that over time it became the ultimate symbol of motion and cyclicality.

2. IDEOGRAMS AND SYMBOLS

Humans are innate image makers and image enjoyers. Millennia before written language, humans employed images to communicate and express themselves, as well as to record and recall events. The earliest signs of this fascination date back to the Upper Paleolithic period, possibly as far back as 35,000 BC, in the form of petroglyphs and pictographs created by hunter-gatherers across Europe, Asia, and Africa. Among the most common geometric figures drawn by prehistoric humans are spirals and concentric and sectioned circles, found everywhere from Gabon, Africa, to Utah, United States /*fig.* 18 /*fig.* 19. These ubiquitous circular marks, whose exact meaning is now long gone, are echoed in nearly every system of letters or ideograms created by humans, as well as countless diagrams expressing a wide range of ideas, from religion to physics, from art to astronomy.

Archaeologist Denise Schmandt-Besserat has long studied the evolution of written language and the emergence of the cuneiform script, the oldest writing system, invented in Sumer around 3500 BC. She has looked particularly closely at the main predecessor of the cuneiform, which dates back as far as 8000 BC. It was a system of small clay tokens used to record transactions. These tokens represented anything from a sheep to a portion of grain. In an effort to make sense of their numerous forms and inscriptions, Schmandt-Besserat identified eighteen primary typologies of clay tokens as the prototypes of subsequent numerical notations that

fig. 18 (left)

Anonymous
Prehistoric petroglyphs of Argyll
date unknown

Drawing from *Ancient British Rock Art: A Guide to Indigenous Stone Carvings* (2007), by Chris Mansell. This set of circular petroglyph patterns was found in Argyll County in western Scotland. Dating such rock inscriptions is hard, but it's been suggested they could have been created as far back as 4000 BC.

fig. 19 (below)

Anonymous
Petroglyph motifs
date unknown

Drawing from *Ancient British Rock Art: A Guide to Indigenous Stone Carvings* (2007), by Chris Mansell. These common rock-art inscription patterns have been found all across the British Isles, estimated to date to anywhere between 5000 and 1000 BC.

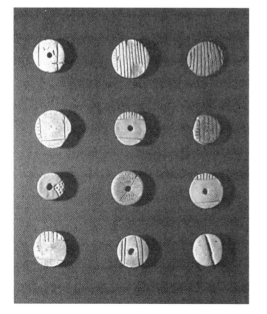

fig. 20 (left)

Anonymous
Disk tokens
3300 BC

Circular tokens from the ancient Sumerian city of Uruk, in modern-day Iraq. While early farmers in the Near East used different token shapes such as cylinders, ovoids, quadrangles, and triangles to represent a variety of merchandise, circular tokens appear to be the predominant type of this protowriting system. This set is thought to depict various textile and garment patterns made of incised lines and dots.

endured in the cuneiform script. Of these eighteen types, no less than nine exhibited some circular shape or motif, making the circle a fundamental construct in the earliest known proto-writing system / *fig.* 20. Circular shapes appear in almost every modern-day alphabet as a primary graphical component of characters and accents, from the Ge'ez script of Ethiopia and Eritrea to the Hangul alphabet of South Korea. But the circle is inexorably associated with one of the most extensively used symbols: the number zero.

Even though the Mayas and Babylonians employed the concept of zero, the numeral we know today came to us from Indian philosophy, where it was found as early as 200 BC. The primeval zero was used in Indian culture as a dot, or *bindu*, "the point from which all things emerged, in other words, the creation of something from nothing."[1] Zero eventually was spread throughout Europe in the Middle Ages by Muslim scholars as part of what became known as Arabic numerals. In most languages, the word *zero* derives from the original Arabic, *ṣifr*, which means "empty." Drawn as a circle or an ellipse, zero has always been the embodiment of emptiness, nothingness, or nonexistence. This idea was apparently quite frightening for ancient Greeks, who saw numbers and philosophy as inseparable entities. Seeded by the Greeks, propagated by the Romans, and ultimately cemented by early Christian ideals, the aversion to zero lasted hundreds of years.[2] To consider the paradox of something emerging from nothing was as blasphemous as questioning the existence of God. Today, most of these associations have faded, and zero is a basic construct of binary code, underpinning contemporary advances in computing and telecommunications.

Circles are not just important atomic elements of numerals and alphabets. A look at the graphics we encounter on a daily basis quickly uncovers myriad circular icons, signs, symbols, images, graphs, and charts; just think of the multitude of international corporations that have adopted circular logos / *fig.* 21.

Many diagrams and illustrations combine multiple circles in order to express a stronger sense of unity or various types of relationships. When two equal circles intersect they create the inner shape known as the *vesica piscis* (fish bladder), a harmonious symbol used in Christian art and architecture. In mathematics, three interlaced circles form the Borromean rings, which were commonly used in medieval manuscripts as symbols of the Christian trinity. More recently, they have been used for the trefoil shape of the warning symbol for biological hazard / *fig.* 22. Four intersecting circles shape the quatrefoil, a popular decorative pattern used in architecture, heraldry, and the military. When even more circles are combined, they can form endless shapes and layouts. Among the most famous are the Olympic logo, designed in 1912 by the cofounder of the modern Olympic Games, Pierre de Coubertin, or the flower of life / *fig.* 23, a geometric motif used for centuries in cultures around the globe.

We couldn't, of course, discuss overlapping circles without mentioning Euler and Venn diagrams. The use of interlaced circles goes back to the popular motifs of prehistoric cultures, particularly that of the Celts, but it was the Swiss mathematician Leonhard Euler in the eighteenth century who first built a logical framework of relationships based on the juxtaposition of circles. Around 1880 John Venn expanded on Euler's idea and created a system of combinations of circles, many of them with wide applicability in logic, mathematics, linguistics, and, now, computer science. Venn diagrams leverage the simplicity of the circle's notion of unity and containment to explore various permutations of inclusion and exclusion / *fig.* 24.

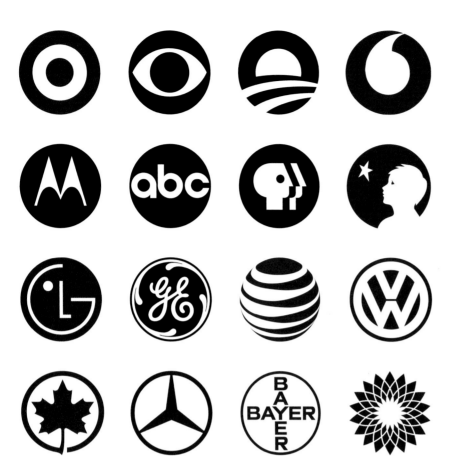

fig. 21

Circular logos

From left to right, top to bottom: Target, CBS, Barack Obama's 2008 presidential campaign, Vodafone, Motorola, ABC, PBS, Danone, LG, GE, AT&T, Volkswagen, Air Canada, Mercedes-Benz, Bayer, BP.

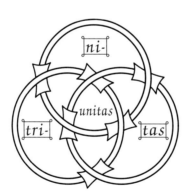

fig. 22

Trefoil models

From left to right: (1) a triple spiral, also known as a triskelion, popular among different European cultures, particularly the Celts, and dating to at least as far back as 4000 BC;

(2) a trefoil from a medieval manuscript depicting the Christian doctrine of the Trinity (*trinitas* in Latin), with unity (*unitas*) at the central overlap of the three rings; (3) the biological hazard symbol created by Dow Chemical Company in 1966.

fig. 23

Flower of life

An ancient geometric motif
found in numerous cultures,
from ancient Egypt to India.
It's composed of a number of
evenly spaced, equally sized,
overlapping circles, creating
a geometric shape that
resembles the core of a flower.
Similar to other universal
symbols such as angels and
dragons, the flower of life
appears to have surfaced
independently in different
areas of the globe and at
different periods in history.

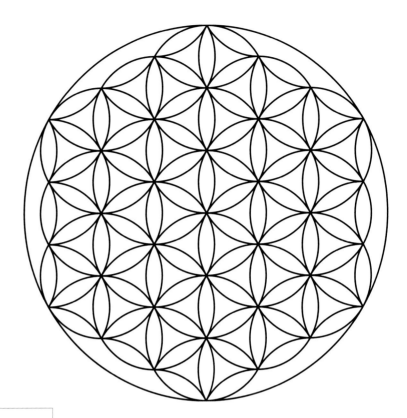

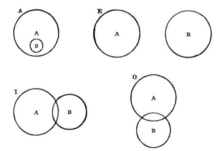

fig. 24

William Hamilton
Euler diagrams
1860

An explanation of different
combinatorial models
afforded by Euler diagrams, a
predecessor to modern-day
Venn diagrams, provided by
Scottish metaphysician Sir
William Hamilton in his *Lectures
on Metaphysics and Logic*
(1860).

3. UNIVERSAL METAPHORS

"Let us go on, the long road urges us," the poet Virgil says as he guides a frightened Dante into the "first circle girding the abyss."[3] In his famous epic of eternal punishment, Dante depicts the Inferno as nine concentric circles that gradually increase in intensity according to the significance of the sin, from the mild circle of Limbo, populated by non-Christians and unbaptized pagans, to the last circle of Betrayal, inhabited by Satan himself /fig. 25. Arguably one of the most famous literary uses of the circle, the *Inferno* stands atop a long-standing tradition of employing the circle in a variety of metaphorical contexts /fig. 26. The seventeenth-century English polymath Robert Fludd devised numerous metaphors centered on the circle /fig. 27; the German philosopher Peter Sloterdijk offers a more contemporary construct in his trilogy *Spheres* (1998–2004), which portrays the history of Western metaphysics as a set of variably sized bubbles, including self-discovery, world exploration, and plurality.

Most metaphors are understood in a shared cultural setting, where everyone appreciates their meaning and nuances. This social group can be as large as a country or as small as your inner circle of friends and family. "Cultural assumptions, values, and attitudes are not a conceptual overlay which we may or may not place upon experience as we choose," say American cognitive linguist George Lakoff and philosophy professor Mark Johnson. Instead, "all experience is cultural through and through."[4]

But cultural metaphors have inherent limitations. Universal metaphors, on the other hand, tend to carry some primeval quality that makes them prevalent across time, space, and culture. Many universal metaphors pertain to general ideas of movement, orientation, or grouping, usually with a corresponding visual symbol. Some of these symbols are as pervasive as the concepts they describe. Ideas of ascension, progress, and up-down movement find their best representation in the image of a ladder, while ideas of dependency, hierarchy, and growth use the image of the tree. A set of elementary ideas pertaining to territoriality and orientation, for example, inclusion-exclusion, in-out, and center-periphery are typically conveyed by the circle. But the circle's associations run much deeper. Of the plethora of rich meanings carried by the circle in different social groups over the ages, four major themes predominate: (1) simplicity and perfection; (2) unity and wholeness; (3) movement and cyclicality; (4) infinity and perpetuity. We will now look at the significance of each theme.

PERFECTION

Ideas of simplicity, perfection, balance, harmony, purity, and beauty are not hard to derive from the symmetrical stability of a circle, the simplest of all geometric shapes. With its properties fully substantiated in Euclid's *Elements* (300 BC), the circle became central to the early development of geometry, astronomy, and astrology, disciplines long perceived to be manifestations of the divine. In line with his theory of forms, Plato argues in his *Seventh Letter* (ca. 360 BC) that the circle is ultimately a mental construct, an idealized form, which doesn't truly exist; certainly, unlike other universal metaphors such as the tree or the ladder, the circle has no equivalent material reality. This assertion forms the critical foundation of the circle's long-lasting connotations of purity and perfection.

The impression of purity and virtue might also explain why this evocative shape has been used in the iconography of major religions such as Christianity, Hinduism, Buddhism,

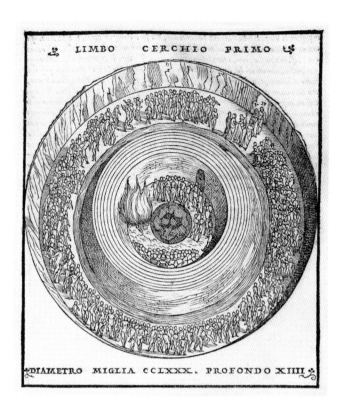

fig. 25 (left)

Alessandro Vellutello
Limbo Cerchio Primo
(Limbo: the first circle)
1544

An illustration depicting an aerial view of the first circle of hell (Limbo) in Dante Alighieri's *Divine Comedy*. Included in Alessandro Vellutello's commentary, *La comedia di Dante Aligieri con la noua espositione di Alessandro Vellutello*, it is accompanied by eighty-six other engravings of different scenes and passages from the epic poem's cantos. All illustrations for the *Inferno* (Hell) employ a circular design similar to the one portrayed here.

fig. 26 (right)

Maria Sibylla Merian, Thomas Norton, Johannes Thölde, and Basilius Valentinus
Tabula Smaragdina (The emerald tablet)
1678

Part of a compilation of alchemical texts and images entitled *Musaeum hermeticum reformatum et amplificatum*, this highly intricate engraving depicts the cosmology conveyed by the Emerald Tablet of Hermes—a highly esteemed Hermetic text, once translated by Isaac Newton, which was the main source of alchemical thought and practice. It represents the philosopher's stone leaving heaven and entering Earth, with the Tetragrammaton (the four Hebrew letters forming the name of God) at the very top, followed by ranks of angels and rings of astrological constellations. The illustration is populated by various Hermetic symbols conveying the relationship between man and the universe, including the dragon, swan, phoenix, and lion.

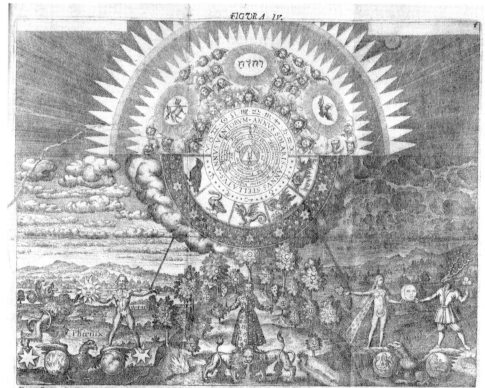

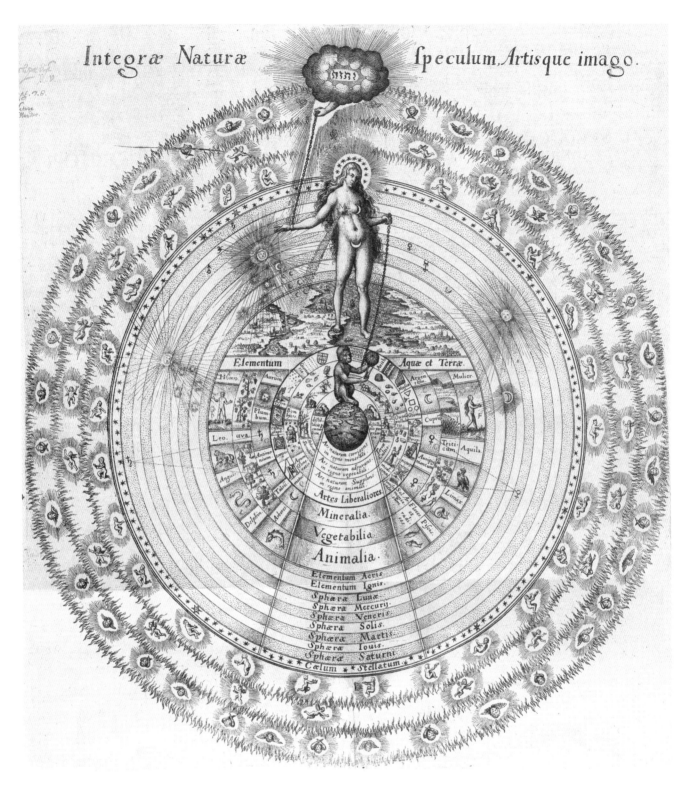

Integræ Naturæ Speculum,Artisque imago.

fig. 27

Robert Fludd
*Integræ Naturæ Speculum
Artisque Imago* (Mirror of the
whole of nature and the image
of art)
ca. 1617

Plate xviii from English polymath
Robert Fludd's remarkable work,
*Utriusque cosmi maioris et
minoris metaphysica, physica,
atque technica historia* (The
greater cosmos and the lesser
metaphysics, physics, and the
history of technology), 1617.
This intricate engraving depicts

the cosmic system, as well the
activity of God, nature, and art.
The outer rings symbolize the
angels, with bands for planetary
spheres, air, and fire closer to
the core. The seven innermost
rings represent the three natural
kingdoms, followed by the
"liberal arts," including painting

and geometry, and their effect
on nature. "Art Supplementing
Nature in the Animal Kingdom"
encompasses medicine and
sericulture, for example; "Art
Helping Nature in the Vegetable
Kingdom," tree grafting; and
"Art Correcting Nature in the
Mineral Kingdom," distillation.

and Islam, normally as a disc of glowing light, known as a halo or aureole, which surrounds the head of sacred and revered figures / *fig*. 28. The circle's inherent balance, harmony, and sense of peacefulness underpins the mandala as a mystical symbol prominent in many Indian religions / *fig*. 29. As a figurative representation of the universe, normally with four gates (at the four cardinal points) leading to an inner circle, the mandala—which means "circle" in Sanskrit—is an important tool for spiritual guidance, enhancing meditation and focus.

This notion of balance and perfection has also encompassed grace, elegance, and, ultimately, beauty. In his seminal *Metaphysics*, Aristotle listed order, symmetry, and definiteness as the general elements of beauty. Many Western philosophers and artists, such as William Hogarth, Francis Hutcheson, and John Ruskin, reinforced this view over the ages (only to be critically challenged in the twentieth century by the adherents of art movements advocating a new type of aesthetics). The important link between symmetry and beauty has been corroborated by modern studies that show a human preference for symmetrical balance in numerous shapes found in nature, including our own faces. Countless artists have explored this aesthetic trigger by embracing radial symmetry in their work / *fig*. 30 / *fig*. 31.

UNITY

Another popular association with the circle is the concept of unity, wholeness, completeness, inclusion, or containment. This follows naturally from the form of a circle, a joined curve that creates two areas: interior versus exterior, inclusion versus exclusion. As such, the circle powerfully embodies ideas of boundary. Lakoff aptly expresses this significance: "There are few human instincts more basic than territoriality. And such defining of a territory, putting a boundary around it, is an act of quantification."[5] The notion of the circle as a container is employed in countless idioms. You might "circle around a problem" to evaluate it properly or "circle a question" to avoid getting into the details. But the more obvious idioms are the ones that employ the circle as a social boundary, which can imply both inclusion and exclusion. You can move "in the same circles," belong to someone's "circle of friends," or perhaps study a given discipline as part of a "philosophy circle" or a "literature circle." Closer to your heart might be your own "family circle," "inner circle," or "circle of love."

One of the oldest circle metaphors, the encyclopedia, acts as a container for the totality of human understanding. The word *encyclopedia*, which was first used in the sixteenth century by Sir Thomas Elyot in *The Book of the Governor* (1531) and one year later by François Rabelais in *Pantagruel* (1532), comes from the Hellenistic Greek as a combination of *enkyklios* (ἐγκύκλιος), meaning "general" or "circular," and *paideia* (παιδεία), meaning "education" or "learning."[6] The combined term *encyclopedia* can be interpreted as "general education" or, in a popular, long-lasting variant, the "circle of learning" or "circle of knowledge." Since most encyclopedic endeavors have striven for a comprehensive coverage of human knowledge, this term provides an important example of the idea of completeness.

But the most definitive expression of human territoriality is the map. Depending on the scale, maps can plot our immediate surroundings or the largest known habitable region, our planet Earth. Maps have always embraced the circle as part of their fundamental makeup. Circular maps of the known world date as far back as 600 BC, when Babylonians created a map of ancient Mesopotamia / *fig*. 32. One of the best-known schematic circular maps of

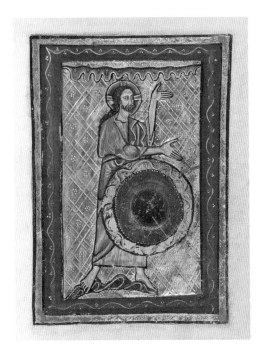

fig. 28

William de Brailes
God the Architect
ca. 1250

A common medieval portrayal of God as the great architect of the universe, with a halo surrounding his head, next to a representation of the world (symbolizing the Genesis creation story). This image is one of thirty-one Bible illustrations by the English artist William de Brailes featured in a medieval manuscript thought to have once contained up to ninety-eight miniatures, making it one of the largest extant illuminated manuscripts from thirteenth-century England.

fig. 29

Anonymous
Thangka of a mandala
ca. eighteenth century

A Tibetan cotton watercolor painting, commonly known as a *thangka*, depicting a mandala with four gates and containing a circle with a center point and surrounded by various miniature figures.

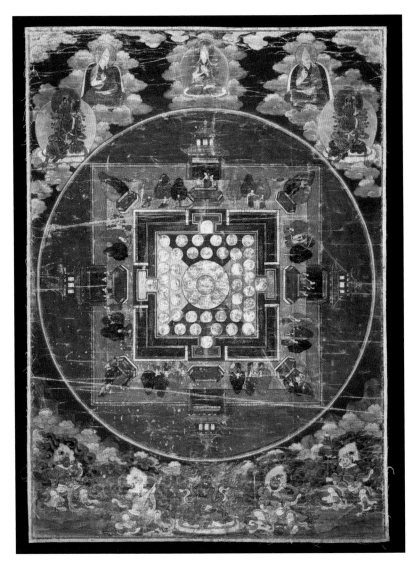

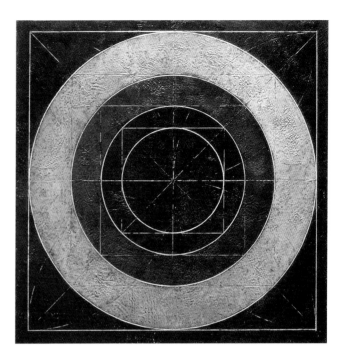

fig. 30

Astrid Fitzgerald
No. 310
2007

Painting, encaustic on wood,
24 × 24 × 1 inches (61 × 61 × 2.5
centimeters).

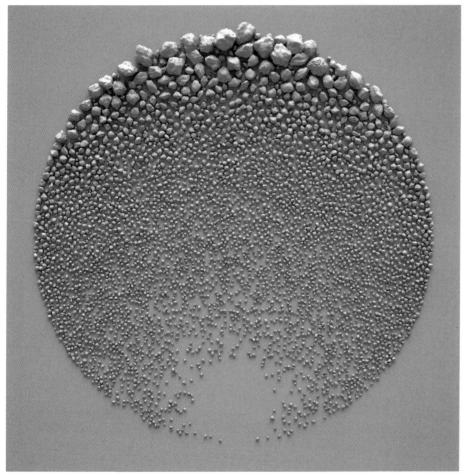

fig. 31

Giuseppe Randazzo
Stone Fields
2009

Computer-generated artistic
composition of stones that uses
an optimal packing algorithm
written in C++. The position
of the virtual stones within the
circle was determined using
several fractal subdivision
strategies.

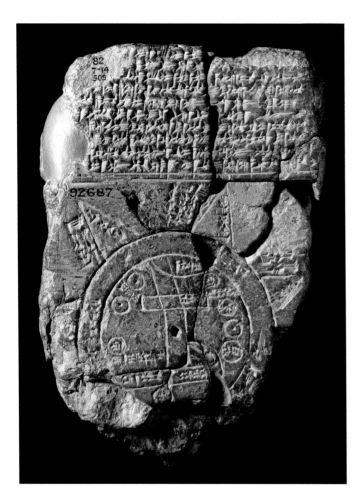

fig. 32

Anonymous
Babylonian map of the world
ca. sixth century BC

Clay tablet displaying a map of the known world as a circle of land surrounded by the Earthly ocean, also known as the Bitter River. Inside the circle there is a cross shape thought to represent the river Euphrates, which divided the city of Babylon in two. Multiple smaller circles inside the circle of land depict neighboring cities and regions, including Assyria and Der. At the edge of the Bitter River, organized in a radial fashion, are seven large triangles, symbolizing seven islands that connect Earth and the heavenly ocean.
© *The Trustees of the British Museum*

fig. 33 (right)

Isidore of Seville
T-O map
1472

Medieval conception of Earth, known as the T-O map. Spanish scholar Isidore of Seville's most grandiose piece, compiled roughly between 615 and 630, was the influential *Etymologiae* (Etymologies), a twenty-volume encyclopedia with quotes from 154 Christian and pagan authors of antiquity. Among its many captivating maps and illustrations was the enduring T-O map. Surrounding the circle of the inhabitable world is the river of salt known as *Mare Oceanum*. The main *T* shape in the map represents three rivers: the Don and the Nile at the top (the horizontal line) and the Mediterranean (the vertical leg). The three rivers divide Asia (top), Europe (bottom left), and Africa (bottom right).

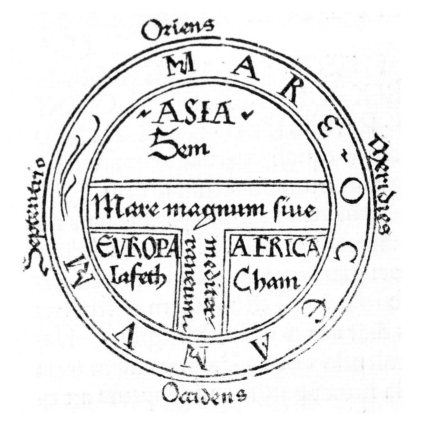

THE BOOK OF CIRCLES

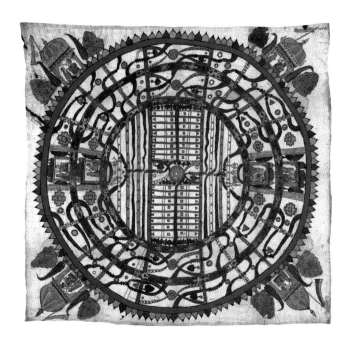

fig. 34

Anonymous
Map of the world of man
ca. 1890

Cosmological diagram of *manuṣyaloka* (the human world) based on the traditions of the Indian religion Jainism. The map shows the two and a half inhabited continents as concentric bands separated by ocean rings filled with fish and swimmers and abounding with rivers, lakes, and mountain ranges. At the core of the diagram is the continent *Jambudvipa* surrounded by the salt ocean *Lavana Samudra.* The following ring depicts the continent *Dhatakikanda* bordered by *Kalodadhi* (a black water ocean). Half of the third continent *Pushkaradvipa* is depicted on the last, peripheral band, surrounded by multicolored mountain peaks.

fig. 35

Fra Mauro
Fra Mauro map
1450

One of the most significant maps in the history of cartography, valued for its level of detail, accuracy, and richness. Measuring 94.5 × 94.5 inches (240 × 240 centimeters), this map of the known world, drawn on parchment, contains more than three thousand descriptive texts and employs many color pigments that were expensive at the time of its creation, including red, blue, and green. South is positioned at the top, and we can clearly perceive Africa on the top right, Asia on the left, and Europe on the bottom right. The main circular map is accompanied by a small sphere in each corner: a map of the solar system according to Ptolemy (top left), an illustration of the four elements (top right), the Garden of Eden (bottom right), and Earth as a globe (bottom left).

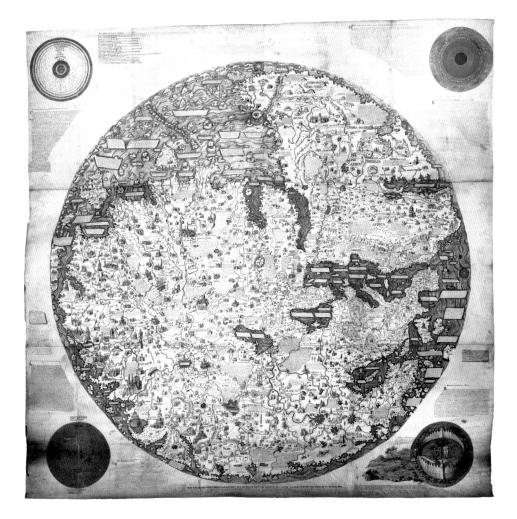

the world was introduced by the Spanish monk Isidore of Seville in his groundbreaking *Etymologies*, first published in the early seventh century and distributed throughout Europe until the Renaissance / *fig.* 33. As Isidore of Seville explains in the prologue of *Etymologies*: "The mass of solid land is called round after the roundness of a circle, because it is like a wheel.... Because of this, the Ocean flowing around it is contained in a circular limit, and it is divided in three parts, one part being called Asia, the second Europe, and the third Africa."[7] His T-O map became a dictating force in medieval European cartography; but various radial world maps were conceived in succeeding periods, such as the Jain world map / *fig.* 34, the Ebstorf world map (1245), the Fra Mauro world map / *fig.* 35, and other examples showcased in chapter 6.

MOVEMENT

The circle is a powerful symbol of generative force, associated over the ages with ideas of movement, rotation, transformation, cyclicality, and periodicity. A circle can be described as the curve drawn by a moving point revolving at a constant distance around a stationary point. This definition is central to the idea of rotation implicit in the circle and reinforced by one of the circle's inescapable manifestations, the wheel. On a different scale, radial motion has been central to the development of modern science and technology, from the small discs used in the zoopraxiscope, an early motion-picture device / *fig.* 36, to the immense seventeen-mile (twenty-seven-kilometer) circular tunnel that is part of the European Organization for Nuclear Research's Large Hadron Collider.[8]

The phrases "the circle of life" and "the wheel of life" express the notion of movement through a cycle from birth to death. One might even bring something "full circle" when ending exactly where one started. For centuries, such ideas of cyclicality had corresponding visual signifiers, some imbued with spiritual and religious significance. The wheel of life of Tibetan Buddhism, known as *bhavacakra*, is a visual representation of the cycle of birth, life, and death, with the main six sections of the wheel standing for the six realms of *Saṃsāra* (continuous movement) / *fig.* 37. In Buddhism, as well as other Indian religions such as Hinduism and Jainism, we find another symbolic wheel: the Wheel of the Dharma, or *dharmachakra*. Found on the flag of India and as the national emblem of Sri Lanka, the *dharmachakra* represents the teachings of Buddha, with the spokes of the wheel standing for the tenets of Buddhist belief.

Among the most ingenious uses of the rotational properties of radial diagrams is the volvelle, or wheel chart. Emerging in the High Middle Ages and popular throughout the Renaissance, particularly among astronomers, these interactive paper structures were early analog computers, using multiple interconnected parts to aid calculation and systematization / *fig.* 38 / *fig.* 39. They could comprise a single revolving wheel or a stack of paper rings that could be independently rotated, thereby permitting a large number of combinations at the intersection of moving layers. As stand-alone pieces or incorporated within manuscripts, volvelles had a resurgence in the twentieth century, as thoroughly documented by Jessica Helfand in her captivating book *Reinventing the Wheel* / *fig.* 40. Arguably, the essence of volvelles exists to this day among the multitude of contemporary, digital, and highly interactive visualizations.

Some of the most significant circular models based on ideas of rotation have described planetary movement, particularly in our own solar system. The idea of a stationary Earth at the center of the universe was firmly established until the Renaissance, when Nicolaus Copernicus

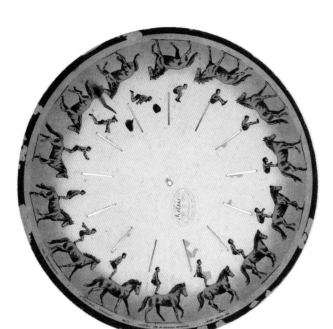

fig. 37

Anonymous
Yama holding the wheel of life
early twentieth century

Tibetan *thangka* painting of the
wheel of life, in which the god of
death, Yama, holds the *Saṃsāra*
cycle of birth, life, and death.
At the core of the wheel are
the three symbols of ignorance,
desire, and hatred: respectively, a
pig, a cockerel, and a snake. The
following ring depicts people either
going to a higher realm based on
their good karma or descending
to a lower realm based on their
bad behavior. The large, sectioned
disk represents the six realms of
existence into which one can be
reborn: the realms of gods, titans,
humans, animals, hungry ghosts,
and demons.

fig. 36

Eadweard Muybridge
Horseback somersault
ca. 1893

Zoopraxiscope disk by the
English photographer Eadweard
Muybridge. Muybridge was a
motion-picture pioneer who
produced thousands of photos
exploring human and animal
locomotion, proving among
other things that horses do
momentarily fly while galloping,
when all four hooves are
simultaneous off the ground.
In 1878 Muybridge devised the
zoopraxiscope, the first movie
projector, which worked through
the rotation of a disk filled with
static, hand-painted images,
giving the illusion of motion.

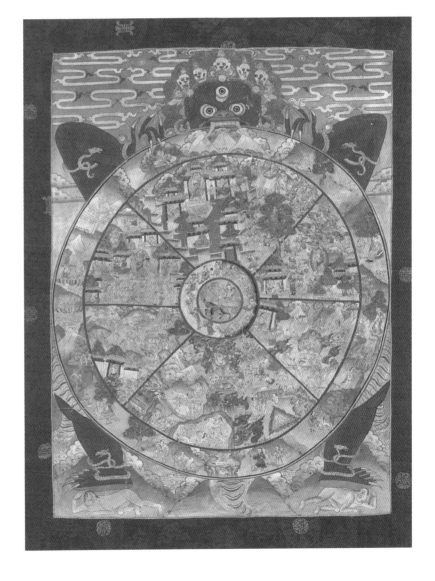

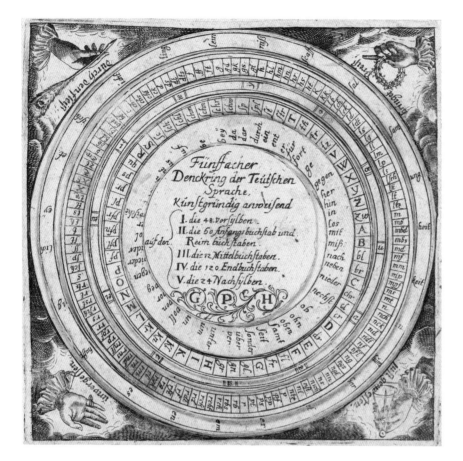

fig. 39 (below)

Peter Apian
Cosmographical mirror
ca. sixteenth century

Illustration from *Cosmographia*,
first published in 1524, a highly
respected work on astronomy
and navigation written by the
German cartographer and
mathematician Peter Apian.
This work was reprinted
more than thirty times in
fourteen languages. The
original edition contained
four volvelles: a paper
instrument for determining
the horizon line, an altitude
sundial, a lunar clock, and a
cosmographical mirror. Shown
here is the cosmographical
mirror, composed of an overlay
marking the annual path of
the sun, which rotates along
the planispheric projection of
Earth below. This mechanism
allows the user to associate
geographical location with date
and local time.

fig. 38 (above)

Daniel Schwenter
*Fünffacher Denckring der
Teutschen Sprache*
(Fivefold thought-ring of the
German Language)
1651–53

Intricate volvelle, by the
German mathematician Daniel
Schwenter, showcasing the
exponential combinatorial
power of information wheels,
which performed much as
early analog computers did.
It displays a database of the
German language based
on five predicate variables,
inscribed in the edge of its five
independent discs: prefixes
(48 values), initial letters or
diphthongs (50 values), medial
letters (12 values), final letters
of diphthongs (120 values),
and suffixes (24 values). Such a
seemingly simple mechanism
allows the generation of up to
97,209,600 words.

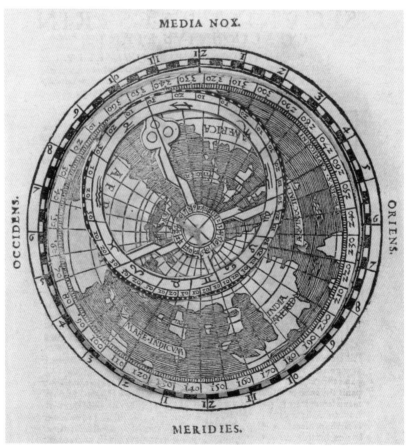

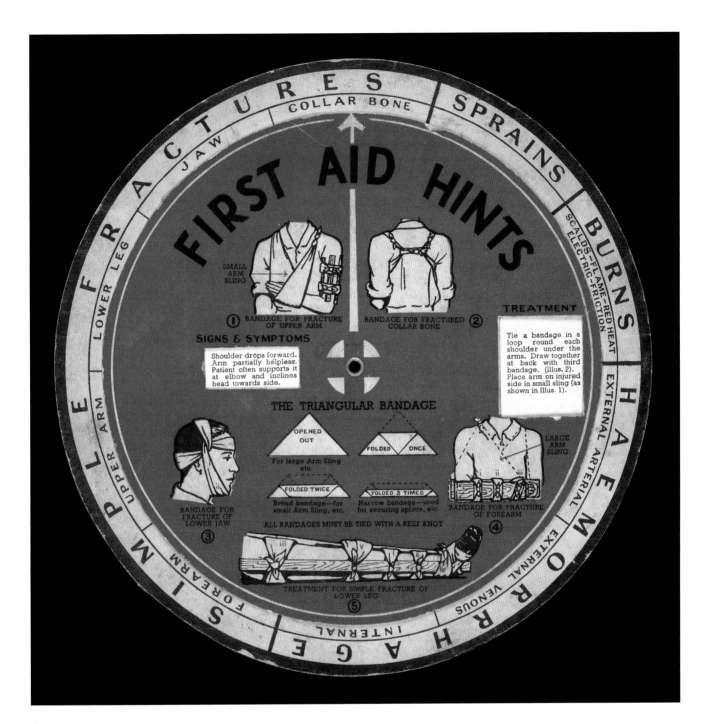

fig. 40

George Philip & Co.
First-aid wheel chart
ca. 1935

Revolving cardboard information wheel designed as a first-aid tool, showing the correct procedures for treating simple fractures, burns, sprains, and hemorrhages. By spinning the wheel and aligning it with a given accident, users can read details on its corresponding symptoms and treatment. These wheels were popular during the first half of the twentieth century; they were based on the long tradition of the volvelle.

fig. 41

Anonymous
Ptolemaic system
1560–64

A drawing of the Ptolemaic
system included in a richly
illustrated collection of maps
of many islands and coastal
regions of the Mediterranean
by an unknown Venetian
cartographer. Devised by
the second-century Egyptian
mathematician and astronomer
Ptolemy, this geocentric model,
with a stationary Earth at the
center and the heavenly bodies
(sun, moon, planets) gravitating
around it, was the predominant
conception of the cosmos for
several centuries.

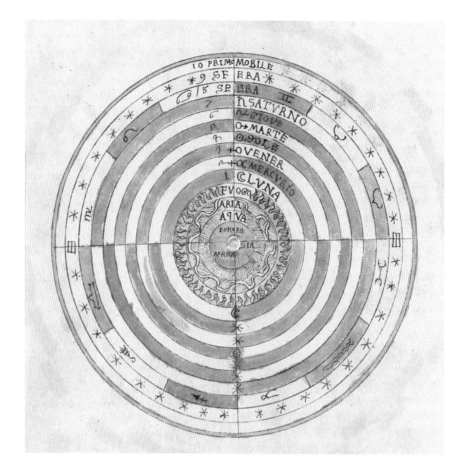

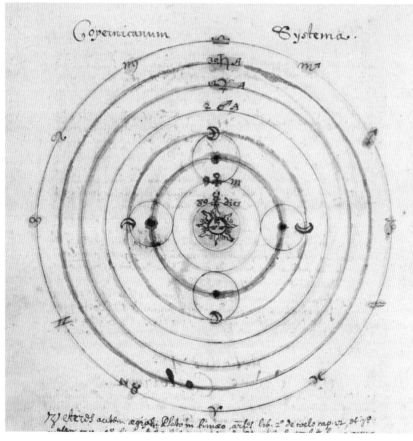

fig. 42

Gabriel Thibauld
Copernican system
1639–41

Representation of the
transformative heliocentric
Copernican system that placed
the sun at the center of our
planetary system. Written by
the French theologian Gabriel
Thibauld, *Summa philosophica
quattor in partes distribute* is a
collection of texts on science
and philosophy, including
discussions of weather, meteors,
logic, and ethics. A section on
celestial physics includes dozens
of richly colored diagrams and
illustrations, including this one.

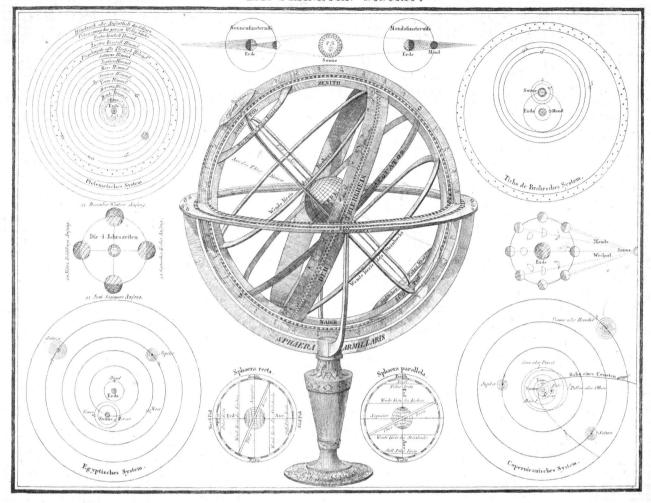

fig. 43

Friedrich Haller von Hallerstein
Das Planeten System (The planetary system)
1822

Engraving showing an armillary sphere at the center, surrounded by four main models of the solar system: Egyptian (bottom left), Ptolemaic (top left), Tychonic (top right), and Copernican (bottom right). The chart includes six complementary insets.

introduced the heliocentric solar system, placing the sun at its center, with Earth and the other planets revolving around it. This model is one of the most important advances in the evolution of science, instigating what became known as the Copernican Revolution. While the image of concentric circles surrounding a central element was a popular visual metaphor for both models, it became a critical representation of the constant circular motion of planet Earth around the sun and on its own axis /*fig.* 41 /*fig.* 42. Such was the mathematical predictability of planetary movement within our solar system that when asked by Napoleon if God occasionally intervened in this machine of the world, the French astronomer Pierre-Simon, marquis de Laplace, famously replied that there was no need for such an assumption /*fig.* 43. As we know today, similar motion occurs well beyond our solar system, underpinning the movement of entire galaxies.

INFINITY

A more esoteric line of reasoning has long associated the circle with ideas of eternity, infinity, perpetuity, and immensity. The notion of infinity as a circle was portrayed by the early Christian father Saint Augustine (AD 354–430), who described God as a circle whose center is everywhere and whose circumference is nowhere. Possibly influenced by the Hermetic tradition, Saint Augustine's analogy was later appropriated by the French mathematician Blaise Pascal, who supplied in his notable *Pensées* (1670) a more deistic interpretation: "Nature is an infinite sphere whose center is everywhere and whose circumference is nowhere."[9] The idea of perpetuity has also been commonly portrayed as an ever-expanding circle. Take this passage from Ralph Waldo Emerson's 1841 essay "Circles": "The life of a man is a self-evolving circle, which, from a ring imperceptibly small, rushes on all sides outwards to new and larger circles, and that without end. The extent to which this generation of circles, wheel without wheel, will go, depends on the force or truth of the individual soul."[10]

Such was the transformative, seemingly divine force of the circle that for centuries researchers pursued the idea of "perpetual motion": a system or machine, normally in the shape of a wheel, that could operate forever without any external source of energy. This unfruitful hunt is itself a remarkable example of the notion of drifting long associated with a circle and expressed by phrases such as "going around in circles," "running circles around," a "circular argument," or a "vicious circle."

Across space and time there have been numerous symbols of infinity, but two critical ones have incorporated the circular shape: the *ouroboros* and the *ensō*. Prominent in Greek and medieval alchemy (but with numerous variants to be found across the globe), the image of a serpent or dragon eating its own tail in a circular configuration, commonly known as *ouroboros*, symbolizes the perpetually cyclical nature of life and the universe /*fig.* 44. This long-lasting mark of eternity might have been a precursor to the mathematical symbol of infinity, with extant modifications of the serpent adopting the sideways figure eight. In the Japanese aesthetic tradition of ink painting, and especially in Zen Buddhism, the simplicity and elegance of the hand-drawn *ensō* (circle) embodies pure enlightenment, the universe, void, and infinity /*fig.* 45.

Finally, if there has ever been a tangible attempt at mapping immensity, it has been through the numerous efforts to interpret outer space and the vast sea of stars in the night sky. Planispheres (star charts) date back to at least the first millennium BC, with remarkable extant examples from Babylon and ancient Egypt /*figs.* 46–50.

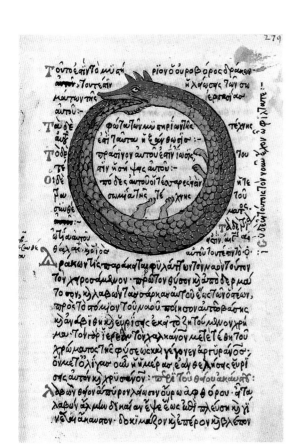

fig. 44

Theodoros Pelecanos
Ouroboros
1478

A diagram of the ancestral *ouroboros* symbol from a Byzantine alchemical manuscript by the Greek scribe Theodoros Pelecanos, based on an early manuscript dating back to the fifth century AD. The circular image of a serpent or dragon eating its own tail is one of the most widely recognized universal visual metaphors of all time, found throughout Europe, Africa, Asia, and the Americas. A long-standing alchemical icon, the *ouroboros* signifies the idea of infinity and the perpetual cycle of life, death, and rebirth.

fig. 45

Kazuaki Tanahashi
Miracles of Each Moment
2014

Acrylic on canvas, 24 × 30 inches (60.9 × 76.2 centimeters). One-stroke ink painting of *ensō*—Zen Buddhism's circle of enlightenment—by the Japanese writer, artist, and calligrapher Kazuaki Tanahashi. A mark of minimalist Japanese aesthetics, commonly painted in a single brushstroke, *ensō* has come to symbolize eternity, infinity, the universe, and the void.

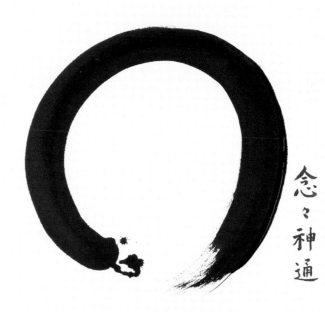

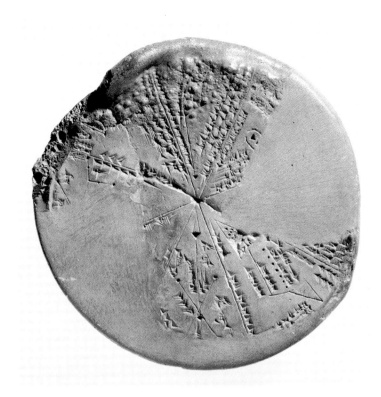

fig. 46

Anonymous
Neo-Assyrian planisphere
ca. 650 BC

Circular clay tablet measuring
16.3 inches (14.1 centimeters)
in diameter. Discovered in the
library of King Ashurbanipal in
Nineveh—the ancient capital of
the Neo-Assyrian Empire—this
tablet shows how the night sky
in Nineveh looked on January
3–4, 650 BC. This stylized
planisphere maps various stars
and constellations, including
those known today as Gemini
(top rectangular shape),
Pleiades, and Pegasus (the two
triangles on the bottom right).
© *The Trustees of the British Museum*

fig. 48

Stellavie
Map I—The Northern Sky
2012

Silkscreen print, 19.6 × 27.5
inches (50 × 70 centimeters),
printed with custom mixed inks.
Highly detailed illustration of
the Northern Hemisphere's sky
and its constellations, created
by multidisciplinary German
design studio Stellavie. The
map is part of a five-hundred-
piece edition of one-color
silkscreen prints, each hand-
numbered and signed.

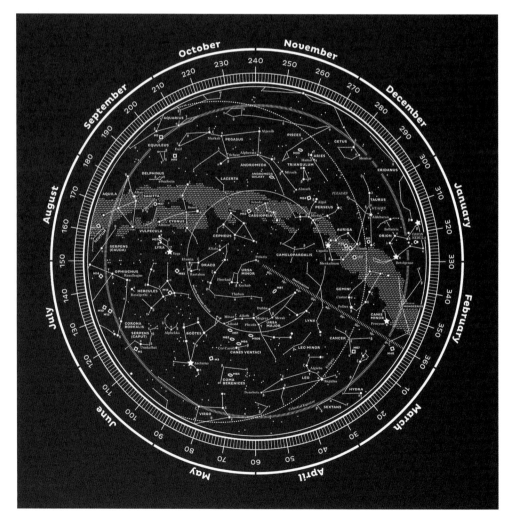

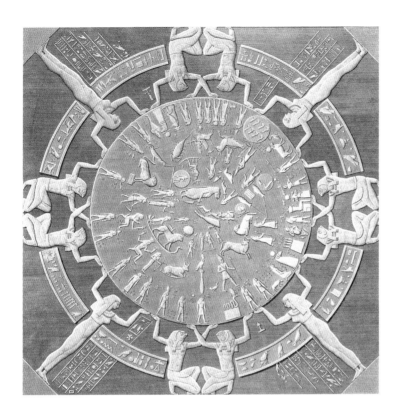

fig. 47

Anonymous
Bas-relief of the Dendera Zodiac
50 BC

Vivant Denon's drawing of the bas-relief planisphere featured in the ceiling of a chapel in the main temple of the goddess Hathor at Dendera, a temple complex in Upper Egypt, built around 2250 BC. It maps a particular configuration of planets among constellations that dates it to between June 15 and August 15, 50 BC. Four women and eight falcon-headed spirits support the main disc of constellations, which contains many recognizable signs of the zodiac, including Aries, Taurus, Scorpio, and Capricorn.

fig. 49

Georg Matthäus Seutter
Circular planisphere
1744

Folded circular planisphere mapping the ancient Greek constellations in the Southern Hemisphere, included in the manuscript *Atlas minor praecipua orbis terrarum imperia* (1744), by German map publisher Georg Matthäus Seutter.

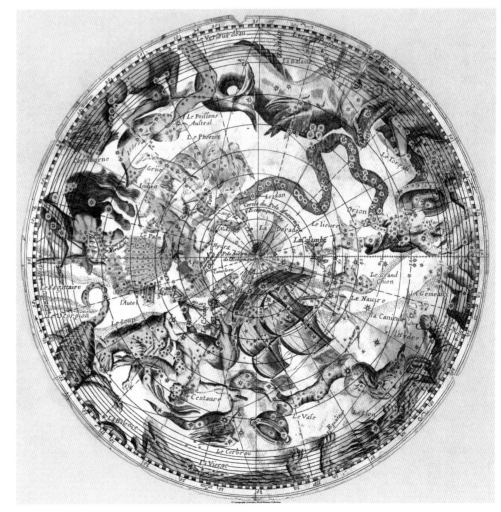

fig. 50

Fu Lü and Weifan Lü
San cai yi guan tu (Map of the
three powers unified)
1722

Incredibly detailed print that
includes maps of China, the
world, and the planets and their
orbits, as well as a chronological
table of Chinese dynasties
and excerpts from Chinese
literature. At the center of the
sheet is a set of planispheres (in
red) of the two polar regions.

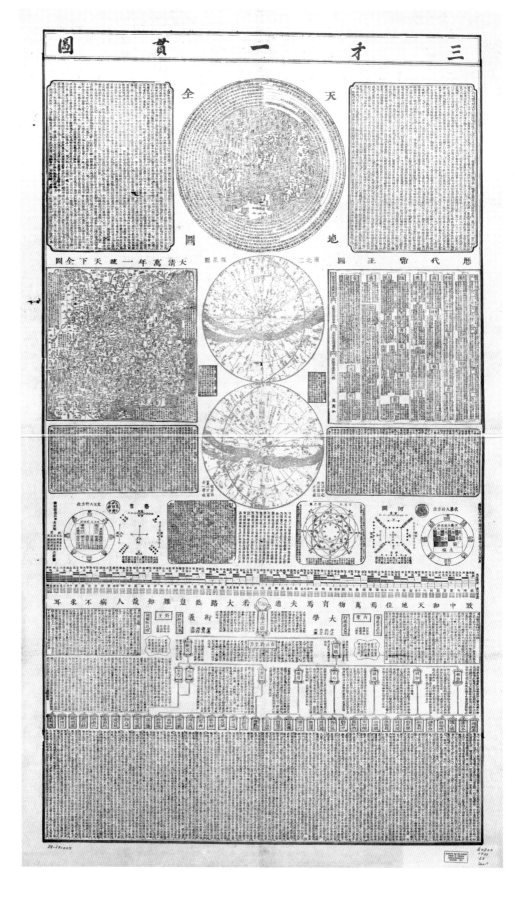

4. ROUNDED SHAPES AND HAPPY FACES

We have seen how the circle has been adopted in every conceivable domain of human knowledge. The interesting question is: Why? The circle is omnipresent in nature, but can this fact alone explain its central role in the cities we build, the objects we design, the visual symbols we create, and the numerous layers of cultural meaning we construe?

A preference for circular shapes is deeply ingrained in all of us from birth. At five months of age, before they utter a word or scribble a drawing, infants already show a clear visual preference for contoured lines over straight ones.[11] As children grow older, their first scribbles are influenced by the holistic tendency of the brain, which merges different elements into a single, continuous contour, typically without stopping or raising their hand, so the circle and spiral become the preferred shape. As perceptual psychologist Rudolf Arnheim explains, "Once the child has, during the early explorations of the new medium, hit upon the idea that the things he is making can be used as pictures of other things, the circle serves to represent almost any object, such as a human figure, a house, a car, a book." But Arnheim goes further in substantiating the circle's long-lasting association with ideas of unity and self-containment. "At the stage of the circle, shape is not yet differentiated at all," he writes. "The circle does not stand for roundness, but only for the more general quality of 'thingness'—that is, for the compactness of a solid object, which is distinguished from the nondescript ground."[12]

Over the last century, researchers on human perception have tried to explain various aspects of our innate propensity for circular and curvy shapes. In a 1921 study conducted by the Swedish psychologist Helge Lundholm, subjects were asked to draw lines representing a set of emotional adjectives. While angular lines were used to depict adjectives like *hard*, *harsh*, and *cruel*, curved lines were the popular choice for adjectives like *gentle*, *quiet*, and *mild*. Over the years, other studies trying to associate feelings with types of lines have corroborated Lundholm's findings.

Typography has been the target of a similar analysis. A study conducted in 1968 by psychologists Albert Kastl and Irvin Child indicated that people associate positive qualities like "sprightly," "sparkling," "dreamy," and "soaring" with curved, light, and possibly sans-serif typefaces. This could in part explain, to many graphic designers' frustration, the wide-ranging popularity of the Comic Sans MS typeface.

In a seminal paper published in 2006 in *Psychological Science*, cognitive psychologists Moshe Bar and Maital Neta conducted an experiment in which fourteen participants were shown 140 pairs of letters, patterns, and everyday objects, differing only in the curvature of their contour /*fig.* 51. The results were not completely surprising: participants showed a strong preference for curved items in all categories, particularly when it came to real objects. To better understand this bias, the same pair of scientists conducted another study one year later, this time by mapping the cognitive response using functional magnetic resonance imaging (fMRI). The results were quite conclusive. Sharp-cornered objects caused much greater amygdala activation than rounded objects. A well-studied region in the temporal lobe of the brain, the amygdala's primary function is to process stimuli that induce fear, anxiety, and aggressiveness and to deal with the resulting emotional reactions. In other words, angular shapes tend to trigger fear and therefore aversion and dislike. Moreover, the authors of the study noted that "the degree of amygdala activation was proportional to the degree of angularity or sharpness

of the object presented, and inversely related to object preference."[13] There are, of course, obvious exceptions to this response. People do not like some curved objects, such as snakes, and do appreciate some angular objects, such as chocolate bars. But as the authors point out, these objects have a "strong affective valence, which can override the effects of contour and dominate preference."[14]

fig. 51

Examples of visual stimuli used in Moshe Bar and Maital Neta's 2006 experiment. From left to right: (A) Arial regular typeface versus Arial rounded; (B) a square-faced watch versus a round-faced watch; (C) an angular sofa versus a curvy sofa.

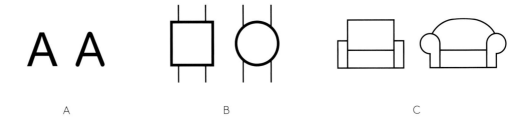

Our instinctual behavior also plays a huge role in the way we perceive the spaces we inhabit. A 2013 study by researchers at the University of Toronto at Scarborough found that curvilinear spaces were perceived by participants as more beautiful than rectilinear ones, exclusively activating the anterior cingulate cortex—a brain area involved in cognitive functions involving empathy, reward anticipation, and the emotional salience of objects. This innate preference and emotional attachment to rounded shapes continues to influence the architects and designers who create our present-day material culture, from the captivating buildings of architect Frank Gehry to the evocative furniture of industrial designer Karim Rashid.

Most of the research in this area seems to point out an evident truth: we prefer shapes and objects that evoke safety and are not so fond of objects with sharp angles and pointed features, as they suggest threat and injury: think of the thorns and spines of a plant, the sharp teeth of an animal, or the cutting edge of a rock. This preference might still prove prudent in an urban world lacking natural threats but abundant with man-made ones. As the ultimate curvilinear shape, the circle embodies all of the attributes that attract us: it is a safe, gentle, pleasant, graceful, dreamy, and even beautiful shape that evokes calmness, peacefulness, and relaxation.

The second evolutionary explanation for our round-shape proclivity is rooted in the idea that human faces and the emotions they express rely on simple geometric shapes. Just think of the number of expressions that emoticons can represent using very rudimentary configurations. This idea touches on deep survival instincts and social behavior. In 1978 psychologist John N. Bassili conducted an experiment in which he painted the faces and necks of several actors and actresses black and then applied one hundred luminescent dots. Participants were then asked to assume different expressions, such as "happy," "sad," "surprised," and "angry." In the final video recording, with only the luminescent dots visible, the outcome was quite revealing: while expressions of anger showed acute downward V shapes (angled eyebrows, cheeks, and chin), expressions of happiness were conveyed by expansive, outward curved patterns (arched cheeks, eyes, and mouth). In other words, happy faces resembled an expansive circle, while angry faces resembled a downward triangle. Researchers at the University of Wisconsin-Milwaukee further validated the triangle-anger link in 2009 while trying to understand emotional reactions to simple geometric shapes. They discovered that a

downward-facing triangle activates the amygdala at a much higher rate than an upward-facing triangle, therefore acting as a strong signifier of threat and danger.

From an evolutionary standpoint, the warm, positive emotions elicited by a circular shape could have their basis in our attraction to the roundness of an infant's face.[15] The evolutionary advantages of these feelings are obvious, particularly since previous studies have indicated an adult preference for infants with prominent rounded features. This also explains a known cognitive predisposition called the "baby-face bias," a tendency to perceive adults with neotenous facial features—large eyes, a rounded face, and a high forehead—as being more naive, honest, and innocent. The dichotomy of circular, happy faces versus triangular, angry faces seems to be rooted in two primordial human imperatives: our need to read our fellow humans' facial expressions and our need to detect threats as quickly as possible.

The first drive underlies our highly social nature and the importance of identifying emotions in improving interpersonal ties and group cohesion. Our brains "are built to connect with others and experience their pain and pleasure," explains the Dutch primatologist Frans de Waal.[16] "We rely on each other, need each other, and therefore take pleasure in helping and sharing."[17] According to the British evolutionary anthropologist Robin Dunbar, our substantial cranial capacity, particularly the sophistication of our neocortex, developed in response to a strong social pressure to belong to larger groups and in turn recognize a larger number of faces. But face perception is an elemental capability shared with other primates, notably chimpanzees and bonobos. Chimpanzees, when presented with pictures of unfamiliar chimps, can easily identify which juveniles are offspring of specific females, a way of detecting blood relatives that's equally intuitive to us.[18] The importance of inferring reactions from faces might even explain why we developed the ability to perceive different colors, in particular the color red.[19]

Cognitive processing speed is critical to emotion and threat detection—sometimes even a matter of life or death. This is where the holistic abilities of our perceptual system play a crucial role, requiring only minimal contours to identify a relevant pattern. This human ability is so powerful that we sometimes mistakenly perceive meaningful signals in meaningless noise, a psychological phenomenon known as pareidolia, apophenia, or patternicity. We all have experienced this when we have stared at the front of a truck or perhaps a piece of toast and identified the shape of a human figure. Not surprisingly, one of the most common types of pareidolia involves the recognition of human faces in inanimate objects, sometimes based on rudimentary arrangements. Thus, our ability to infer emotions from minimal perceptual input helps explain why the elementary geometric shapes of the circle and the triangle can act as abstract representations of joy and anger. In addition to being imbued with positive traits like safety, calm, peace, and beauty, we have just seen that the circle also represents the most fundamental image of happiness, due to thousands of years of evolving as highly social animals, depending and relying on others but also knowing when to evade them.

The third and last explanation for the universal allure of the circle might be rooted in our own visual cognitive apparatus and the way we view the world around us. The human eye is undoubtedly a fascinating object of study: an organ so complex and demanding that half of our brain is dedicated to processing visual perception. These spherical orbs abound with circularity, their most noticeable elements being the iris and pupil, responsible for filtering light into our retina. Most important, such spheres create a natural circular frame for our visual field, which

on its own could substantiate an innate preference for matching geometric shapes. This allure can be further explained by understanding the spherical distortion caused by our eyeballs.

The spherical geometry of our visual field is normally called non-Euclidean—as opposed to Euclidean (named after the Greek mathematician Euclid), which employs a Cartesian coordinate system to visualize plane and solid figures. In a non-Euclidean space there are no true straight, parallel lines, as they tend to always converge toward the periphery. For example, when you move toward a set of vertical lines, the closer you get, the more they seem to naturally bow outward, particularly if you get really close. You can think of it in a similar way to the alteration of the world captured by a fish-eye lens or a crystal ball. In his groundbreaking book *The Vision Revolution*, theoretical neurobiologist Mark Changizi presents a set of optical illusions that show the influence of our spherical visual field in perceiving different types of visual input. He explains, "The space of directions from you to all the objects around you is inherently shaped like the surface of a sphere." Therefore, "a non-Euclidean geometry is the relevant one to use in discussing how objects change over time in your visual field."[20] / *fig.* 52

fig. 52

Illustrations and optical illusions analogous to the ones presented by Mark Changizi in his book *The Vision Revolution*. From left to right: (A) an orthogonal grid based on Euclidean geometry; (B) the same grid in a non-Euclidean space, similar to the spherical geometry of our visual field; (C) two simple vertical lines representing an abstract door seen from afar; (D) the same vertical lines appearing to bow out when a set of radiating lines are placed in the background to provide a sense of forward motion.

A B C D

Thus, the circular framing and spherical distortion of our visual field could further reinforce our innate tendency toward all things circular. Perhaps the brain prefers forms and contours that have a better fit within such a conditioned field of view. This could well explain the almost hypnotic effect of concentric circles, one of the oldest configurations of the circle and the subject of numerous optical illusions.

In the second volume of *Modern Painters* (1843–60), English art critic John Ruskin proposes six main attributes of beauty. In what seems like an uncanny argument for the inherent attractiveness of the circle, Ruskin's list includes the following elements: (1) infinity, (2) unity, (3) repose, (4) symmetry, (5) purity, and (6) moderation. Ruskin's assessment of beauty is not just in line with some of the circle's traditional associations. As we know today, Ruskin's list appears to shed light on a set of universal, deeply ingrained perceptual preferences.

I began by asking if the broad cultural adoption of the circle could be justified entirely by its omnipresence in nature. The answer should be evident by now: the circle's natural ubiquity has certainly been a contributing factor, but not the decisive one. The more we dig into our shared cognitive biases, the more we recognize that the copious layers of cultural meaning we have added to the circle through the ages are ultimately grounded in an instinctive evolutionary proclivity. As with many other areas of human aesthetics, the circle's inescapable beauty seems deeply rooted in our biology.

The three epigraphs to this chapter are drawn from Ralph Waldo Emerson, *Essays*, 239; John Richard Jefferies, *Story of My Heart: My Autobiography*, 181; Audrey Yoshiko Seo and John Daido Loori, *Ensō: Zen Circles of Enlightenment*, 6.

Notes

1 Seo and Loori, *Ensō*, 2.
2 Seife, *Zero*, 26.
3 Alighieri and Musa, *Inferno*, 33.
4 Lakoff and Johnson, *Metaphors We Live By*, 57.
5 Ibid., 29.
6 Pombo, *O Círculo dos Saberes*, 43.
7 Makuchowska, *Scientific Discourse in John Donne's Eschatological Poetry*, 21.
8 The Large Hadron Collider is the largest particle-physics structure ever made. It tests the collision of particle beams moving at super-high speeds within its underground ring structure.
9 Pascal, *Pensées*, 60.
10 Emerson, *Essays*, 241.
11 This insight was the result of a 2011 eye-tracking study conducted by researchers at Harvard University and the University of Southern California. The study measured the attention span of infants looking at various line shapes and configurations. Amir, Biederman, and Hayworth, "Neural Basis for Shape Preferences."
12 Arnheim, *Art and Visual Perception*, 140.
13 Lidwell, Holden, and Butler, *Universal Principles of Design*, 62.
14 Bar and Neta, "Humans Prefer Curved Visual Objects."
15 Larson, Aronoff, and Steuer, "Simple Geometric Shapes."
16 de Waal, *Bonobo and the Atheist*, 54.
17 Ibid., 51.
18 Ibid., 15.
19 According to the theoretical neurobiologist Mark Changizi, humans evolved color vision to recognize color changes in our faces, an important skill for interpreting vital signs in our young in the absence of language—which might explain why women are rarely color-blind, compared to 10 percent of men—and for sensing emotions in our friends and enemies. Changizi, *Vision Revolution*, 20.
20 Ibid., 256.

The twelve main graphic variables employed to produce the diversity of circular visual archetypes showcased in this book.

Concentric Order

Radial Order

Placement

Connection

Number of rings

Number of slices

Size

Shape

Thickness or Height

Angle or Length

Pictogram

Color

A TAXONOMY OF CIRCLES

Man is a classifying animal. We understand phenomena by describing, grouping, and comparing them. This impulse is not just the basis of natural sciences; it's also our primary method of comprehending history, architecture, literature, design, art, or any other cultural manifestation. We can witness this behavior in the enduring effort to formalize the visual structure of images. The idea is seemingly simple: If human language can be arranged in a set of building blocks with a defined set of rules and mechanisms, can't images abide by a similar logic? American engineer Willard Cope Brinton described this aspiration in his *Graphic Methods for Presenting Facts* (1914): "The rules of grammar for the English language are numerous as well as complex, and there are about as many exceptions as there are rules. Yet we all try to follow the rules in spite of their intricacies.... It is interesting to note, also, that there are possibilities of the graphic presentation becoming an international language, like music, which is now written by such standard methods that sheet music may be played in any country."[1]

Of course, Brinton was not the first to express such an ambition. We can trace one of its strongest manifestations—arguably the roots of modern-day information visualization—to the High Middle Ages and the emergence of *ars memorativa* (the art of memory), a set of mnemonic techniques aimed at supporting biblical exegesis and the efficacy of images and diagrams. Proponents of *ars memorativa* created a set of principles, many still used to this day by graphic and information designers, that highlight the importance of layout choices such as order, positioning, association, and chunking.

The drive to make knowledge visible that occurred during the Renaissance triggered a well-studied revival of the effort to organize images into a visual grammar, with exceptional figures such as German polymaths Athanasius Kircher and Gottfried Leibniz and the Spanish scholar Ramon Llull all pursuing a pure, universal symbolic language that could replace or enhance institutionalized linguistics. In the last two centuries, artists Paul Klee and Wassily Kandinsky tried to deconstruct the underlying structure of images, while semioticians and psychologists, including Charles Sanders Peirce, Ludwig Wittgenstein, Carl Jung, Rudolf Arnheim, Hans Wallach, Richard Gregory, and Semir Zeki, have ventured into this domain with some success. Designers Max Bill, Bruno Munari, and Michael Twyman have distinctively explored the boundaries of visual literacy; however, it was Austrian sociologist Otto Neurath who made one of the most significant contributions with the development of the Isotype (International System of Typographic Picture Education) in the 1930s—now a pervasive visual element in buildings and airports across the world.

One of the most powerful attempts at analyzing visual language was made by Donis A. Dondis in her eminent *A Primer of Visual Literacy* (1973). Dondis deconstructed many qualities of visual representation, such as balance, symmetry, and contrast, into smaller building blocks, which she called the "skeletal visual force": dot, line, color, shape, direction, texture, scale, dimension, and motion. According to Dondis, these components "comprise the raw material of all visual information in selective choices and combinations" and are employed according to the nature of what's being designed—the final aim of the piece.[2]

Finally, in the modern field of information visualization, numerous researchers have tried to create holistic frameworks encompassing a complete grammar of graphics. French cartographer Jacques Bertin aimed at a grand structure for charts and graphs in his *Semiology of Graphics* (1967)—to this day considered a theoretical foundation of the discipline. Similar efforts have been conducted by Robert L. Harris (1996), Ed H. Chi (2002), Leland Wilkinson (2005), and Katy Börner (2014).

Despite the sheer number of attempts over the years, no system has been accepted as a unified, all-encompassing method of formal visual communication, at least not to the extent of any textual alphabet. The reason is simple. As professor of history David J. Staley explains, while "the syntax of writing is linear and one-dimensional…the syntax of visualization is not so confining…[and is] far more complex than that of writing."[3] While both writing and visualization are capable of encoding and storing information, the intricate multidimensionality of visual imagery makes the decoding part a much harder task.

If an all-encompassing framework for visual language is seemingly unattainable, a collection of smaller taxonomic efforts targeting discrete archetypes seems considerably more achievable. This book constitutes a single step toward that goal by focusing on the diverse manifestations of one of the most universal and long-lasting visual metaphors: the circle.

Most of the examples in this book come from the domain of information visualization. However, if this is meant to be a comprehensive taxonomy of the circle, its reach needs to extend well beyond a single time frame or discipline. It's critical for us to look deep into history and conceive an elongated spectrum of human innovation, because the past continuously revisits the present. Notwithstanding our advanced modern tools and piles of new data, we are still using visual metaphors that are similar and at times identical to those used to convey knowledge throughout history. This is why you may notice a contemporary project from, say, 2012 adjacent to one from the fifteenth century.

Another insight that should come as no surprise to attentive readers is that the universality of the circle traverses numerous disciplines. I have therefore included, next to the multitude of examples from information visualization, many specimens from other disciplines, such as art, biology, architecture, technology, and astronomy. This juxtaposition of seemingly disparate areas and time periods is one of the unique aspects of this volume and, ultimately, a testament to the circle's exceptional adaptability.

The sheer diversity of projects in this taxonomy of circles is an impressive demonstration of human ingenuity. But if we take a closer look at the numerous diagrams and illustrations, we can perceive a concise set of variables underpinning most executions. The illustration on page 56 highlights twelve graphical variables that steer all twenty-one models presented in this volume. It's a small number, yet, when intelligently combined, creates endless possibilities for depicting the most complex subjects.

The twenty-one patterns in the book are grouped into seven archetype families, based on their visual configuration. Each family comprises three archetypes. Since the first three families contain the most primeval representations, I will emphasize their foundational relevance.

*fig.*1

Concentric circle patterns. From left to right: (A) astronomical symbol for the sun used in ancient Egypt and early Chinese script; (B) roundel used by the air forces of numerous countries, including the United Kingdom and France; the band The Who; and the retailer Target; (C) petroglyph pattern found in the Jug Handle Arch, on Potash Road in Moab, Utah, from ca. 2000 BC; (D) petroglyph motif found in Argyll County of western Scotland, from ca. 4000 BC; (E) typical construct of an archery target, normally colored (from inner to outer rings): yellow, red, blue, black, and white.

*fig.*2

Collection of spoke line patterns. From left to right: (A) motion streaks typical of our visual field when we are moving at a fast speed; (B) abstract pattern of the forward-motion effect, which appears as a set of converging lines with a central vanishing point; (C) typical wheel model, also known as the sun cross, an ancestral symbol used by numerous cultures across space and time; (D) typical pie chart, which assigns a numerical proportion to each slice, conveyed by its angle and area; (E) variant of the pie chart, known as a polar area diagram, where slices have the same angle but vary in length from the core.

Family 1

RINGS & SPIRALS

(pages 65 to 89)

 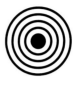 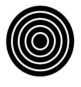

A · B · C · D · E

As we saw in the introduction, spirals and concentric circles are among the earliest human motifs, appearing in prehistoric petroglyphs and pictographs throughout the world. The spiral is among the first shapes drawn by infants and is an elemental cipher of nature, visible in shells, the growth pattern of plants, hurricanes, and the immensely large structures of celestial galaxies. Concentric circles not only feature in a large number of natural arrangements, from the rings of a tree to ripple patterns on water, but they also hold a strong perceptual allure. Both spirals and concentric circles are commonly used as visual stimuli in hypnosis (at times enhanced with motion), which, if nothing else, attests to their ability to induce focus and concentration. It's therefore no coincidence that the bull's-eye, a pattern of concentric circles, is used as a target in sports such as darts, archery, and shooting. A similar motif has been widely used in heraldry, the military, and popular culture—from the logo of the British band The Who to the large retailer Target / *fig.* 1. The roundel is an important national emblem, displayed on military aircraft in countries such as the United Kingdom, France, El Salvador, India, Turkey, Bahrain, Gabon, and Nigeria. The remaining archetype of this first family is a subtle, more contemporary variation on the concentric-circles model in which each ring has a varying length, generally corresponding to a specific data value. Because the viewer needs to interpret often subtle differences in length among individual rings, there are some obvious readability problems with this model; nonetheless, it has become increasingly popular in the past decade, appearing in various contexts from mobile digital interfaces to printed charts.

Family 2

WHEELS & PIES

(pages 91 to 117)

A · B · C · D · E

In his book *The Vision Revolution*, Mark Changizi provides a possible explanation for our primordial fascination with wheel symbols. Changizi explains that most classic geometric illusions possess diagonal "spoke" lines, perhaps because when we observe these, our brain "interprets those lines as motion streaks due to forward motion."[4] Many of the examples included in the second family of circles explore this abstract pattern, notably the very first model, which is defined by a set of converging lines on a central vanishing point. You could certainly think of countless examples of visual phenomena that convey a similar sense of forward motion, including perspective drawings, the illusion seen while you drive down a highway as trees and road lines appear to converge in the middle, or even science fiction renditions of spacecraft traveling at warp speed, as popularized by *Star Trek*. This cognitive trigger, together with the pattern's ubiquity in nature—from scallop shells and palm leaves to the radiating sun—could explain the allure of the numerous drawings and charts, found in both art and science, that display converging diagonal lines. As the English artist Walter Crane observed, "If there can be said to be one principle more than another, the perception and expression of which gives an artist's work in design peculiar vitality, it is this principle of radiating line."[5]

The second and third models of this family enclose this primal visual motif within a circular frame, opening the door to a new set of graphical possibilities. Even though the Scottish engineer William Playfair is credited with inventing the modern pie chart in 1801—now a basic visualization model that illustrates proportions within a whole—the notion of a sectioned circle is one that dates back to Bronze Age Europe and is deeply rooted in the concept of the wheel. One of its most popular manifestations is the astronomical symbol for Earth, also known as the sun cross, solar wheel, or wheel of the year. It can represent our globe, showing the equator and a meridian, or the four seasons of a year / *fig.* 2. Variations of the sun cross divide the circle into eight equal areas instead of four, representing the midpoints of the seasons. Another important icon that uses a similar eight-spoke motif is the *dharmachakra*, also known as the wheel of the law, a symbol revered by Hindus and Buddhists and frequently used in Tibetan Buddhism. Resembling an exploded pie chart, the very last model of this family, commonly known as a rose chart or polar area diagram, was popularized by English social reformer Florence Nightingale in her famous "Diagram of the Causes of Mortality in the Army in the East" (1858).

fig. 3

Evolutionary basis for the third family of circle archetypes. The juxtaposition of concentric rings (A) and the wheel model (B) generates a large number of possible design grids, such as the static graticule (C), the volvelle (D), and the sunburst model (E). In turn, variants of these grids underpin many of the visual models described in families four through seven.

Family 3

GRIDS & GRATICULES

(pages 119 to 145)

 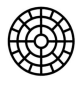

A B C D E

THE BOOK OF CIRCLES

The circles in the third group combine two of the primordial circle archetypes: the concentric and sectioned models. Both schemes can express a considerable number of variables on their own, dictated by the number of instances (rings or slices), the ordering of instances (generally central-peripheral or clockwise), and the size of instances (their width or angle). However, when we overlay a ring on a wheel model, the resulting grid greatly expands a chart's multidimensional capability. Early medieval designers realized the power of such a flexible grid, which continues to underpin many contemporary circular diagrams /fig. 3.

The first model in this family is a somewhat restricted one, allowing only for single, linear informational patterns, either via an inner-outer or revolution axis, largely due to each sliced ring being fixed in its position within the chart. By allowing each sliced ring to rotate independently along the central axis, the second model enables endless combinations among rings. A significant device that takes advantage of this flexibility is the previously described paper wheel chart known as the volvelle, a combinatorial artifact so powerful that some examples are considered prototypical computing devices.

The third group within this family depicts hierarchical structures by using the radial segmentation of each ring as a nesting mechanism. Known variously as the sunburst, radial tree map, fan chart, or nested pie chart, this model employs the logic of a radial tree, with the root at the core of the diagram and the remaining ranks (rings) expanding outward from the middle. Each individual cell usually corresponds to a given quantity or data attribute, with color indicating an additional characteristic. Ranking is emphasized in two ways: by distance from the center within the concentric circles moving toward the diagram's periphery and by position within groups of subsections that appear within the angle swept out by parent sections.

fig. 4

Common radial ebb and flow patterns. From left to right: (A) the outline of a simplified radar chart with a small number of variables; (B) a more elaborate, multivariate radar chart; (C) a circular bar chart, which can be reminiscent of a human iris; (D) a multiseries radial line chart; (E) a radial area chart.

Family 4

EBBS & FLOWS

(pages 147 to 173)

 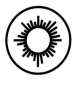

A B C D E

The fourth group includes many contemporary visual models that demonstrate an increasing emphasis on quantification. Most projects in this family could be easily conveyed by means of traditional bar, area, or line charts but instead feature a circular arrangement to showcase the ebb and flow of a given measurement, typically moving in an inner (closer to the core) to outer (closer to the periphery) pattern. Such configuration makes it harder to interpret vertical dimensions when compared with their standard horizontal counterparts; however, it succeeds at emulating the allure of common circular motifs. At times reminiscent of natural patterns found in the eye's iris, in a radiating sun, or in a flower's core, some projects, such as polar, radar, or natal charts, employ conventional charting methods, while others involve more eccentric layers of meaning and association/*fig.* 4.

fig. 5

Popular shape and boundary models. From left to right: (A) an arrangement of multiscale circles within a circular boundary; (B) a typical circle-packing motif aiming to maximize the available space within a circular container; (C) a circular treemap exposing several hierarchical levels; (D) a simple Voronoi partitioning scheme, commonly found in nature and used to depict data quantities; (E) a Voronoi treemap exposing three hierarchical levels.

Family 5

SHAPES & BOUNDARIES

(pages 175 to 199)

 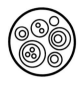

A B C D E

The first two models in our fifth family explore the captivating image of circles within a circle. The first exemplifies the multivariate possibilities of the circle diagram by conveying a range of data points through the size and location of smaller internal circles, either in a static illustration or in a pattern that emulates planetary movement as a metaphor for understanding complex relationships. The second archetype employs circle packing—a two-dimensional technique that aims at arranging circle units inside a given geometric shape (in this case a circular container) so that no overlapping occurs and every inner circle is contiguous with its neighbors. Some examples go a step further by continuously subdividing inner circles into smaller ones based on a hierarchical scheme commonly known as a circular treemap. The last model in this group is the enticing Voronoi diagram, a partitioning scheme found all over nature that evolved as a graphical method for dicing and slicing a given circle into distinct geometric shapes, which at times can express the ranking of a tree structure. The size and color of these divisions can be associated with different data values / fig. 5.

fig. 6

Examples of blueprint and map motifs. From left to right: (A) an abstract architectural blueprint pattern; (B) the outline of the Babylonian map of the world from ca. sixth century BC (see page 38), encircled by an ocean, traversed by the Euphrates River, and featuring many regions such as Assyria and Der (inner circles); (C) the simple outline of an urban circular map; (D) a typical contour of a medieval regional or world map; (E) a small-world view of a given region, normally at the core of the sphere.

Family 6

MAPS & BLUEPRINTS

(pages 201 to 227)

 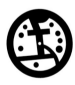 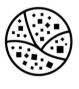 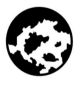

A B C D E

As we saw in the introduction, the circle has been a recurrent frame for cartography for thousands of years, dating back to at least the sixth century BC. The fact that we inhabit a sphere bounded by a rounded horizon and are surrounded by other spherical celestial bodies might have dictated why the circle has always been an attractive shape for mapping geography. The sixth family of visual archetypes features a wide range of cartographic approaches, from abstract diagrams and architectural blueprints to more intricately detailed maps of a specific territory. The last type in this group is a clear manifestation of the "small world"

approach—making good use of a sphere's non-Euclidean geometry to highlight a given core entity while deemphasizing elements that fall near the periphery. It's almost impossible to browse this particular model without the image of Antoine de Saint-Exupéry's *The Little Prince* immediately coming to mind/*fig.* 6.

fig. 7

Radial tree and network diagrams. From left to right: (A) an abstract radial tree diagram; (B) a more detailed radial tree motif, commonly used in taxonomic dendrograms; (C) a radial convergence model, where all nodes are plotted along a main guiding circle; (D) a partially connected network with visible nodes, typical of planispheres; (E) a densely connected network motif that gives more emphasis to edges (or links).

Family 7

NODES & LINKS

(pages 229 to 255)

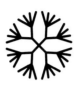 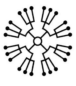 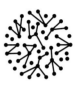

A　　　　　　B　　　　　　C　　　　　　D　　　　　　E

In the very last group of diagrams the circle is a vehicle for expressing connectivity among entities. Conventional graphs, composed of nodes (vertices) and links (edges), appear in many other forms beside circles. They have adopted an impressive array of visual configurations over the centuries, as one can easily attest by browsing my previous books. However, the circle has been a prevalent scaffold for mapping both trees and networks, by expressing a given hierarchy through a radial tree diagram—as seen in the first model of this family—or plotting all nodes of a given network along the edge of a guiding circle—visible in the second archetype. The last class of diagrams in this family, arguably the most intricate of the entire collection, is an expression of the network as a new cultural and scientific meme, a testimony to a contemporary movement I labeled "networkism" in my first book, *Visual Complexity: Mapping Patterns of Information* (2011)/*fig.* 7.

Notes
1　Brinton, *Graphic Methods*, 3.
2　Dondis, *Primer of Visual Literacy*, 39.
3　Staley, *Computers, Visualization, and History*, 47.
4　Changizi, *Vision Revolution*, 243.
5　Quoted in Gordon, *Esthetics*, 170.

RINGS & SPIRALS

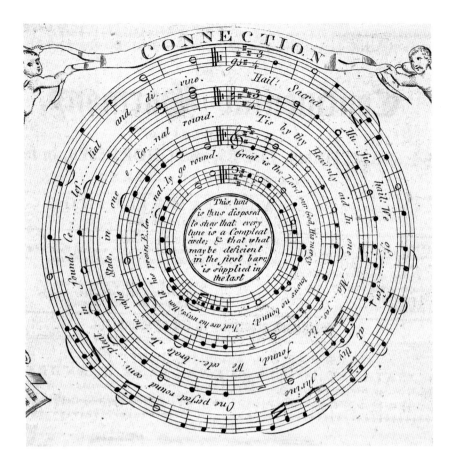

William Billings
Musical score for the song "Connection"
1794

Frontispiece to *The Continental Harmony* (1794), a book by William Billings containing dozens of psalm anthems and hymns. Billings was a prominent early American choral composer. This illustration represents the score for the tune "Connection" as a four-stave, circular piece of music, which starts at the top of the outermost ring and works its way to the center.

Martin Krzywinski
Circos
2009

Chart depicting human chromosome 1 in a set of concentric colored rings. These rings demonstrate one of countless possible configurations for Circos, a software package for visualizing data and information using a circular layout. It has been an influential tool within the scientific community, particularly in mapping genomic data, and drawings constructed with Circos have appeared in numerous publications such as the *New York Times*, *Science*, *Nature*, *American Scientist*, and *Bioinformatics*.

Klari Reis
Petri dish painting details
(*Petri Projects*)
2009–present

Painting by San Francisco–based artist Klari Reis, who is inspired by microscopic organic cellular imagery and natural reactions to create images that explore our complex relationship with today's biotechnology industry. Shown here is one of a large set of petri dishes painted by hand with epoxy polymer, an industrial plastic typically used for flooring. The dish is part of an installation project in which pieces hang on a wall on steel rods at varying distances from one other.

Leonardo Dati
Earth and the four elements
fifteenth century

Watercolor drawing featured in
La Sfera (The sphere), a book
by Italian friar and humanist
Leonardo Dati containing texts
on astronomy, geography,
poetry, mathematics, and
fortune-telling. This drawing is
a representation of the long-
lasting geocentric model of the
universe, showing the classical
elements, with the heaviest
one, earth, at the very core,
surrounded by water, air, fire,
and the final ring of celestial
ether.

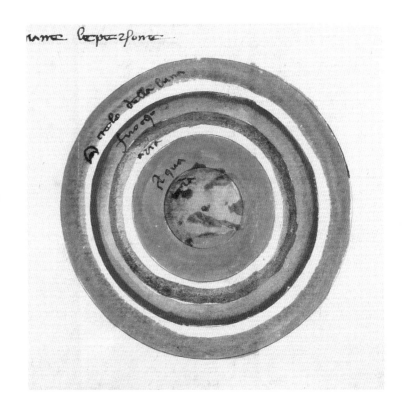

Oronce Finé
Geocentric model
1549

Drawing taken from the popular
astronomy textbook *Le Sphere
du Monde* (The sphere of the
world), written by prominent
French mathematician Oronce
Finé—a text so authoritative
that an illustrated copy of the
manuscript was given to King
Henry II of France. It shows
a geocentric model of the
universe, where two of the four
elements (water and land) are
placed at the center, while the
remaining elements, the moon,
the planets, and the sun radiate
out. The final outer ring is the
firmament, the sphere that
contains the fixed stars and
separates the Earthly world from
heaven.

Dave Bowker
One Week of the Guardian:
Wednesday
2008

Part of a series of experiments exploring how to visualize the content of the *Guardian* newspaper in an artistic and engaging way, a diagram showing the popularity of fifty-four news articles. The concentric circles group articles into color-coded categories (e.g., life and style articles are shown by orange, technology by cyan, and science by blue), with the least popular category positioned in the center. Word counts for each article are noted within speech bubbles.

Carlos Simpson
How Old Is the Internet?
2013

Mimicking the rings of a tree, a diagram showing the development of the Internet over the past thirty years. The start of the Internet is shown at the center; each ring radiating out represents a single year. The logos of various technology companies are placed to show when they launched, giving a sense of the explosion of activity in the past ten years. The colored lines that protrude from the circle indicate various legislative efforts to regulate the Internet and other key commercial milestones; for example, the orange line represents the adoption of email by ARPANET, while the gray one conveys the development of Mosaic in 1993.

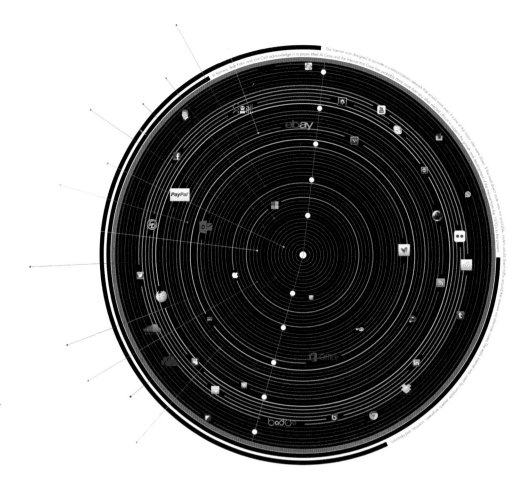

Valentina D'Efilippo
The Shining—*A visual deconstruction*
2009

D'Efilippo's visual deconstruction of Stanley Kubrick's movie *The Shining* in terms of its timing, action, and color. D'Efilippo extracted frames from the original movie and then divided and separated them to create a tempo pattern-diagram, which gives an overall view of the film's editing rhythm.

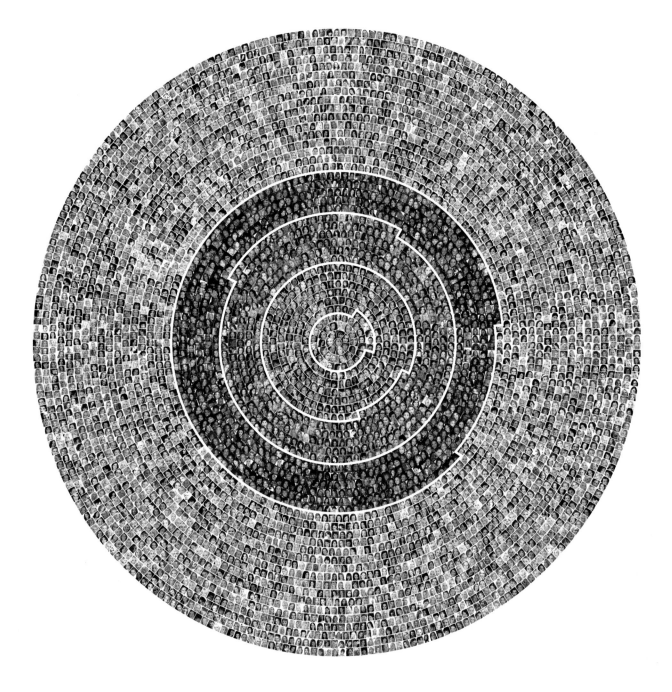

Jon Millward
Deep Inside: A Study of 10,000 Porn Stars and Their Careers
2013

Diagram focusing on ethnicity, from the British journalist Jon Millward's analysis of more than ten thousand adult-film performers' demographic records (taken from the Internet Adult Film Database). The five concentric rings filled with the head shots of adult performers indicate their racial backgrounds, from outside to inside: Caucasian (70.5 percent), black (14 percent), Latin (9.3 percent), Asian (5.2 percent), and other (1 percent).

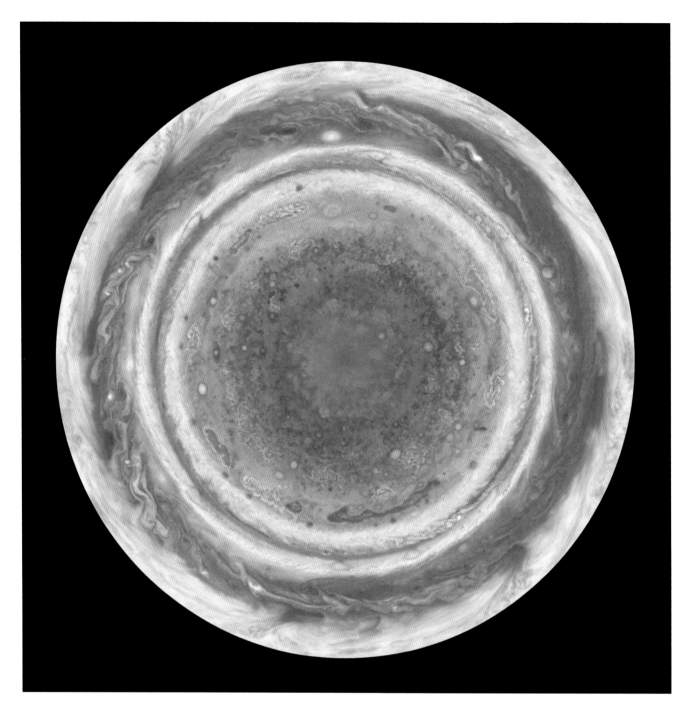

Cassini Imaging Team (NASA)
Jupiter's North Pole
2000

Picture of Jupiter constructed from images taken by NASA's *Cassini* spacecraft in 2000, forming one of the most detailed global color maps of the planet ever produced. It shows a variety of cloud features (e.g., the parallel reddish-brown and white bands), multilobed chaotic regions, white ovals, and many small vortices.

Amy Keeling
*Shift: Thirty Years of the
New York Times (1981–2012)*
2012

Interactive project in which
users select one of twenty-four
different topics derived from
Gallup trends. The topic is then
matched to an archive of thirty
years' worth of *New York Times*
articles to generate a data circle
that reveals trends and explore
how our society's attitudes and
values have changed over time.
Each dot represents one news
article; its color is determined
by the year in which it was
published. Older articles (1980s
and early 1990s) are represented
by cooler colors, while more
recent articles are shown by
warmer colors. A wide band
of a single color shows strong
interest during a specific time
period. In this view, the selected
topic is oil and gas; the graph
reveals a relatively consistent
interest in the subject over forty
years.

Jax de León
Illinois: *Visualizing Music*
2009

Illustration from a project that
analyzes the language used in
the American songwriter and
performer Sufjan Stevens's
album *Illinois*. Each concentric
circle corresponds to a word
used in the song "The Predatory
Wasp of the Palisades Is Out to
Get Us!" The thickness of the
circle relates to the number of
times each word is used, with
the most commonly used words
at the outermost edges and the
least commonly used words in
the center.

RINGS & SPIRALS

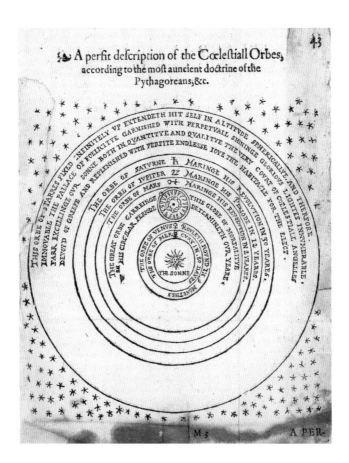

Thomas Digges
A Perfit Description of the Cœlestiall Orbes
1605

Diagram of celestial orbits. In this illustration of the Copernican planetary system, the mathematician and astronomer Thomas Digges places the sun at the center of the universe, surrounded by Mercury, Venus, Earth (with the four elements and the moon), Mars, Jupiter, and Saturn. The final ring shows heaven, which is placed in a starry sky, an early attempt to gesture at an infinite rather than fixed number of stars.

Alex Murrell
European Unemployment
2011

Based on Eurostat data from September 2011, this chart maps the extent of European national unemployment (among those age 15 to 74) in the left half of the circle and European youth unemployment (among those age 15 to 24) in the right half. Countries are represented by individual bars and are organized by region, from the center outward: western Europe (yellow), southern Europe (green), eastern Europe (red), and northern Europe (blue). The length of the bars corresponds to percentages of unemployment, growing from zero at the middle in a counterclockwise (national) or clockwise (youth) direction.

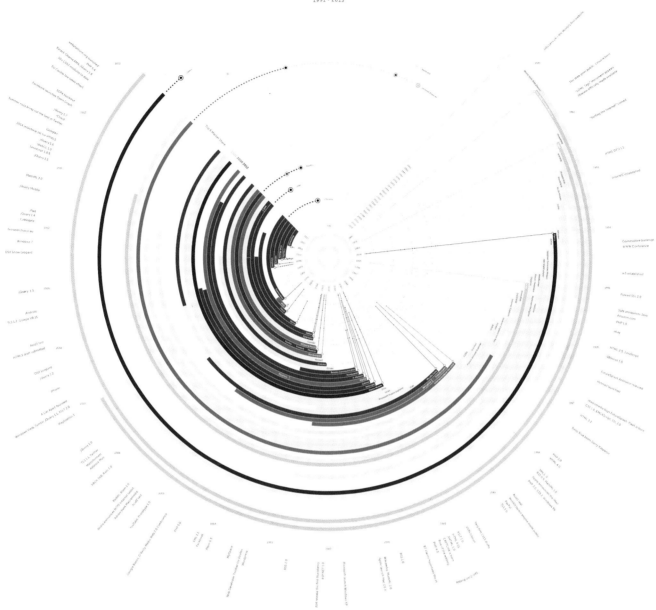

Omid Kashan
Browser History
2011

Every major Web browser from
1991 (upper-right-hand side)
to 2013 (upper-left-hand side),
arrayed in a radial time line. The
various browsers are shown as
rings, color-coded according

to their graphic layout (e.g.,
dark green is Gecko, purple is
Presto, and green is MS Trident).
Significant relationships among
browsers are indicated with a
small circle and a line. The chart
also includes several references
in its outer ring to major events
in the history of the Web.

The first booke of the Spheare.

A figure of the whole world, wherein are set forth the two essentiall parts before mentioned, that is to say, the eleuen heauens and the foure Elements.

Thomas Blundeville
Figure of the Whole World
ca. 1613

Illustration from *M. Blundeuile: His Exercises* (1613). The English mathematician Thomas Blundeville is known for his work on logic, astronomy, education, and horsemanship, as well as for inventing the protractor. As in the medieval conception of the universe, the Earth appears at the center of the universe in this diagram, nested within the four elements and then the celestial spheres, which contain the eleven "heavens" (planets such as Mercury, Venus, and Mars, as well as the stars and the realm of the blessed).

IIB Studio
Stock Check
2011

Diagram displaying the numbers of years left before various natural resources run out. Resources are categorized and color-coded for ecosystems (yellow), fossil fuels (blue), and minerals (red); each is represented as a single bar extending clockwise around the one-hundred-year span of the matrix, with each quadrant representing twenty-five years. The remaining years for each natural resource are indicated inside the circle at the end of its bar.

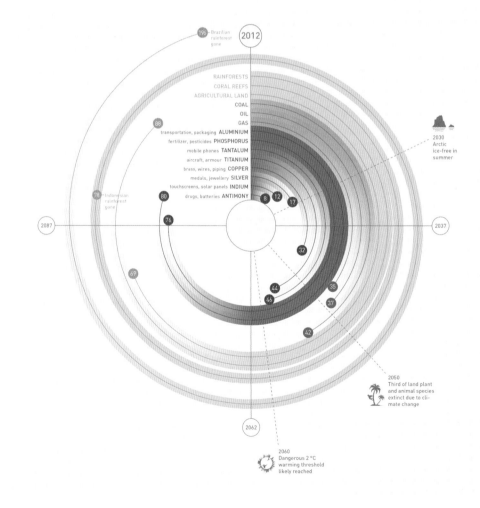

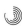

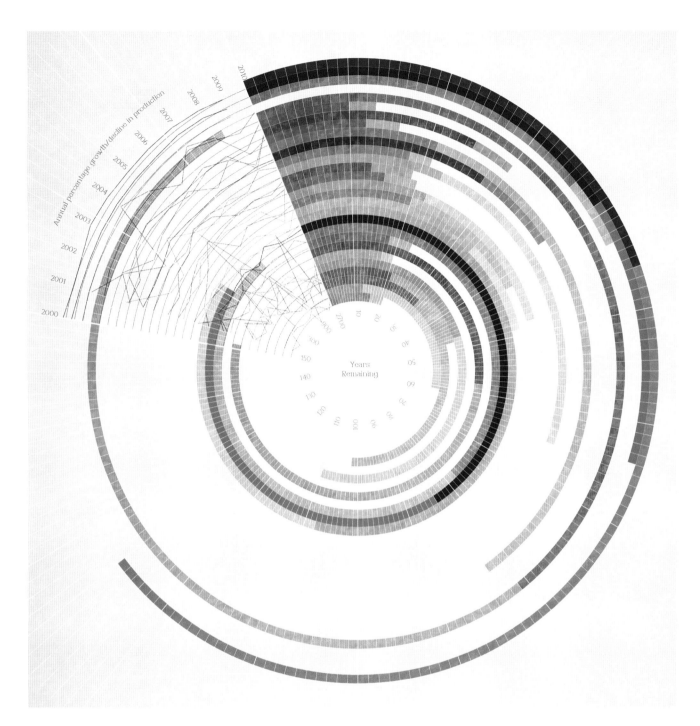

Matt Dalby and Robbie Ormrod
Stock Check
2011

Chart depicting the remaining
duration of the most valuable
natural resources in our planet.
This project was short-listed
for the 2011 Information Is
Beautiful Awards, a visualization
competition whose first
challenge asked participants to
"visualize data on the world's
nonrenewable resources."

Each individual tile represents
a year, and each colored ring
represents a different resource.
The colors indicate two levels
of information: the darker
shades show the number of
years remaining if production
continues to rise at the current
rate; the lighter shades show
the length of time left with
a static production rate. The
chart also outlines the change
in production rates of these
resources over the past decade.

Piero Zagami
UNSC/R
2008

Chart mapping the large number of resolutions passed by the United Nations' Security Council executive body. More than 1,700 resolutions have been passed since 1946, accounting for up to 4,000 printed pages. Each ring represents a year and each colored tile a resolution. Color ranges differentiate the activity of the council across the years. The last resolution of each year is represented in black, with each string of preceding resolutions following the same gradation of colors (black to white to yellow to red to blue). The years with the highest variations of color are those with the highest numbers of resolutions.

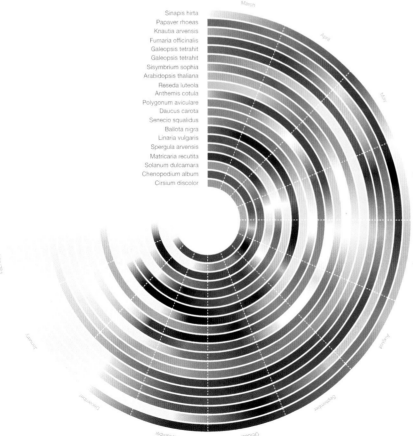

Sinapis hirta
Papaver rhoeas
Knautia arvensis
Fumaria officinalis
Galeopsis tetrahit
Galeopsis tetrahit
Sisymbrium sophia
Arabidopsis thaliana
Reseda luteola
Anthemis cotula
Polygonum aviculare
Daucus carota
Senecio squalidus
Ballota nigra
Linaria vulgaris
Spergula arvensis
Matricaria recutita
Solanum dulcamara
Chenopodium album
Cirsium discolor

Vladimir Guculak (Terrain Vague)
Landscape visual assessment
2012

Diagram from a series of studies produced as part of a natural landscape assessment of the Hoo Peninsula in Kent, England. It shows the evolution of color in the landscape over a year, highlighting the periods of blossom and growing seasons of selected plants. Twenty key species are shown, each in its own ring. Months are laid out radially in a clockwise fashion, beginning with spring, in March.

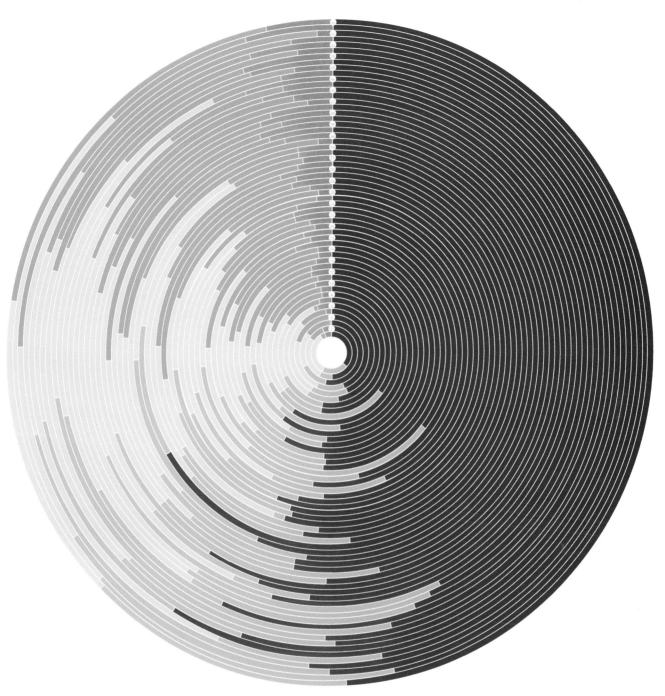

Carolina Andreoli
56 Days Worth of Food
2010

Detailed study of the designer's
food consumption from
February 1 to March 31, 2010.
Each circle represents the food
Carolina Andreoli ate each
day and is broken down by
main nutrients (carbohydrates
represented by pink, fat by blue,
protein by light green, sugars
by dark green, and fiber by
orange).

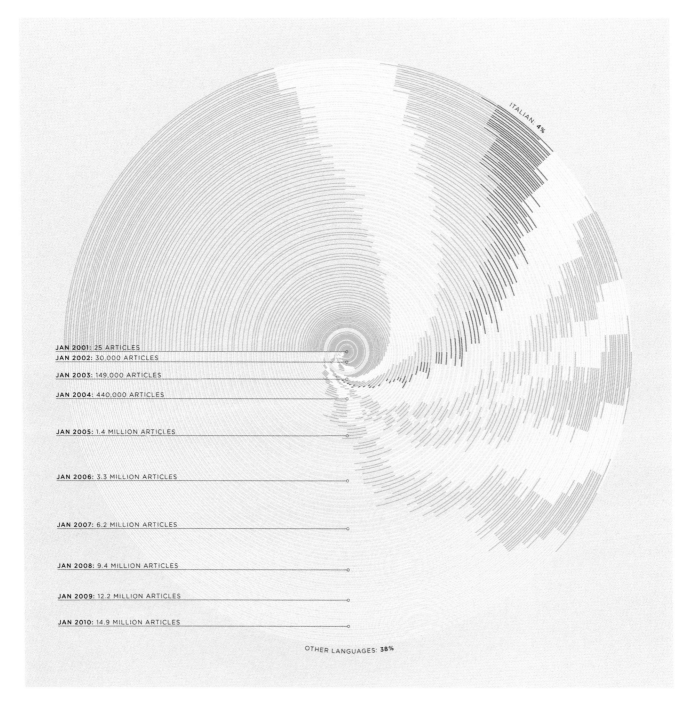

ITALIAN: 4%

JAN 2001: 25 ARTICLES
JAN 2002: 30,000 ARTICLES
JAN 2003: 149,000 ARTICLES
JAN 2004: 440,000 ARTICLES
JAN 2005: 1.4 MILLION ARTICLES
JAN 2006: 3.3 MILLION ARTICLES
JAN 2007: 6.2 MILLION ARTICLES
JAN 2008: 9.4 MILLION ARTICLES
JAN 2009: 12.2 MILLION ARTICLES
JAN 2010: 14.9 MILLION ARTICLES

OTHER LANGUAGES: 38%

Nicholas Felton
Wikipedia at Ten
2011

Diagram illustrating the number of articles and language distribution on Wikipedia from January 2001 (the center of the circle) to September 2010 (the outermost ring). The length of each ring is determined by the number of articles written that year; each is broken down by color according to which language the articles are in. Clockwise from the top-left quadrant: English (cyan: 21 percent), German (white: 7 percent), French (cyan: 6 percent), Italian (gray: 4 percent). Other languages are depicted in the last (yellow) band, corresponding to 38 percent.

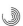

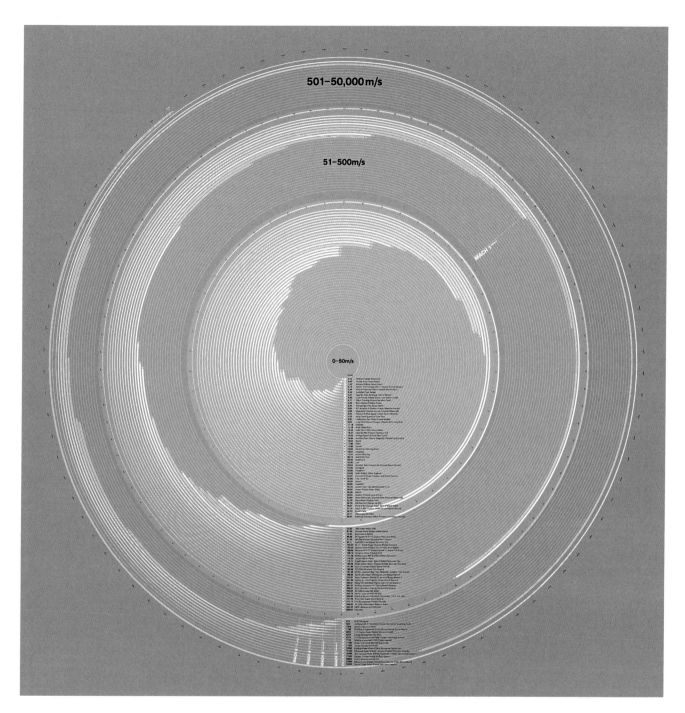

Robert Wilson (Signal Noise)
One Second Speed Map
2013

Chart displaying the speed of a selection of animals, people, vehicles, and objects. The white line inside each ring indicates distance traveled per second, in meters. The slowest entities, such as the tortoise and female giant house spider, are placed in the center of the chart, with the speedier ones (e.g., the *Helios 2* solar probe) on the outer edges. Three bands of color (light, medium, and dark orange) indicate different levels of speed; the number listed next to each name indicates the precise speed.

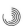

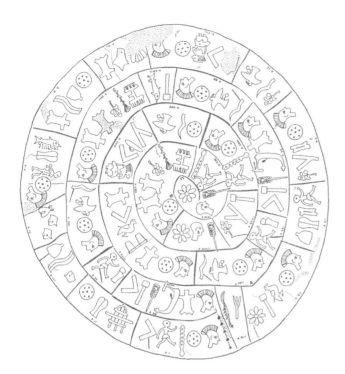

Anonymous
Phaistos disk
ca. 1700 BC

Sir Arthur Evans's drawing of
the stamped disk discovered
by Italian archaeologist Luigi
Pernier in 1908 at the Minoan
palace of Phaistos in Crete.
One of the most remarkable
artifacts of the ancient world,
imprinted on both sides with
various symbols arranged in a
spiral, this disk made of fired
clay contains a total of 241
tokens and 45 different glyphs.
The meaning of most of the
ideograms, believed to be some
type of protowriting system,
continues to be indecipherable
today.

Ross Racine (opposite)
Greenfield Lakes
2008

Inkjet on paper, 31.5 × 23.75
inches (80 × 60 centimeters).
Digital drawing depicting an
imaginary urban landscape in
the shape of a spiral.

New York World
The *World*'s Globe Circler
1890

Board game released by the
newspaper the *New York World*,
based on the record-breaking
trip of American journalist Nellie
Bly in 1889–90. Bly had been
inspired to re-create the journey
described in Jules Verne's 1873
novel *Around the World in 80
Days*. Each of the squares along
the spiral represents one of the
seventy-three days of her travels
and is illustrated with an image
from her journey.

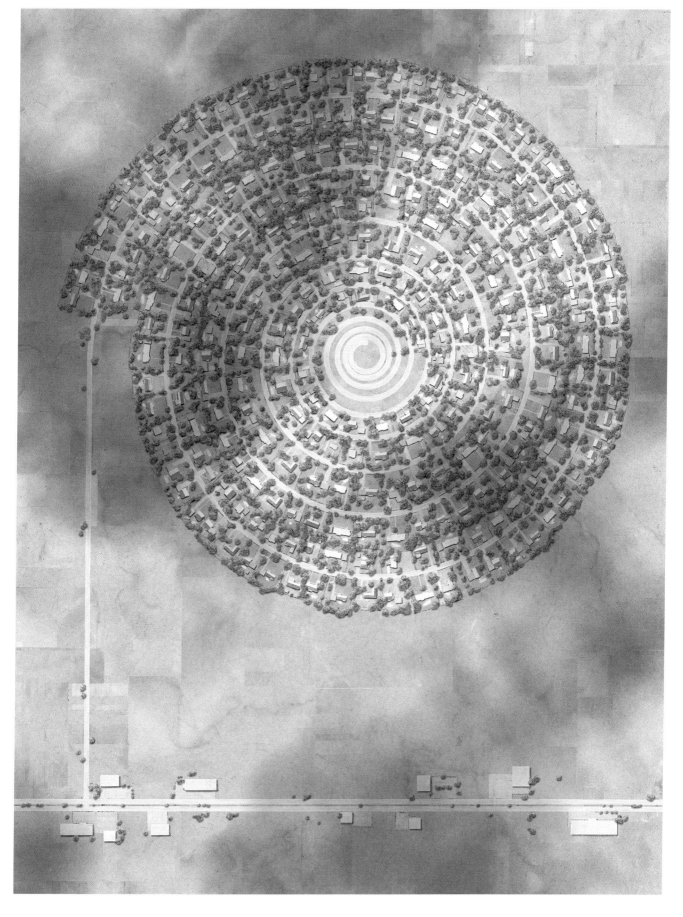

Christian Tominski and
Heidrun Schumann
*Enhanced Interactive
Spiral Display*
2008

An interactive spiral diagram
showing temperature
fluctuations in the city of
Rostock, Germany, between the
years 2008 (at the origin of the
spiral) and 2014. Color ranges
from dark blue (-20°C) to dark
red (40°C). Users can control the
structural layout of the spiral
(band width, center offset, and
segments per cycle), as well as
the color range.

Julie Marin, Michael Suleski,
Madeline Paymer, and
Sudhir Kumar
Spiral Tree of Life
2015

Collective evolutionary tree
of 50,632 species published in
2,274 studies. At the core of
the spiral chart is the common
origin of life, with time shown in
billions of years in a logarithmic
scale sprouting from the center
(in gray). Important taxonomic
groups are labeled along the
spiral and colored according to
taxa divisions.

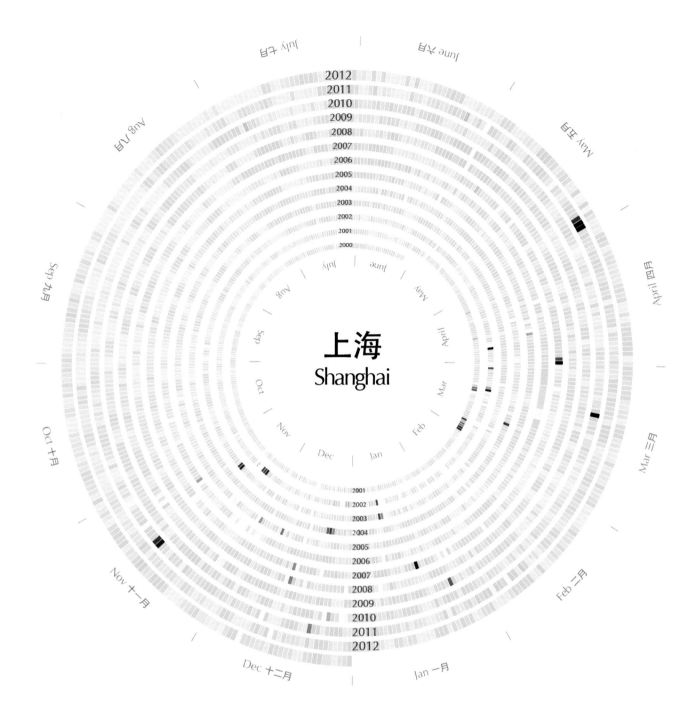

Xiaoji Chen
Sky Color of Chinese Cities
2013

Chart depicting air pollution in the city of Shanghai. Using air pollution–index data released by the environmental protection ministry of China, Xiaoji Chen created a series of spiral visualizations that show the air quality in major Chinese cities from 2000 to 2013. Blue indicates the lowest amount of air pollution; red and black indicate the highest. Each tile represents a day, and each full band of the spiral completes one year, with all twelve months mapped in a counterclockwise arrangement.

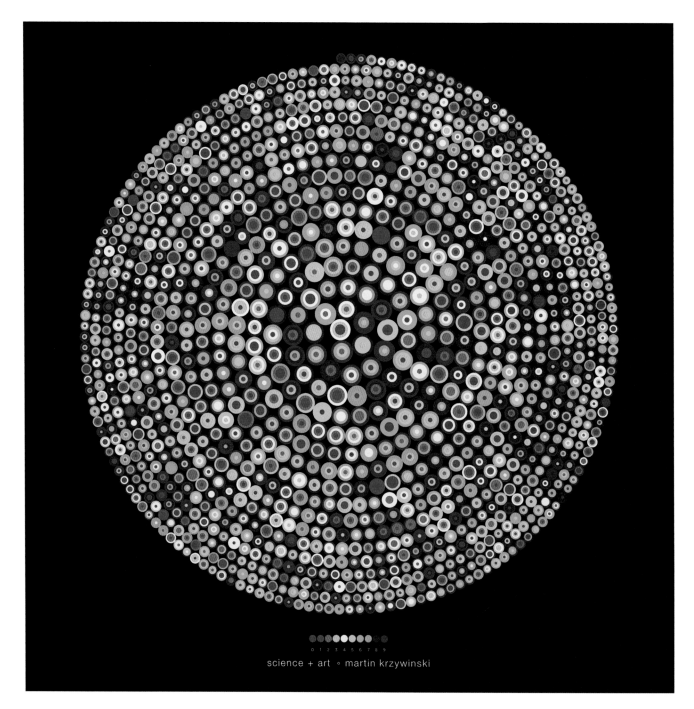

Martin Krzywinski
Pi Day 2014 poster
2014

Chart created to celebrate Pi Day. Based on an Archimedean spiral, it portrays the frequency distribution of 4,988 digits of pi in groupings of four, represented by a single circle with four inner bands. Each digit from zero to nine is conveyed by an individual color, while the width of each band is proportional to the number of times the given digit appears.

THE BOOK OF CIRCLES

Matt DesLauriers
Polartone
2015

Plot in real time of the
SoundCloud audio track
Something About You, by
Hayden James. DesLauriers's
project *Polartone* applies polar
coordinates on top of sonic
waveforms and plots them
along a spiral. The visualization
of the track begins at the
outermost edge of the circle
and moves inward.

Nicholas Rougeux
Between the Words
2016

Analysis of the punctuation
in Lewis Carroll's *Alice's
Adventures in Wonderland*
(1865), with assorted markings
from chapter 1 (outer edge)
to chapter 12 (at the core).
Rougeux explores the visual
rhythm of punctuation in
well-known literary works by
removing all letters, numbers,
spaces, and line breaks from the
text to create one continuous
line of punctuation symbols.

The Luxury of Protest
(Peter Crnokrak)
Maths Dreamed Universe
2009

Map of the numbers 0 to
100,001 in a logarithmic spiral
made using a custom-built
generative process (created
with the programming language
Python). Underpinning the visual

pattern of numerous natural
structures, such as shells and
galaxies, a logarithmic spiral
is defined by a curve whose
radius grows exponentially
with the angle. Numbers are
distributed from the center (0)
to the outer edge (100,001).
The size of the dots indicates
the occurrence and frequency
of prime factors.

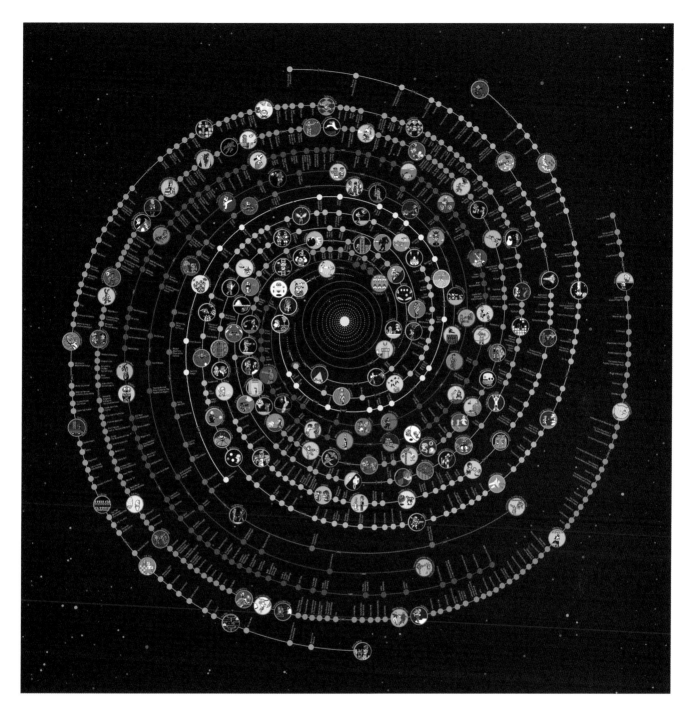

Pop Chart Lab
The Nebula of NES Games
2013

Graphic displaying all
seven hundred Nintendo
Entertainment System games
released in the United States
from 1984 to 1993. Starting
chronologically in the center,
each game genre has its own
spiral. A circle indicates each
game's release date, with the
more notable titles, such as
Battletoads and Tecmo Bowl,
featuring an illustration.

WHEELS & PIES

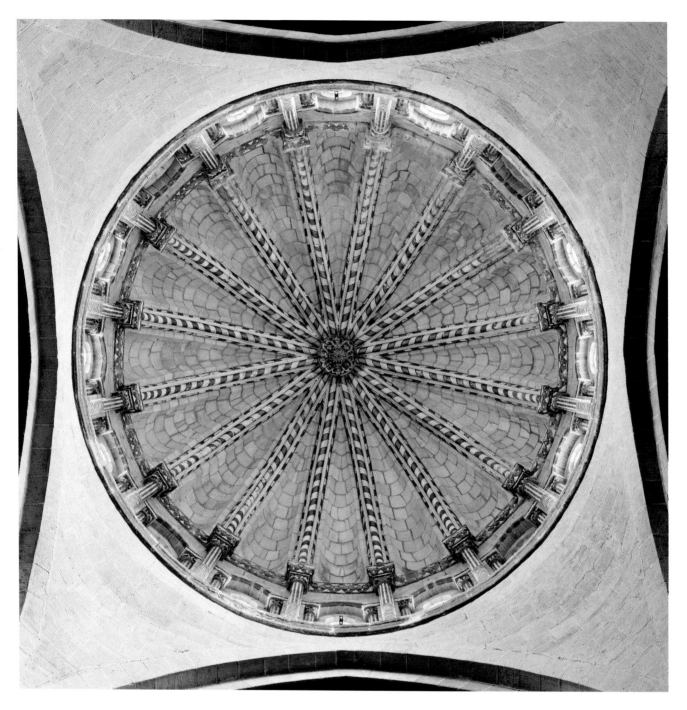

**Dome of the Cathedral
of Zamora, Spain**
ca. 1151–74

Photograph by David
Stephenson, from *Visions of
Heaven.*

Dirty probes on the inlet rake
of an F/A-18 fighter jet
1994

Photograph by Jim Ross
(NASA). In order to test pressure
points under different angles
of attack, NASA introduced
forty ports for low- and
high-frequency pressure
measurement in the inlet rake
of the High Alpha Research
Vehicle, a modified McDonnell
Douglas F/A-18 Hornet used
by NASA to research controlled
flight. This photo shows the
eight-legged, one-piece wagon-
wheel design of the rake.

Jean Vincent Félix Lamouroux
Asteria echinites
1821

Victorian lithograph of a
type of starfish called *Asteria
echinites*, plate 60 of *Exposition
méthodique des genres
de l'ordre des polypiers*
(Methodical exposition of
polypary). This book by the
French biologist Jean Vincent
Félix Lamouroux was part of
Charles Darwin's library.

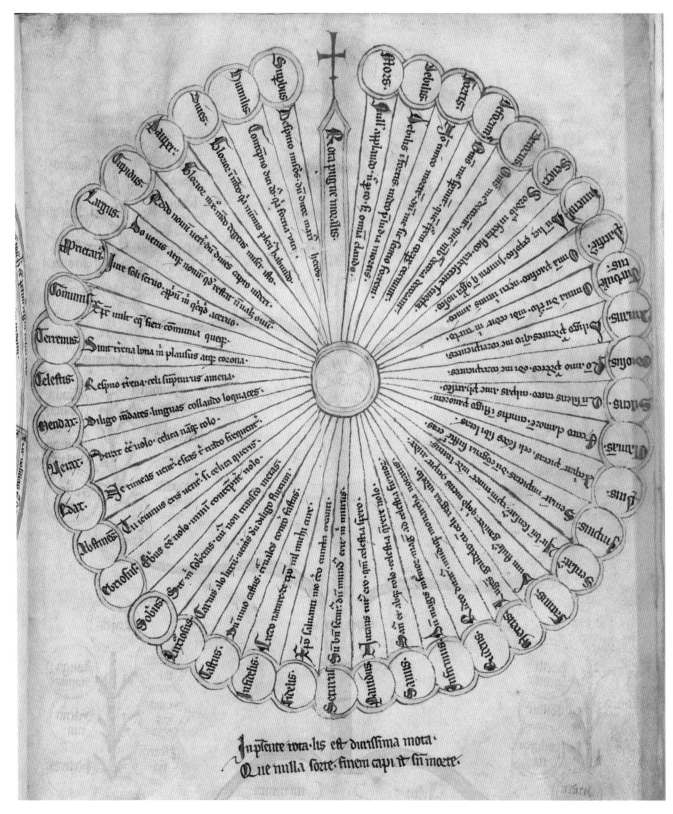

Anonymous
The wheel of moral struggle
ca. thirteenth century

A wheel showing twenty-one pairs of virtues and vices, published as part of *Speculum theologiae*. Created in Germany at the end of the thirteenth century, Speculum theologiae is composed of multiple illustrations that are designed to help readers remember moral principles. This diagram is distinct from the rest of the illustrations in the manuscript, as it appears to be for the laity as well as clerics. A single unpaired spoke representing death is shown at the top, reminding the reader of the mortality of man.

Cara Barer
Two Dreams
2007

Photograph from Cara Barer's series *Becoming a Myth*, in which she experiments with "new ways to repurpose books that no longer have a reason to exist." Barer transforms books into art by sculpting them, dyeing them, and then photographing them in their new state. As Barer explains, in the digital context of the twenty-first century, she hopes that "people will consider the ephemeral way in which we choose to obtain knowledge, and the future of books."

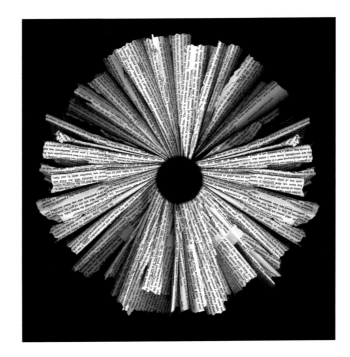

Cristian Ilies Vasile
Pi as Dots
2012

Chart created with data visualization software Circos to display the progression and adjacency of the first ten thousand digits of pi. Each number from 0 to 9 is represented by a colored segment at the inner circle. This system is then used to color and place the digits; for example, if the digit 5 is succeeded by 9, a dot is placed on the fifth position (central-peripheral) of the fifth segment (wedge) and adopts the color of the ninth segment. By using this approach, it is possible to see the uniform distribution of the digits in pi: no one digit dominates the piece.

Brookhaven National Laboratory
End view of a gold-ion collision in the STAR detector
2000

Photograph taken within the STAR (Solenoidal Tracker at RHIC) detector, which was built to track the thousands of particles produced by each ion collision at Brookhaven National Laboratory's Relativistic Heavy Ion Collider (RHIC). The collider re-creates the conditions of the early universe so that scientists can better understand the moments immediately after the Big Bang. The collision creates a fireball where quark-gluon plasma—matter in which quarks and gluons join to form a single entity—can momentarily be seen. This image reconstructed the particle tracks captured visually in STAR's time projection chamber to prove the existence of quark-gluon plasma, which to that point had been theoretical.

Valerio Pellegrini
La febbre del Sabato sera
(Saturday night fever)
2014

Diagram showing the most-searched musical artists in each Italian region from 2009 to 2014. Each ring represents a year, and each axis represents a region; each pair of circles represents the most searched artist in that region (in colors shown on bottom left legend) and the second most searched (in gray, on bottom right legend). If an artist appears multiple times over the years in a certain region, the related circles are linked to one another to highlight the recurrence.

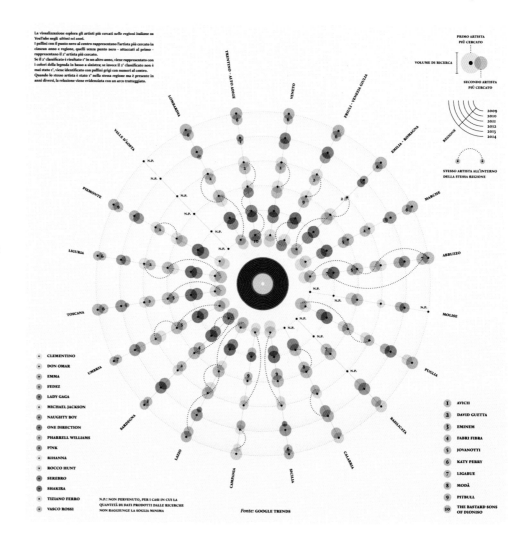

• CLEMENTINO
• DON OMAR
• EMMA
• FEDEZ
• LADY GAGA
• MICHAEL JACKSON
• NAUGHTY BOY
• ONE DIRECTION
• PHARRELL WILLIAMS
• P!NK
• RIHANNA
• ROCCO HUNT
• SEREBRO
• SHAKIRA
• TIZIANO FERRO
• VASCO ROSSI

1 AVICII
2 DAVID GUETTA
3 EMINEM
4 FABRI FIBRA
5 JOVANOTTI
6 KATY PERRY
7 LIGABUE
8 MODÀ
9 PITBULL
10 THE BASTARD SONS OF DIONISO

N.P.: NON PERVENUTO, PER I CASI IN CUI LA QUANTITÀ DI DATI PRODOTTI DALLE RICERCHE NON RAGGIUNGE LA SOGLIA MINIMA

Fonte: GOOGLE TRENDS

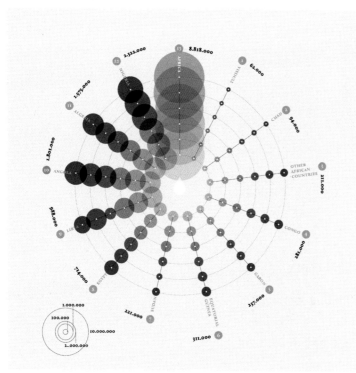

Valerio Pellegrini
AFRICA—Big Change / Big Chance
2014

Pellegrini's exploration of the relatively consistent contribution of various African countries to oil production between 2008 and 2013. Each country is represented by a separate axis, with the total for Africa shown at the top. Next to each country's name is the number of barrels produced per day in 2013. Circles along the axis indicate the barrels per day, from one hundred thousand (smallest radius) to ten million (largest radius). Each ring represents a year, from 2008 (inner ring) to 2013 (outer ring).

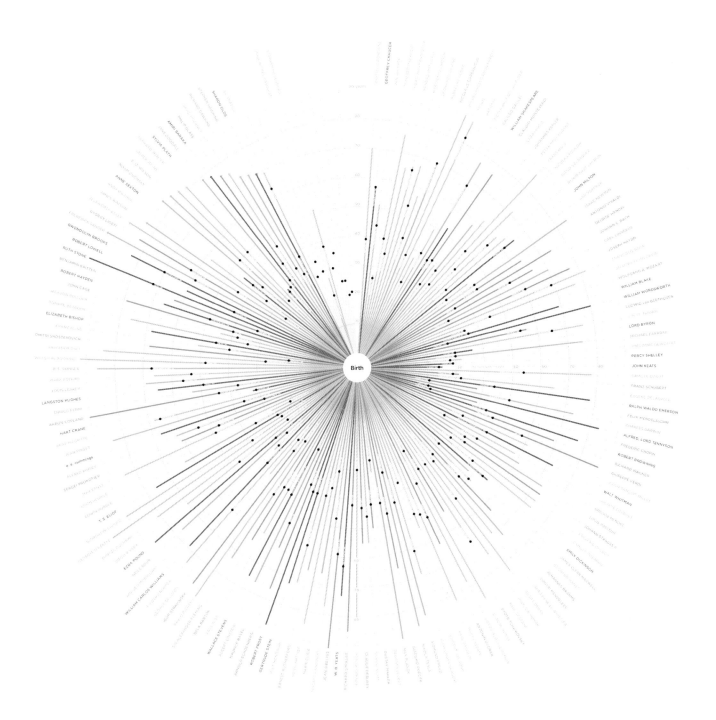

Oliver Uberti
Lifelines
2013

Diagram plotting the lifespan of more than 170 creative thinkers, with each spoke representing one person. Time is expressed on the underlying set of concentric rings, from birth at the core to ninety years in the outer ring. Artists are represented by orange, composers by purple, poets by red, scientists by green, and software developers by blue. The creation of each person's most notable work (as chosen by Uberti) is shown by a black dot. The peak of creativity appears to occur in your thirties, particularly if you are an artist or scientist.

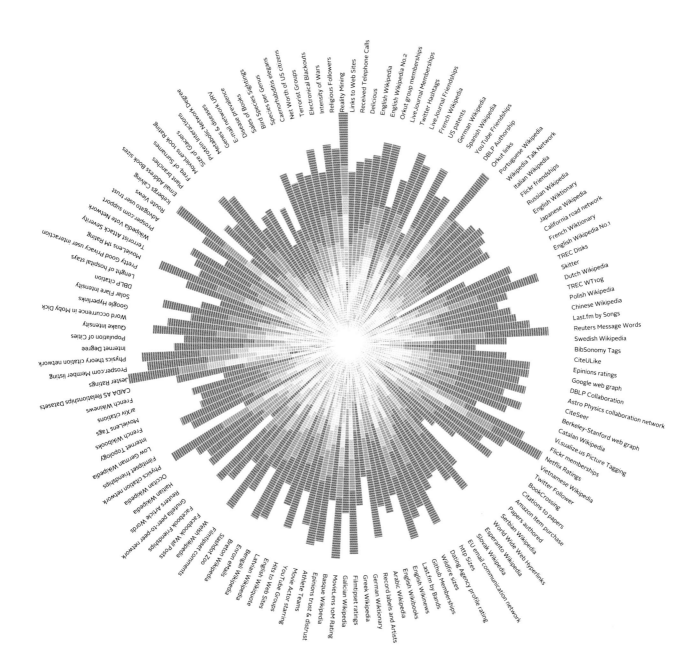

Kim Albrecht
Outliers n>1
2012

A chart mapping the similarities and differences of 140 natural, technological, and social phenomena whose occurrences follow a power-law ratio, part of a series of diagrams entitled *Atlas of Powerlaws (2012)*. A power law is a type of probability function where a high percentage of effects is driven by a low percentage of variables. Examples can be found in the structure of the World Wide Web, the system of airport connections, and the metabolic networks of cells. Each phenomenon is mapped along an axis; colors indicate the percentage of effect driven by a small number of users (red indicates 90 percent, orange 80 percent, yellow 70 percent).

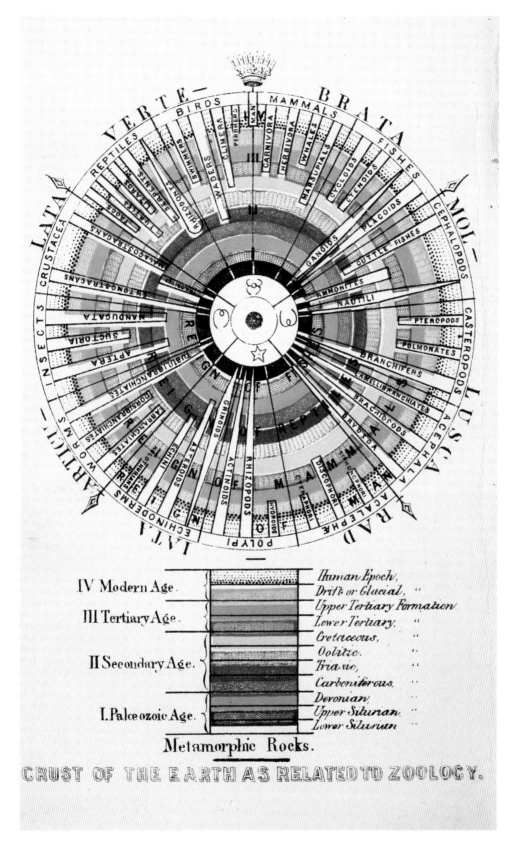

Louis Agassiz
Crust of the Earth as Related to Zoology
1851

Chart featured as a colored frontispiece to the volume *Outlines of comparative physiology touching the structure and development of the races of animals, living and extinct*, by the Swiss biologist Louis Agassiz. At the core of the radial diagram are metamorphic rocks (in black), with various colored geologic periods grouped into four main eras, from inner to outer layer: Paleozoic Age, Secondary Age, Tertiary Age, and Modern Age. The various radial spokes across the chart (in white) represent various species, such as whales, marsupials, and serpents, grouped by class at the outermost ring. The spokes for different species vary in length, depending on each one's estimated origins, with a few going as far back as the Paleozoic Age, or more than five hundred million years ago.

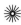

Peter Apian
World map
ca. sixteenth century

Map from the highly
respected work on
astronomy and navigation
Cosmographia, written by the
German cartographer and
mathematician Peter Apian.
Cosmographia was reprinted
more than thirty times in
fourteen languages. This map
shows a somewhat accurate
rendering of Europe, the Middle
East, and Africa, reflecting the
growing interest in exploration
at that time. Its estimates of the
circumference and diameters
of the globe (written in the bars
that divide the chart in four
quadrants) are less accurate.

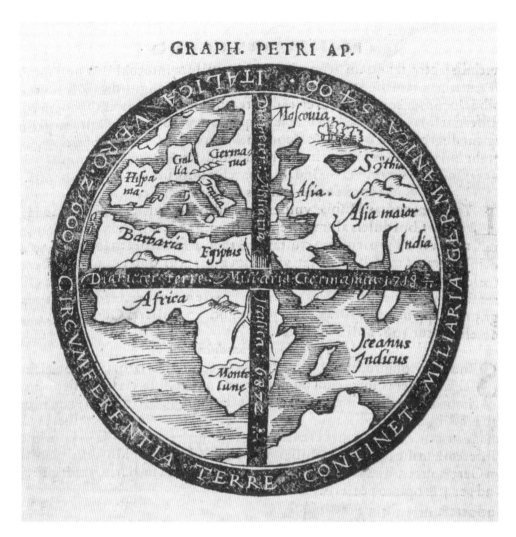

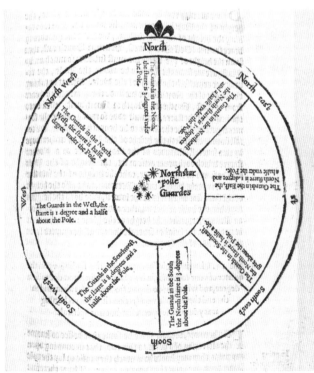

William Bourne and
Thomas Hood
North Star chart
1601

Image showing how to find and
position the North Star in order
to navigate. When Thomas
Hood updated William Bourne's
popular book on navigation,
A Regiment for the Sea, he
included charts of "celestial
declinations," which allowed
sailors to avoid going through
the laborious process of finding
the locations of the stars
themselves.

Nicholas Felton
Feltron 2007 Annual Report
2008

Pie chart displaying the statistics for an average day of the author, plotting various data such as number of emails sent, miles run, or cups of coffee consumed. Between 2005 and 2015, information designer Nicholas Felton meticulously documented his daily activity to create his Personal Annual Reports, compilations of information graphics that give an overview of each year, set out in the style of corporate reporting. The project is an exploration of how to graphically encapsulate the activities of an entire year, as well as how we can glean data from rapidly changing technology.

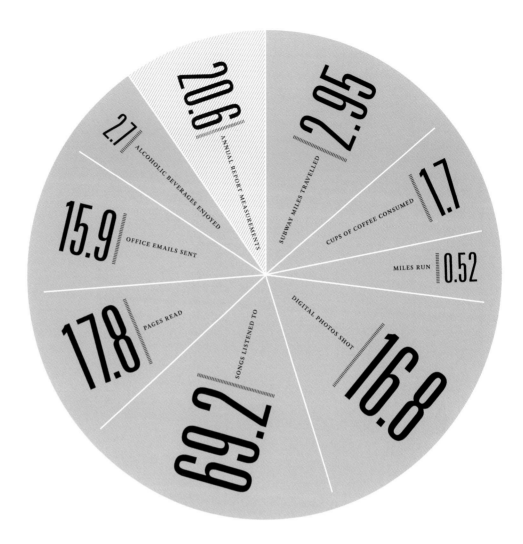

Thomas Blundeville
Wind chart
1613

Illustration of the twelve directional winds, taken from a section of the early textbook *M. Blundeuile: His Exercises*. This book, by the English mathematician Thomas Blundeville, provided an overview of the knowledge needed for a young gentleman. English names of the winds are written around the outside of the circle; inside the circle, Greek names appear on one side of each wind line, while Latin ones are shown on the other.

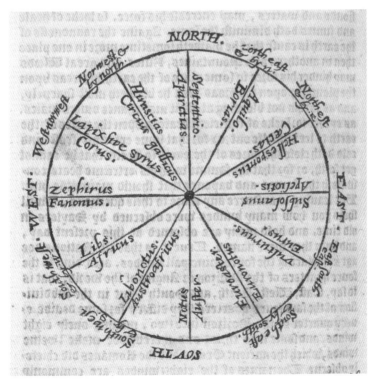

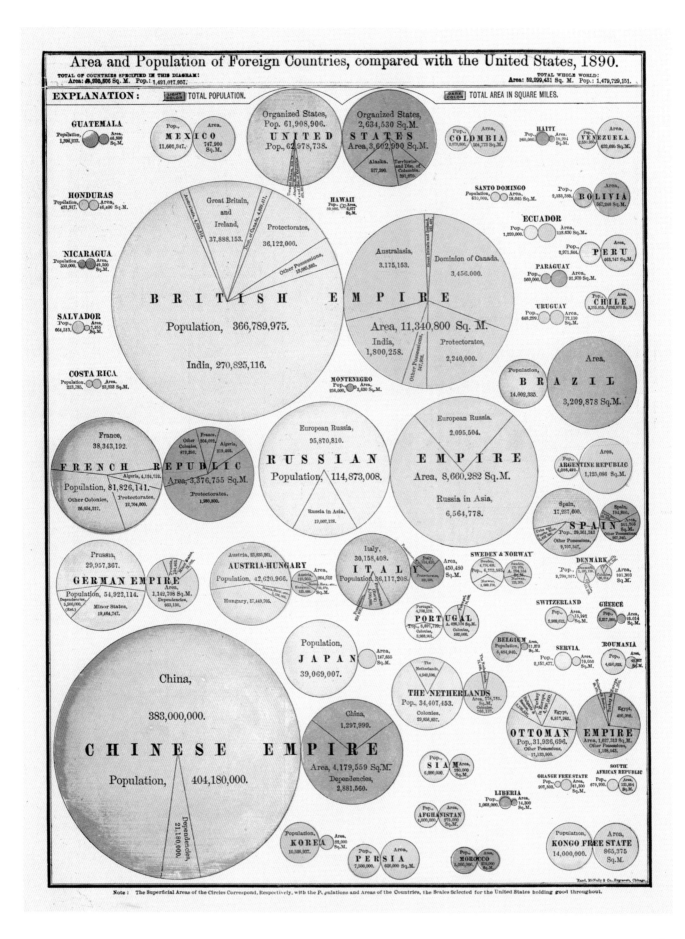

Area and Population of Foreign Countries, compared with the United States, 1890.

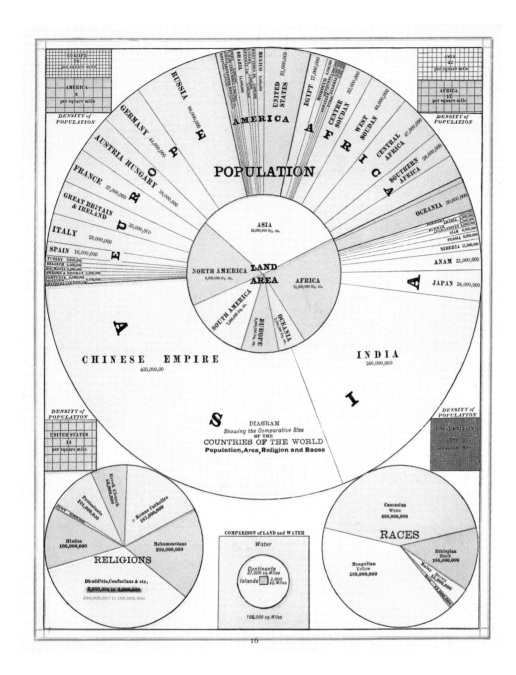

*Diagram Showing the
Comparative Size of the
Countries of the World:
Population, Area, Religion
and Races*
1883

A Victorian diagram that uses
different pie charts to showcase
the comparative size of the
countries of the world in terms
of population (central pie chart),
area (inner central pie chart),
religion (bottom left), and race
(bottom right).

Rand McNally and Company
(opposite)
*Area and Population of Foreign
Countries, Compared with the
United States (1890)*
1897

Chart that represents each
country or empire by two
juxtaposed circles, one for
total population (left) and
one for total area in square
miles (right). When an entity
comprises multiple regions
(e.g., the British Empire), pie
charts are used to indicate
the corresponding breakdown
within each individual region.
All circles and pie charts are
scaled depending on the total
population or area.

Henry Gannett
*Composition of Church
Membership of the States
and Territories (1890)*
1898

Chart that was part of a
statistical atlas of the United
States, based on the results of
the eleventh US census from
1890. The area of each circle
signifies the entire church
membership of that state. The
various segments represent,
proportionally, the strength of
each denomination.

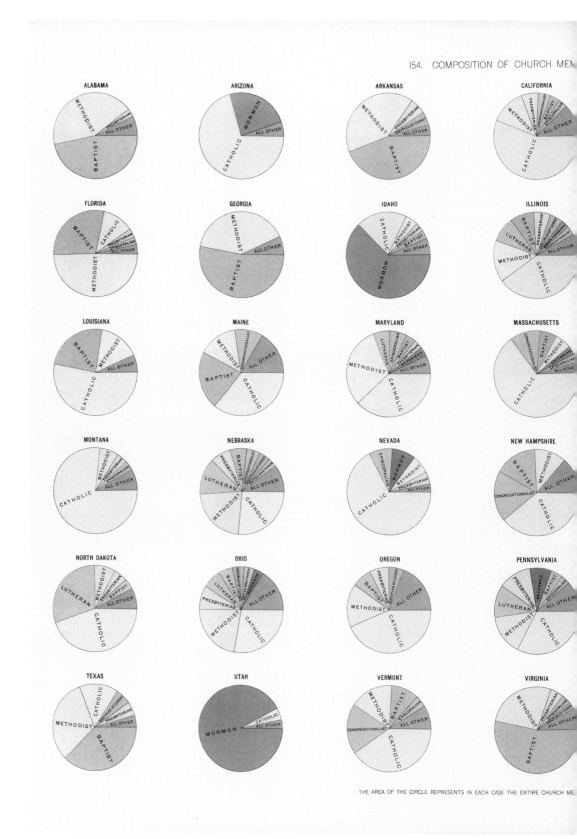

THE BOOK OF CIRCLES

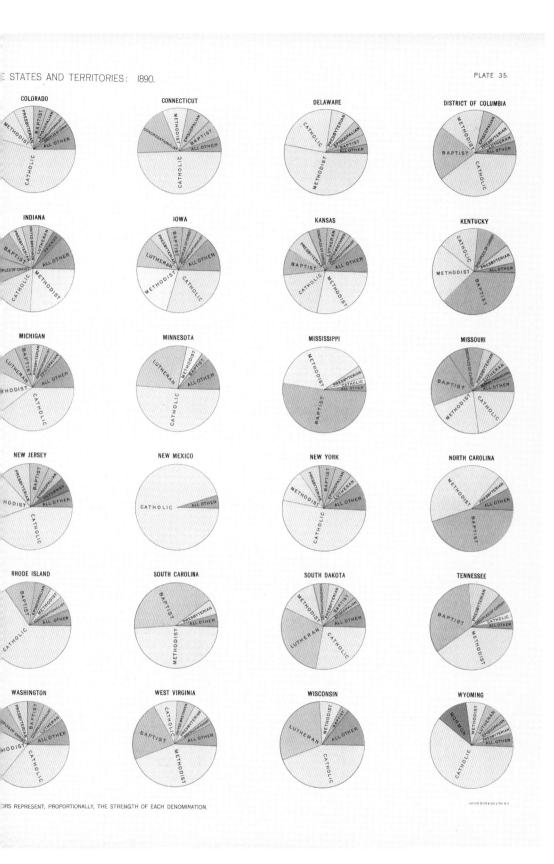

COLORADO

CONNECTICUT

DELAWARE

DISTRICT OF COLUMBIA

INDIANA

IOWA

KANSAS

KENTUCKY

MICHIGAN

MINNESOTA

MISSISSIPPI

MISSOURI

NEW JERSEY

NEW MEXICO

NEW YORK

NORTH CAROLINA

RHODE ISLAND

SOUTH CAROLINA

SOUTH DAKOTA

TENNESSEE

WASHINGTON

WEST VIRGINIA

WISCONSIN

WYOMING

ORS REPRESENT, PROPORTIONALLY, THE STRENGTH OF EACH DENOMINATION.

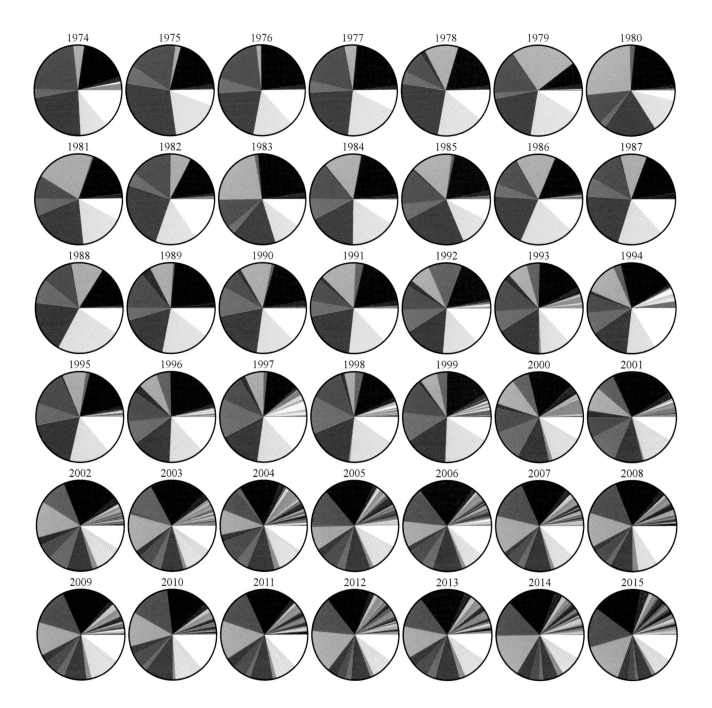

David Eaton
LEGO Color Evolution
2015

Collection of pie charts generated using a computer program Eaton wrote to analyze the changing colors of Lego sets over the past thirty-five years. Based on data from BrickLink.com and Peeron.com, Eaton's charts reveal an obvious increase in the overall number of colors offered, beginning in 1993. While primary colors (red, yellow, and blue) constituted more than half of the spectrum in the 1970s, we now see a more diverse range, currently dominated by black and tones of gray.

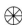

Kentuckey
115,000 Sq. Miles.

Georgia
150,000 Sq. Miles.

New Jersey
105,000 Sq. Miles.

North Carolina
84,000 Sq. Miles.

Virginia
169,000 Sq. Miles.

Massachussets
73,000 Sq. Miles.

South Carolina.
25,000 Sq. Miles.

Maryland
14,710 S.M.

New Hampshire.

Vermont.

New York
Connecticut
Rhode Island
Delaware

East & West Florida.

not yet united

LOUISIANA
Extent 725,000 Square Miles

Extent 450,000 Square Miles

WESTERN TERRITORY

WESTERN TERRITORY

WESTERN TERRITORY. Newly Acquired (in 1804.)

William Playfair
Statistical Representation of the United States of America
1805

One of the earliest uses of the modern pie chart, a visualization model that the Scottish engineer William Playfair is credited with inventing. Found in the *Statistical Account of the United States of America*, the chart shows a breakdown of the square mileage of the United States in 1805. The dominance of the Western territories (in light green), and particularly the newly acquired Louisiana Territory (1804), is quite evident in the diagram. Below the pie chart one can read: "This newly invented method is intended to show the proportions between the divisions in a striking manner."

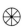

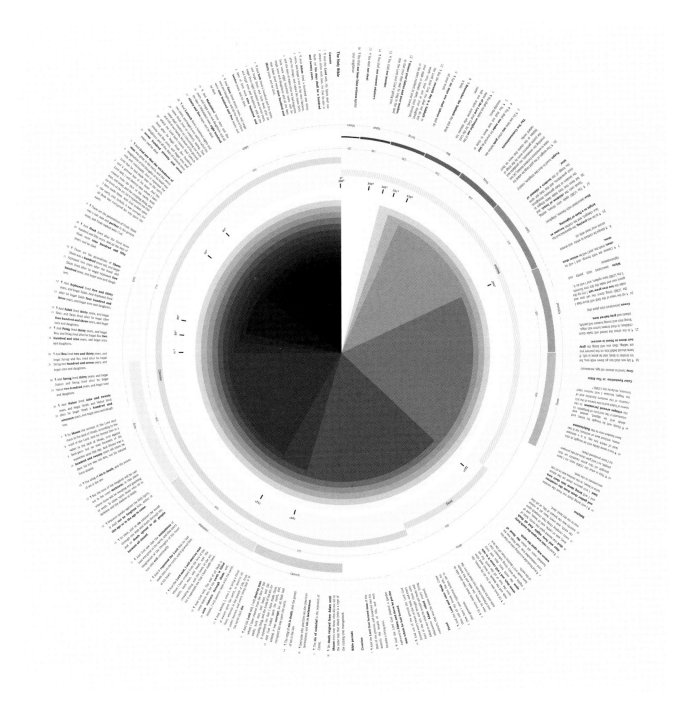

Anna Filipova
Lineage of Sin in the Bible
2009

Chart measuring time through sins, as described in the Bible, displaying an inverse relationship between longevity and sin. Longevity decreases from Adam (the first man) to Moses at the same time that sin increases. The outer ring, read counterclockwise, moves through the major events of the Old Testament. Relevant biblical verses that reveal someone's age are cited, and the average age for an epoch is shown underneath (colored rings).

The Luxury of Protest
(Peter Crnokrak)
Never Forever Never for Now
2011

Visualization showing all known empires, colonies, and territorial occupations from 2,334 BC to the present day. Each empire occupies a slice of the pie chart, with its known start and end dates. Each slice is assigned a transparency value of 10 percent, which allows concurrent empires to be visualized: the more empires that occupy the same period of time in history, the whiter the graph.

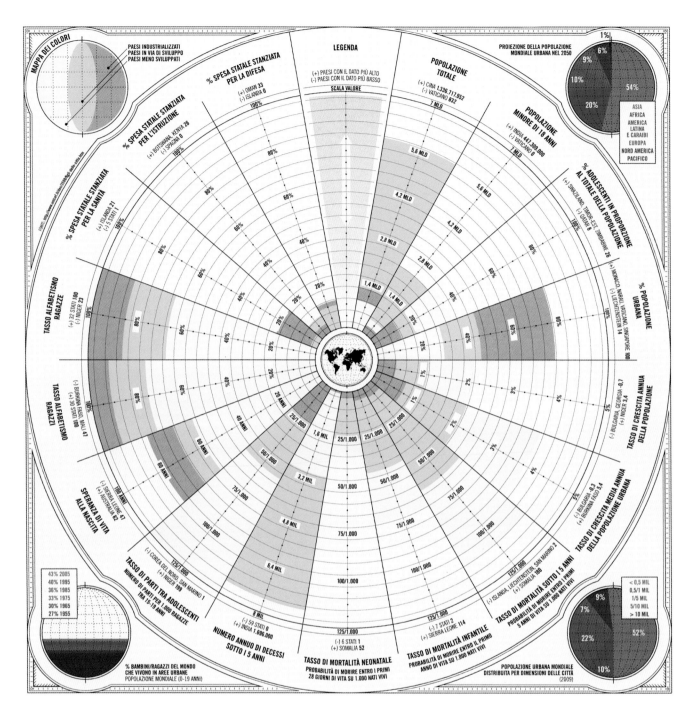

Andrea Codolo and
Giacomo Covacich
*Il futuro? 450 milioni di piccoli
indiani* (The future? 450 million
young Indians)
2012

Created for the Italian news-
paper *La Lettura* and using data
from a 2012 UNICEF study, a
diagram showing the impact
of a large youth population
in Asian countries. Segments
show different indicators (e.g.,
state spending on education,
life expectancy at birth, number

of deaths of those under
fifteen years old per year) in
the outermost ring. From the
center (zero), working outward,
the rings show the percentage
or number of the relevant
indicators. The country directly
underneath each indicator is
that with the highest number

for the statistic measured;
under that is the country with
the lowest. The color scale
indicates each country's level
of development: yellow for
industrialized countries, light
green for emerging countries,
and dark green for developing
countries.

City of New York
(1960 - 2000)

Software FX Product
Management Team, Chart FX
for WPF
Wind chart
2011

Rose chart showing wind
direction and speed in New York
City from 1960 through 2000.
Data has been aggregated
and distributed along axes
corresponding to wind
direction. Colors represent
ranges of wind speed: one
to four knots in red, four to
seven knots in orange, seven to
twelve knots in yellow, twelve
to nineteen knots in green,
nineteen to twenty-five knots in
blue, and more than twenty-five
knots in purple.

Erik Jacobsen (Threestory
Studio) and Peter Cook
*Coastal Fisheries Success
Factors*
2014

Interactive chart synthesizing
twenty interconnected factors
(shown along the edge of the
outer ring) that contribute
to the success of fisheries in
developing countries. Users
can select various stakeholders
to see how they might
prioritize factors and how their
priorities overlap (or fail to
overlap) with those of other
stakeholders. The radius for
each factor is proportional to
the amount of emphasis the
selected stakeholder might
place on that factor. In this
version, the interests of a
conservationist (in green) and
a fisher (in blue) are shown.

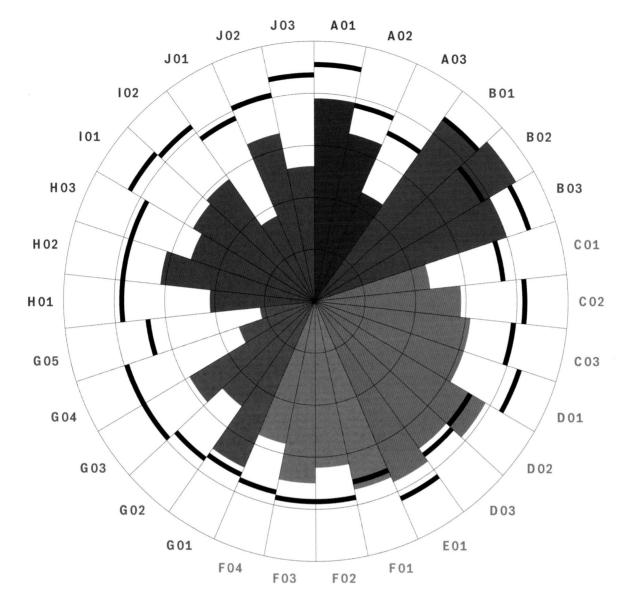

Barbara Hahn and
Christine Zimmermann
(Hahn+Zimmermann)
Team Diagnostic Survey
2008

Chart resulting from a scientific
study on the work and
functioning of multidisciplinary
teams, in which subjects
evaluated thirty aspects of
their team's performance on
a scale of one to five. Team
averages are indicated through
colored pie segments that can
be compared with the Swiss
average (marked by black bars).

Barbara Hahn and
Christine Zimmermann
(Hahn+Zimmermann) (opposite)
Internet Economy
2013

A rose chart describing the
total German Internet economy
from 2009 to 2016, comparing
the growth of various sectors.
Each year's wedge is divided
into individual sectors by
color: infrastructure/operating
(purple), service/application
(orange), aggregation/
transaction (green), paid
content (pink), and consulting
services (cyan).

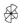

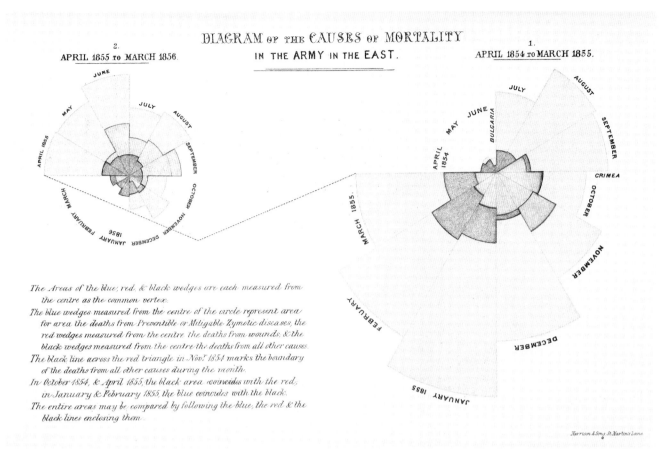

DIAGRAM of the CAUSES of MORTALITY
IN THE ARMY IN THE EAST.

2.
APRIL 1855 to MARCH 1856.

1.
APRIL 1854 to MARCH 1855.

The Areas of the blue, red, & black wedges are each measured from
the centre as the common vertex.

The blue wedges measured from the centre of the circle represent area
for area the deaths from Preventible or Mitigable Zymotic diseases, the
red wedges measured from the centre the deaths from wounds, & the
black wedges measured from the centre the deaths from all other causes.

The black line across the red triangle in Nov.r 1854 marks the boundary
of the deaths from all other causes during the month.

In October 1854, & April 1855, the black area coincides with the red,
in January & February 1855, the blue coincides with the black.

The entire areas may be compared by following the blue, the red & the
black lines enclosing them.

Harrison & Sons St. Martin's Lane

Florence Nightingale
*Diagram of the Causes of
Mortality in the Army in the East*
1858

Pioneering diagram showing
the causes of mortality in British
troops engaged in the Crimean
War, from March 1855 to March
1856. Florence Nightingale
was a celebrated English
social reformer and one of the
founders of modern nursing.
This visualization demonstrates
that most of the British soldiers
who perished during the war
died of sickness (indicated in
blue) rather than of wounds
or other causes (indicated in
red or black). The right half
of the diagram also shows
that the death rate was higher in
the first year of the war, before
improvements in the treatment
of soldiers reduced sickness.

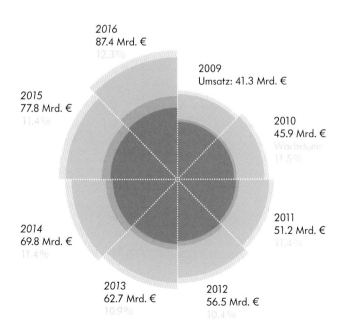

2016
87.4 Mrd. €
12.3%

2009
Umsatz: 41.3 Mrd. €

2015
77.8 Mrd. €
11.4%

2010
45.9 Mrd. €
Wachstum
11.5%

2014
69.8 Mrd. €
11.4%

2011
51.2 Mrd. €
11.4%

2013
62.7 Mrd. €
10.9%

2012
56.5 Mrd. €
10.4%

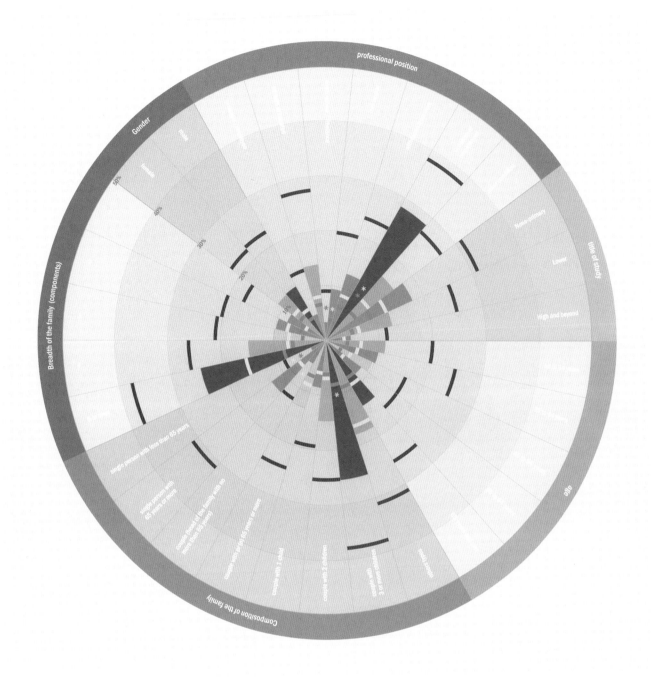

Débora Nogueira de França Santos
The Profile of Italian Poverty
2008

Infographic that demonstrates the strong links between poverty in Italy and a variety of socioeconomic indicators. According to the Italian Statistical Agency, there were more than seven million people, or nearly 13 percent of the entire Italian population, living in poverty in 2008. This diagram segments the population by age, education, gender, family composition, and participation in the labor market. The inner rings indicate the percentages that meet these various criteria, radiating out from 0 percent in the center to 50 percent at the outermost edge. The colors indicate different parts of the country (red indicating the south, yellow the center, and green the north), revealing a strong concentration of poverty in the south of Italy.

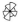

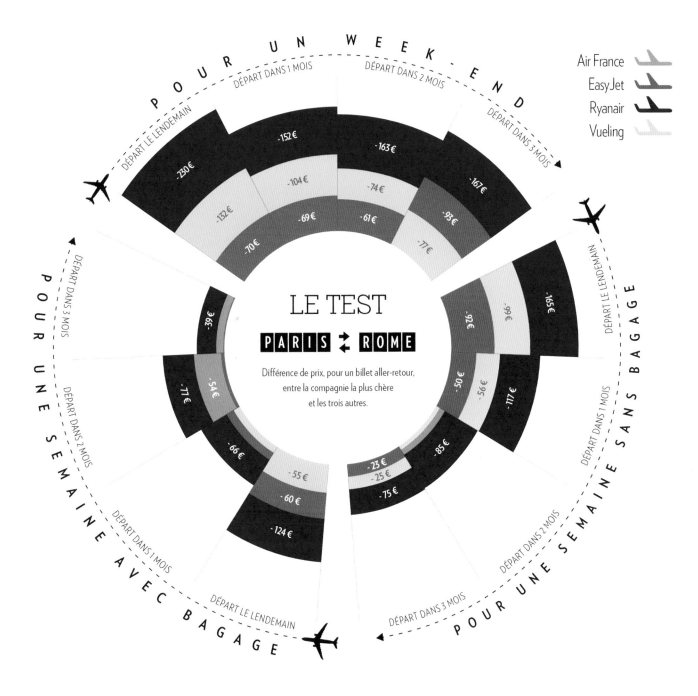

POUR UN WEEK-END

DÉPART DANS 1 MOIS
DÉPART DANS 2 MOIS
DÉPART DANS 3 MOIS
DÉPART LE LENDEMAIN

Air France
EasyJet
Ryanair
Vueling

-152 €
-163 €
-230 €
-104 €
-74 €
-167 €
-132 €
-69 €
-61 €
-93 €
-70 €
-77 €

LE TEST

PARIS ⇄ ROME

Différence de prix, pour un billet aller-retour,
entre la compagnie la plus chère
et les trois autres.

-39 €
-92 €
-99 €
-165 €
-54 €
-50 €
-56 €
-117 €
-77 €
-66 €
-85 €
-55 €
-23 €
-25 €
-60 €
-75 €
-124 €

DÉPART DANS 3 MOIS
POUR UNE SEMAINE AVEC BAGAGE
DÉPART DANS 2 MOIS
DÉPART DANS 1 MOIS
DÉPART LE LENDEMAIN

DÉPART LE LENDEMAIN
POUR UNE SEMAINE SANS BAGAGE
DÉPART DANS 1 MOIS
DÉPART DANS 2 MOIS
DÉPART DANS 3 MOIS

Ask Media
Low Cost
2013

Chart by the French design agency Ask Media investigating whether low-cost airline companies are cheaper than traditional companies. Prices for

a trip between Paris and Rome booked at different times (a day ahead of departure, a month ahead of departure, two months ahead of departure, and three months ahead of departure) were compared among three low-cost airlines (Ryanair, easyJet, Vueling)

and one traditional airline (Air France). The chart is divided into three sections, according to trip length: a weekend, one week without luggage, and one week with luggage. Differences in price among carriers are shown in the area of each wedge, colored according to airline.

Richard Garrison
Circular Color Scheme: Target, June 27–July 3, 2010, Page 1, "Pack Your Cooler With Savings"
2010

Watercolor, gouache, and graphite on paper, 25 × 25 inches (63.5 × 63.5 centimeters). *Circular Color Schemes* (2008–15) is a series of drawings derived from advertising circulars by the American artist Richard Garrison. Garrison measures the amount of space occupied by the objects on these fliers and then mathematically converts those amounts into scaled multicolored wedges within a circular grid. Finally, he paints the drawing, matching the colors of the original flier, to reveal the palette and design of American consumerism.

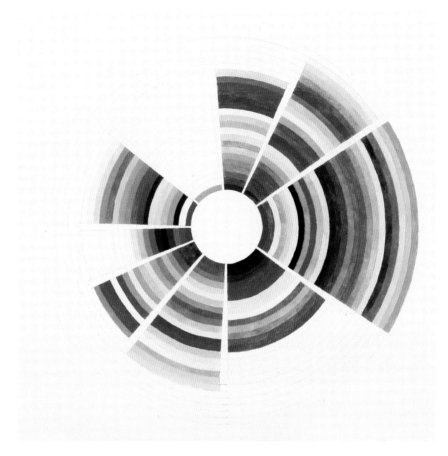

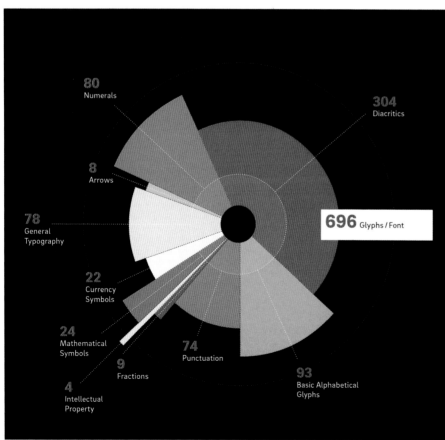

Hannes von Döhren and Livius Dietzel (HvD Fonts)
Brix Sans type family
2014

Overview of the Brix Sans type family, created by the German graphic designers Hannes von Döhren and Livius Dietzel. It breaks down the 696 glyphs that compose this sans serif family into multiple categories (e.g., currency symbols, numerals, arrows, and mathematical symbols). Numbers indicate how many glyphs of the font are dedicated to each function.

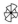

93% Support the Protests

Gender
- 1.5 Other
- 37.5 Female
- 61 Male

Age
- 23.5 24 and Under
- 32.0 Over 45
- 44.5 25 - 44

School
- College 60.7
- Grad School Educated 29.4
- High School or Lower 9.9

Job
- Full-time 47
- Part-time 19.9
- Unemployed 12.3
- Other 10.7
- Full-time student 10

Income
- < $25,000
- $50,000 or Over 30.1
- $25,000 - $49,999 23.3
- 46.5

Politics
- 70.2 Independent / Other
- 27.4 Democrat
- 2.4 Republican

Ethnicity
- 81.2 White
- 2.8 Asian | 1.6 Black / African American
- 6.8 Hispanic / Latino
- 7.6 Other

Jess3
Who Is Occupy Wall St?
2011

Chart breaking down the demographics of the Occupy Wall Street movement by categories such as gender, age, education, employment status, and salary, as well as political leanings. It is based on an analysis of 5,006 surveys collected by Harrison Schultz, who helped develop occupywallst.org, and Héctor R. Cordero-Guzman, from the School of Public Affairs at Baruch College.

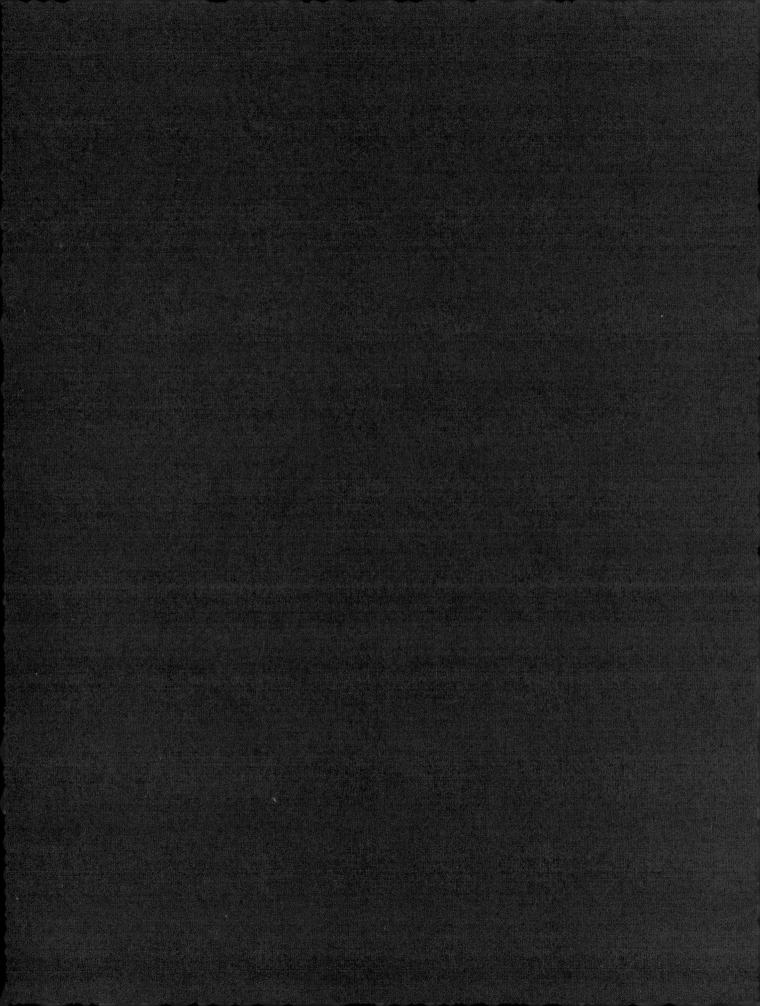

GRIDS & GRATICULES

Li Xuechuan
Jing, ying, shu, yuan, jing (The points of the yang channels)
1817

A Chinese woodcut found in *Zhenjiu fengyuan* (The source of acupuncture and moxibustion). This series of circular diagrams sets out the acupuncture locations for the yang channels in the *gan zi wu* (the traditional Chinese calendar of Heavenly Stems & Earthly Branches). The locations recorded include the *sanjiao* (triple burner), *shaoyang* (channel of the hand), *yangming* (large intestine channel of the hand), *taiyang* (bladder channel of the foot), *yangming* (stomach channel of the foot), and *shaoyang* (gall bladder channel of the foot).

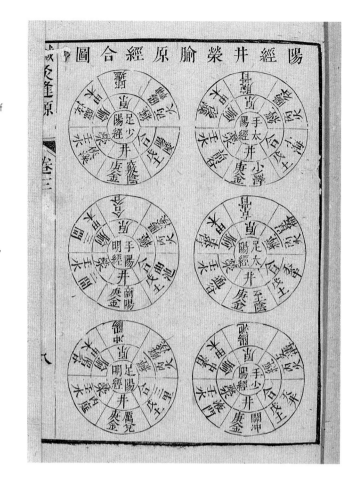

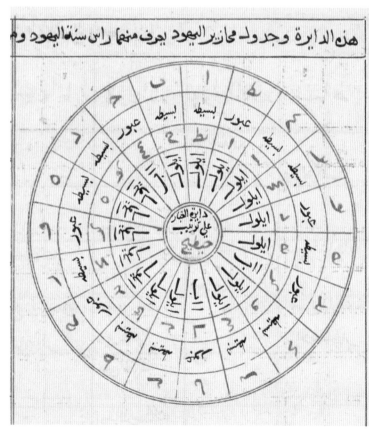

Jamist al-Rumi
The Lights of the Stars
seventeenth century

Illustration based on the *Al-zīj al-jadīd* (the new astronomical tabulations), by Alī ibn Ibrāhīm Ibn al-Shāṭir, a prominent fourteenth-century Muslim astronomer who departed from the traditional Ptolemaic model for astronomy that was prevalent in medieval Europe. His mathematical equations were nearly identical to those used by Copernicus to explain the same phenomena nearly two hundred years later. This illustration shows the four elements (earth, wind, fire, and water) at the center, surrounded by the zodiac signs.

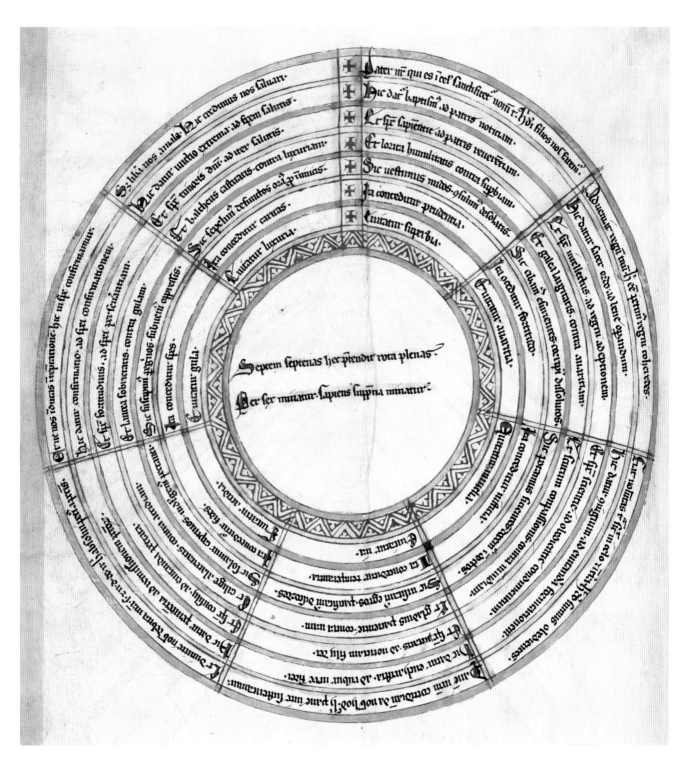

Anonymous
The wheel of sevens
ca. thirteenth century

Illustration from *Speculum theologiae*, exploring a number of Christian theological concepts. Seven concentric rings are divided into seven radial segments. (Saint Augustine ascribed significance to the number seven, associating it with the unification of heaven and earth.) This visual arrangement allows the author to link seemingly disparate ideas. The wheel can be read either horizontally around its concentric rings (each representing a different ecclesiastical sacrament) or vertically by segment (indicating themes reinforced by repetition).

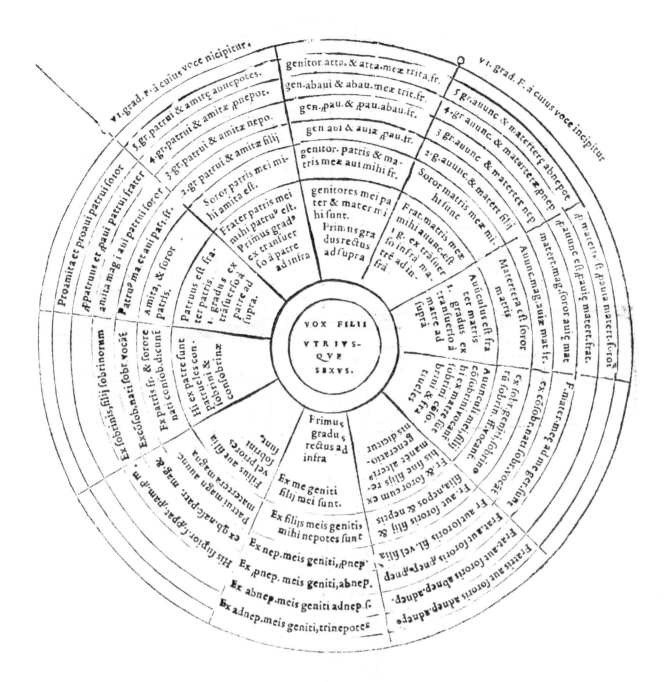

Isidore of Seville
Stemmata Stirpis Humanae
(Pedigrees of the human race)
1577

Illustration from a 1577 reprint of Saint Isidore of Seville's *Etymologiae*, a compendium that summarized and organized hundreds of texts from classical sources. Saint Isidore was the Archbishop of Seville and widely considered to be the last scholar of the ancient world. Here various relationships among generations are shown. At the center is the self; each circle radiating out represents another generation. Segments show different types of relatives (e.g., sons and cousins).

Henry Dawson Lea and
Frederick Hockley
The Wheel of Wisdom
1843–69

Illustration from the book
Five Treatises upon Magic
(1843–69). Frederick Hockley
and Henry Dawson Lea were
nineteenth-century British
occultists who practiced the art
of "crystallomancy," or invoking
spirits by crystals in order
to communicate with them.
This chart displays mystical
hierarchies and was intended
to be used for "magical
operations." Within the wheel
are written names of angels,
sacred signs, plants, and days of
the week.

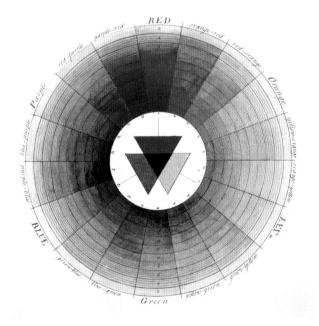

Moses Harris
Prismatic color wheel
1785

Illustration from *The Natural
System of Colors* (1785), by
the English entomologist
and engraver Moses Harris.
First published between 1769
and 1776, this work examines
the science of Isaac Newton;
although only ten pages long, it
had a profound effect on visual
culture. Unlike Newton, who
was concerned with colored
light, Harris wanted to reveal
how different colors related to
each other in the material world.
This color wheel shows how
new colors could be created
from red, yellow, and blue and
is the first explained example of
subtractive mixing: black forms
in the central triangle where
the three primary colors are
superimposed.

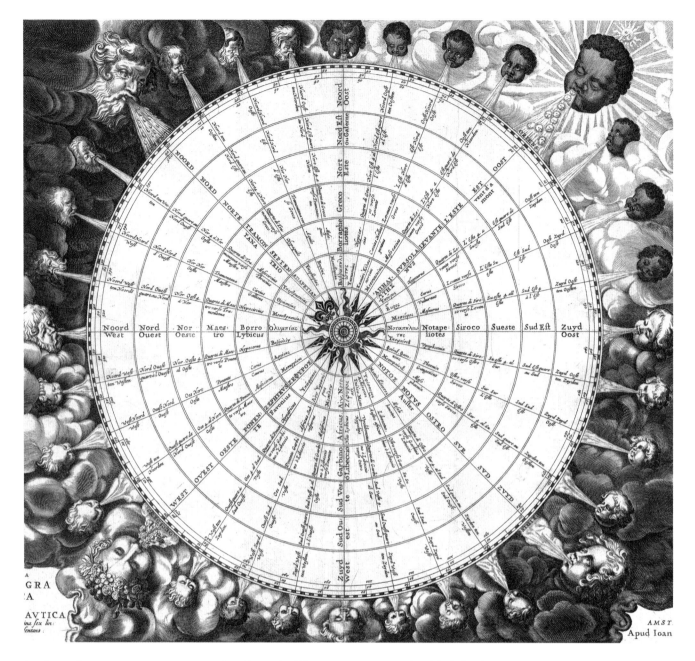

Jan Janssonius
Tabula Anemographica seu Pyxis (Map of the winds)
1650

Anemographic, or wind rose chart. Over the centuries, various wind systems were created and known by different names. The Dutch cartographer Janssonius tried to clarify and organize these competing classifications in this beautiful diagram. Thirty-two winds are shown on the relevant compass points, as well as a degree system, and are labeled with their directional names in Greek, Latin, French, and Dutch. In the area surrounding the sphere, each wind is personified by a figure associated with the represented region.

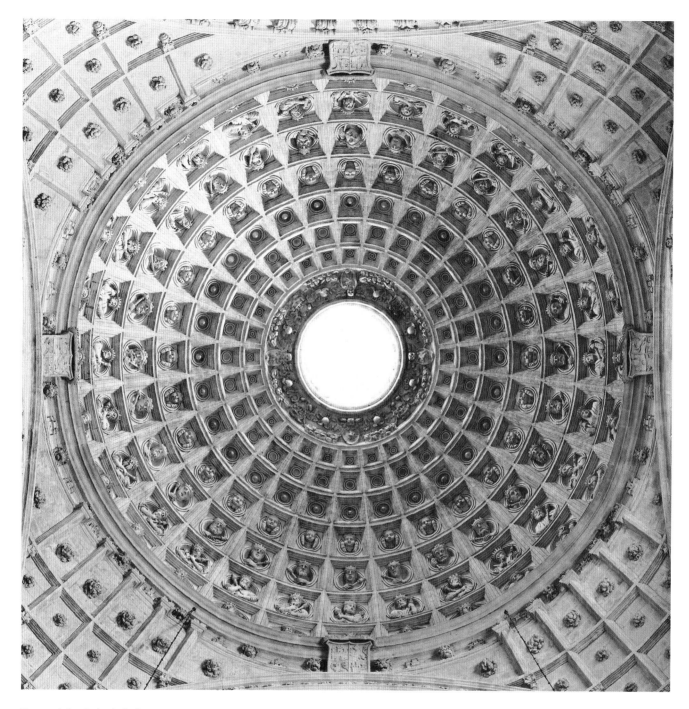

**Dome of the Cathedral of
the Sagrario, Seville, Spain**
seventeenth century

Photograph by David
Stephenson, from *Visions of
Heaven*.

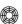

Martin Krzywinski
Charting the Epigenome
2008

Circular chart produced using the software package Circos. The epigenome comprises various chemical compounds that regulate genome activity. This diagram depicts a large number of such compounds, called methyl groups, which are attached to segments of chromosome 22 (one of twenty-three pairs of chromosomes in the human genome). Each concentric ring of bars depicts one of seven types of human tissue where such small molecules can be found, from sperm cells (inner ring) to muscle cells (outer ring). The height of each individual bar indicates the amount of methylation (a form of alkylation) in each methyl group.

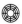

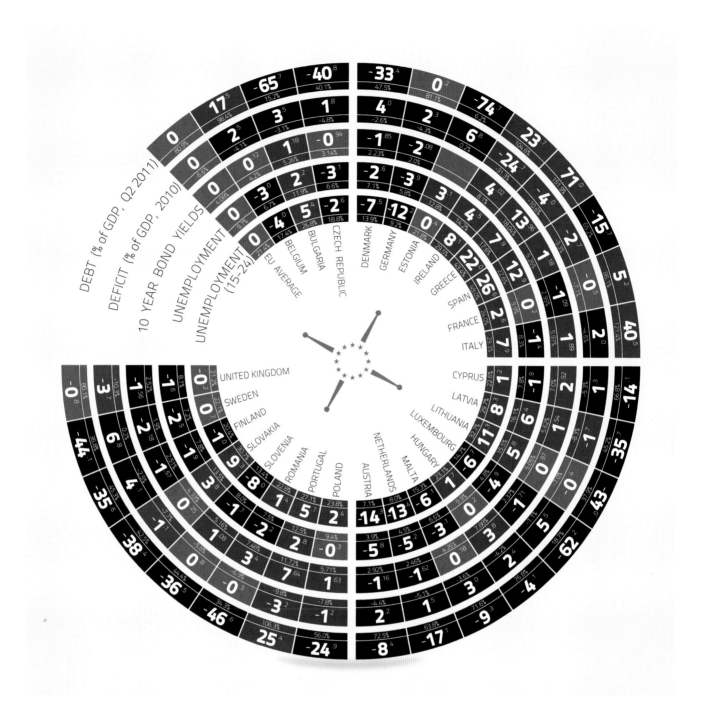

David Farrell
SpecuNations
2011

Visualization representing the political response to the financial crisis in Europe, using gambling as a metaphor. Economic indicators are compared to European averages for easier cross-country comparisons.

Each of the rings represents a different indicator (debt, deficit, ten-year bond yields, unemployment). The first segment shows the European average; each successive segment represents a different European Union country. Tiles are coded by color: green indicates the EU average; black indicates figures above the EU average; and red, those below.

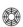

Dead reckoning

Cardiovascular disease claims three out of 10 people as the world's leading cause of death. In wealthy countries, seven people in 10 die aged 70 or over, mainly through chronic diseases. In low-income countries, the predominant cause of death is from infectious disease, where about four in 10 deaths are children under 15 years old

Top 6 causes of death in low-income countries

LRI · IHD · Stroke · Diarrhoea · HIV/AIDS · NN preterm

Top 6 causes of death in high-income countries

IHD · Stroke · Lung C · Self harm · Alzheimer's · Cirrhosis

Ranking of causes of death

Main cause · 2nd · 3rd · 4th · 5th · 6th · 7th · 8th · 9th · 10th · Country

Where are these low-income countries?

Oceania: Kiribati, Vanuatu, Marshall Islands, Micronesia, Tonga, Samoa, Solomon Islands
Caribbean: Dominica, Saint Lucia, Saint Vincent and Grenadines, Grenada, Antigua and Barbuda, Belize
Western sub-Saharan Africa: Guinea-Bissau, Gambia, Sao Tome and Principe
Eastern sub-Saharan Africa: Comoros, Seychelles, Djibouti

Meaning of abbreviations

IHD=ischaemic heart disease
LRI=lower respiratory infections
CKD=chronic kidney disease
PEM=protein-energy malnutrition
NN encephalitis=neonatal encephalitis
NN preterm=preterm birth complications
C=cancer. **HTN HD**=hypertensive heart disease
TB=tuberculosis **CMP**=cardiomyopathies
COPD=chronic obstructive pulmonary disease
NN sepsis=neonatal sepsis **Congenital**=congenital disorders

the **20 poorest countries** in the world

the **20 richest countries** in the world

Alberto Lucas López
Dead Reckoning
2015

Analysis of the world's leading causes of mortality. The twenty richest countries occupy the right side of this chart, the twenty poorest the left. Causes of death can be read vertically up the rings through color-coded tiles (highest incidence at the core and lowest at the periphery). Ischemic heart disease (IHD), illustrated in red, is the main cause for most countries, as visible in the inner ring.

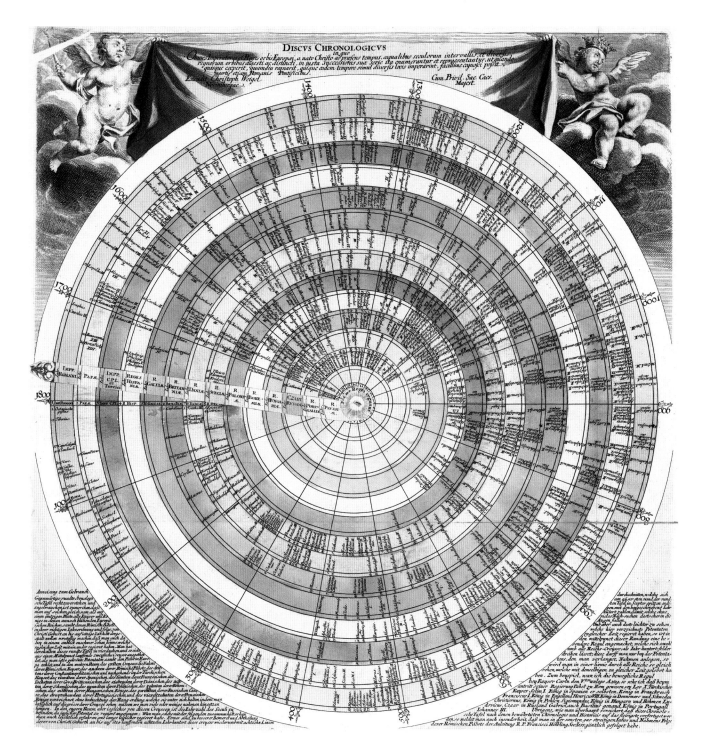

Christoph Weigel

Discus Chronologicus in quo Omnes Imperatores et Reges Orbis Europaei (Chronological disc of all the emperors and kings of Europe)
1730

Explanation of the chronology of the ruling classes of the most important Italian duchies and kingdoms from the year 0 to around 1800, created by the German engraver, art dealer, and publisher Christoph Weigel.

The chart is read chronologically by starting in the mid-left-hand segment of the circle (AD) and moving counterclockwise. Each twenty-degree circle wedge represents a century, while the names of noblemen of fourteen

different nations appear on the corresponding concentric ring. The paper pointer attached to the center provides a key to the families and allows the viewer to easily read who was in power when and in which nation.

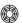

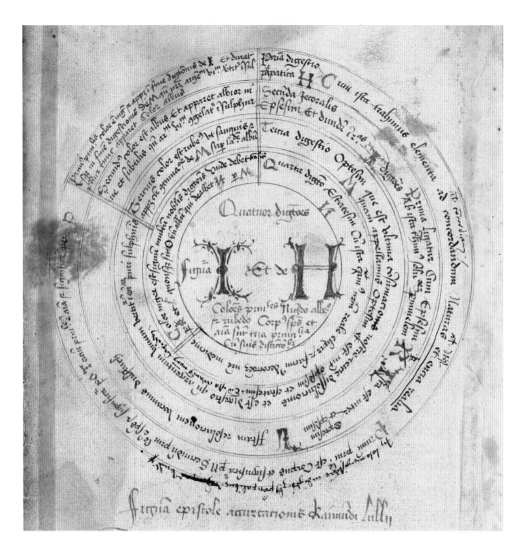

Wang Weiyi (below)
Rules for acupuncture prohibitions
1443

Woodcut from *Tong ren shu xue zhen jiu tu jing* (Illustrated manual of acupoints on the bronze man). Wang Weiyi was an eleventh-century Chinese physician appointed by the government to revise acupuncture textbooks. This diagram composed of four concentric circles graphically represents prohibitions for acupuncture. These prohibitions are established by a complex combinatory system structured according to the phases of the moon, as observed in the Earthly Branches system, a Chinese timekeeping system based on the orbit of Jupiter.

Ramon Llull (above)
Paper machine
ca. 1450

Illustration typical of the mnemonic visual system that Ramon Llull developed as part of his *Ars Magna* (General art). First published in 1305, *Ars Magna* described a new method for integrating different philosophical and religious concepts, for which several visual tools and "paper machines" such as this one were devised. Born in Majorca, Llull was an influential philosopher who translated numerous Arabic sources on alchemy. The concentric discs of this chart are offset to create different combinations of letters, with some variants allowing each ring to rotate as a volvelle. These were then used to create words, phrases, or sequences to aid the memorization of alchemical texts, an idea that was widely copied in later alchemy textbooks.

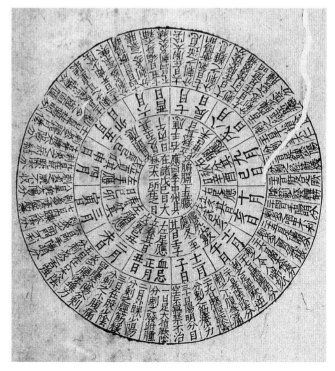

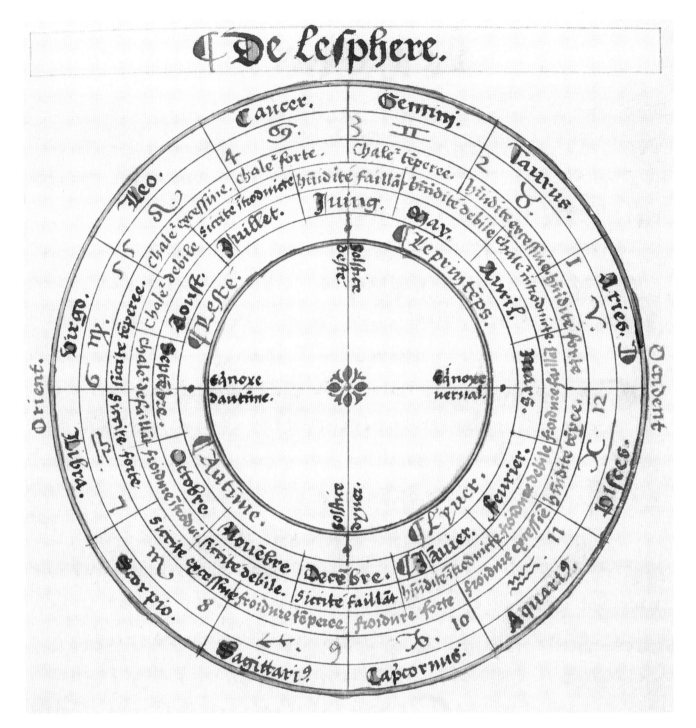

Oronce Finé
Astrological calendar
1549

Circular astrological calendar from the popular astronomy textbook *Le Sphere du Monde* (The sphere of the world), by French mathematician Oronce Finé. "Judicial" astrology, or the art of forecasting events by calculating the relationships of the planets and stars to Earth, was taken extremely seriously during that period; Finé's unfavorable alternate reading of the prince of France's horoscope had landed him in jail in 1524.

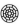

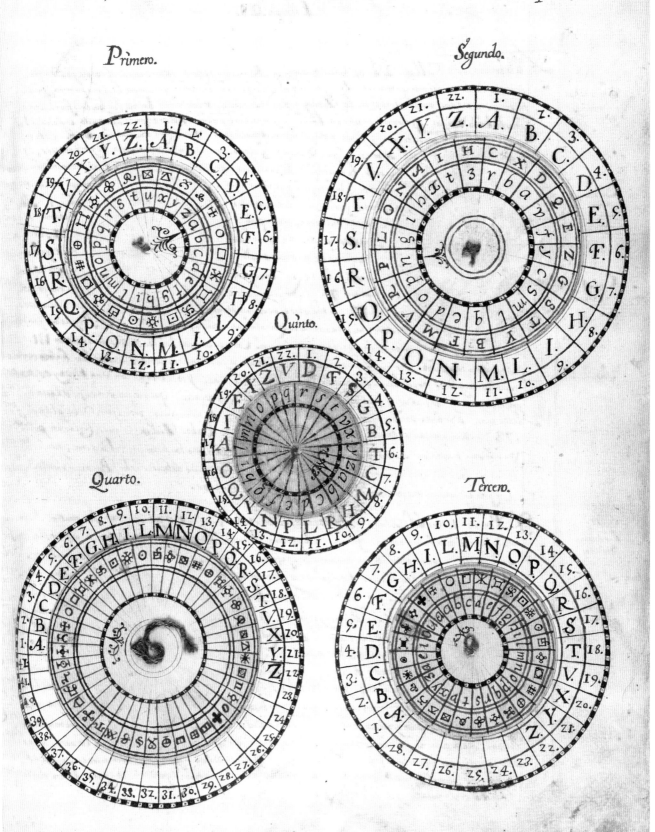

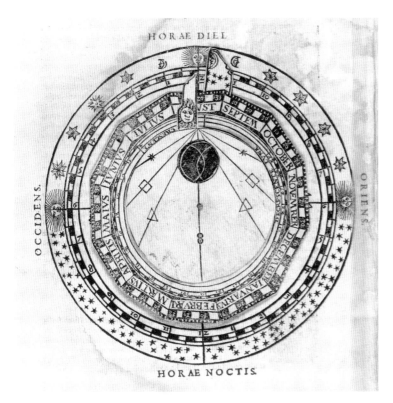

HORAE DIEI

OCCIDENS.

ORIENS.

HORAE NOCTIS

Thomas Blundeville (below)
Rectificatorium Stellae Polaris
(Rectifier of the North Star)
1613

Volvelle from *M. Blundeuile: His Exercises* (1613). This visual mechanism for pinpointing the North Star illustrates a set of navigational tables that preceded it in the manuscript.

Peter Apian (above)
Lunar volvelle
ca. sixteenth century

Lunar clock by the German cartographer Peter Apian. Apian's *Cosmographia* is heavily illustrated and contains information on astronomy, geography, and cartography. It makes use of volvelles, or paper wheel charts, to allow the reader to explore and interact with many of the concepts discussed, such as finding the positions of the sun and planets or calculating latitude using the sun's height above the horizon. In this example, it is possible to move the lunar clock dial in order to calculate the time at night.

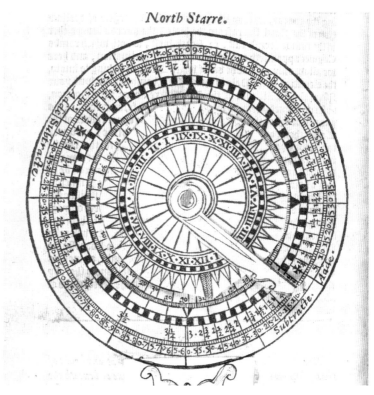

North Starre.

Anonymous (opposite)
Círculos de movimiento
(Circles of movement)
ca. 1600

Illustration of the volvelle's use as an aid for encoding messages,

from *Dos Discursos de la Cifra* (Two works on ciphers). Written by an unknown cryptographer in the early seventeenth century, this work contains descriptions of twenty-four methods for enciphering and deciphering

information using numerous tables, movable sleeves, and grilles. At that time, the volvelle was a common device for creating codes, allowing for a private correspondence between two recipients.

Jussi Ängeslevä and
Ross Cooper
Last Clock
2002

An installation that displays the
history and rhythm of a physical
space. The clock hands receive
live video feeds from various
sources, such as a remote
streaming camera or a direct
local TV signal. As they rotate,
the face displays imagery from
the last minute (outermost
ring), hour, and twelve hours
(innermost ring).

A. SUBJECTS OF CONCERN WHILE FALLING ASLEEP

Loneliness Death Money Bedbugs The New York Knicks

B. LOOKING AT MY CREDIT-CARD STATEMENT MAKES ME ...

Hope the next text is a contract offer from the Yankees.

Concerned about how I will retire by age 34.

Regret buying that limited-edition "Star Wars" VHS boxed set.

Wonder if Donald Trump has ever even eaten instant ramen.

Avoid ads for newfangled gadgets that can do "everything."

Justify getting a bigger TV because it "keeps me company."

Annoyed when stinking-rich people complain about anything.

Whiny, irritable and always thirsty for eight (cheap) beers.

Remind myself how much worse some people have it.

C. THOUGHTS WHILE SCRATCHING A LOTTERY TICKET

I'll take the brownstone with a hoop in the backyard!

Who doesn't need a second laptop just for chatting?

I will spend $100 on albums every week from now on.

You need to have something to give before you give back!

What would I do with all my free time?

Is being "not rich" more punk?

What's a beach house when you have the Internet?

I have everything I need. (Except height.)

Rich or not, there's always a reason to feel bad.

The first thing I will buy is a better brain!

Andrew Kuo
My Wheel of Worry
2010

Radial chart illustrating various personal worries. Twenty-four distinct concerns are given unique colors and grouped in three categories, corresponding to the three concentric rings. The inner ring depicts five subjects of concern while falling asleep, such as money, loneliness, and bedbugs. The two outer rings are related to thoughts while looking at a credit card statement and while scratching a lottery ticket.

Martin Krzywinski
Circos
2009

This chart is part of a tutorial on how to use the software package Circos to depict a set of concentric, stacked bar plots. Each ring matches several data points, normalized for this experiment, out of a total of twenty-seven random data sets. Color relates to a unique ID assigned to each individual data value.

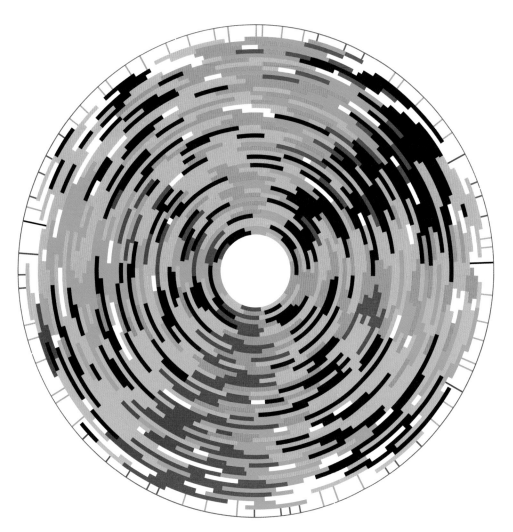

Joshua Kirsch
ACP Donor Wheel
2008

A conceptual drawing for an interactive installation that showcases the names of Arts Council of Princeton donors. The names of two thousand donors are arranged alphabetically in this sculpture for the Paul Robeson Center for the Arts in Princeton, New Jersey. The viewer can explore contributions by selecting a letter of the alphabet on a keypad, which then highlights all the corresponding names in white LED lights.

Lola Migas and Ryan Diaz
*Chromapoems—I Have
a Dream*
2010

Diagram from *Chromapoems*, a
series of images analyzing the
language used in poetry and
writing, made with the software
package Processing. Each ring
begins at a line break (the end
of a line in poetry or the end
of a paragraph in prose), and
each block represents a word.
Blocks of a similar hue are
from the same sentence. Each
letter is assigned a saturation
value based on its frequency
of use: the more uncommon
the letter, the higher the value
and the more saturated a
block becomes. This particular
execution is the representation
of Martin Luther King Jr.'s
"I Have a Dream" speech.

Zhang Shixian
Tuzhu nanjing maijue (The "Classic of Problems" and "Verses on the Pulses" annotated and illustrated)
1510

Woodcut from China's Ming period (1368–1644), featured in the two classics of Chinese medicine. This diagram uses graphic techniques to explain the problems set out in *Huang Emperor's Canon of Eighty-*

One Difficult Issues (late Han dynasty, ca. second century AD). The twenty-seventh problem ("on parting and meeting of true and vicious energies") is illustrated here by showing the twelve internal channels of energy distribution of the body (jingmai zai li), comprising six channels for the arm and six for the leg (with three yin and yang channels per limb) and, finally, the eight extraneous channels (qijing bamai).

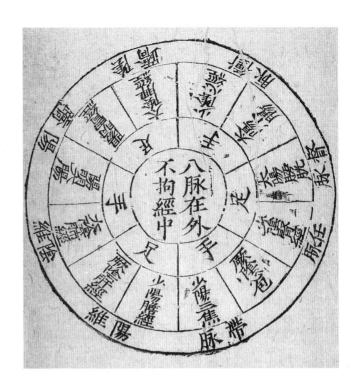

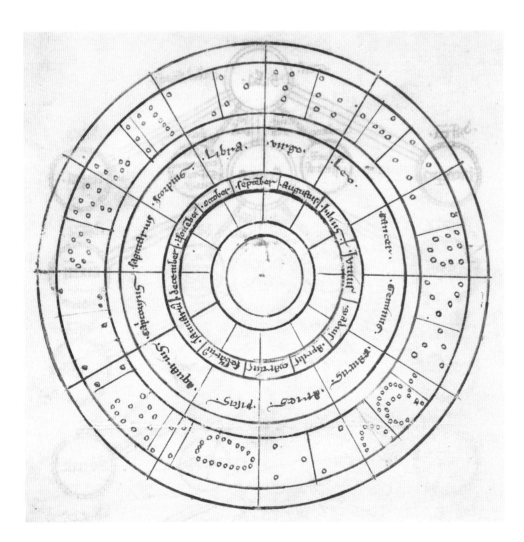

Gerard of Cremona
Canones Arzachelis in Tabulas Toletanas/Theorica Planetarum (The Toletanas tables in the Arzachelis canons/Theory of the planets)
fourteenth century

Astrological chart translated from the work of Iban al-Zarquala (or al-Zarqali), an Arabic astronomer from Córdoba, Spain. Gerard of Cremona was the translator of more than eighty-seven scientific books from Arabic into Latin, popularizing new and lost mathematical and astronomical concepts.

Christina Bianchi, Anna-Leena Vasamo, and Bryan Boyer
Ageing in Helsinki
2010

Draft diagram that constructs a 360-degree map of all individuals who play a part in caring for the elderly in Helsinki, Finland. It places an individual at the center of a complex network that radiates outward through different systems of support at private, community, city, and national levels. The slices of the pie represent categories keyed to Maslow's hierarchy of needs in order to include nontraditional resources such as sports and cultural organizations.

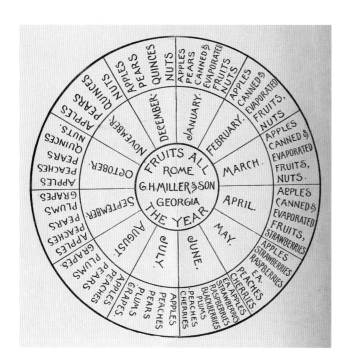

Anonymous
Fruits All the Year
1890

A radial chart featured in the catalog *Wholesale Trade List of G. H. Miller & Son* (1890). In the catalog, it bears the caption: "The above diagram illustrates how the farmer, suburban resident, with only a small tract of land may have a full supply of health-giving fruits during the entire circle of the months.... A little study of this diagram and of this catalogue will show you what varieties to plant to secure for yourself and family fruits all year."

Stephen Watkins Clark
Etymological Chart of the English Language
1847

Designed to accompany Stephen Watkins Clark's *A Practical Grammar* (1847), a diagram breaking down the English language into its various constituent parts, including subject, predicate, and object, primary and secondary adjuncts. The explosion of literacy in the nineteenth century (in part due to the printing press and educational reforms) meant that such guides were extremely popular.

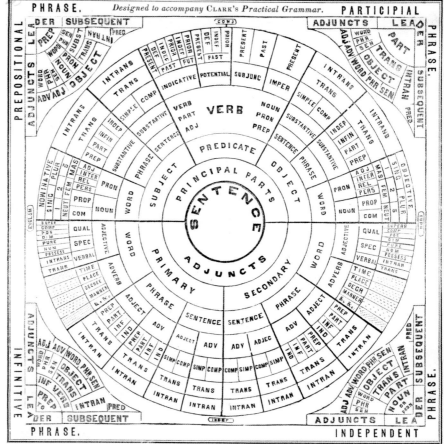

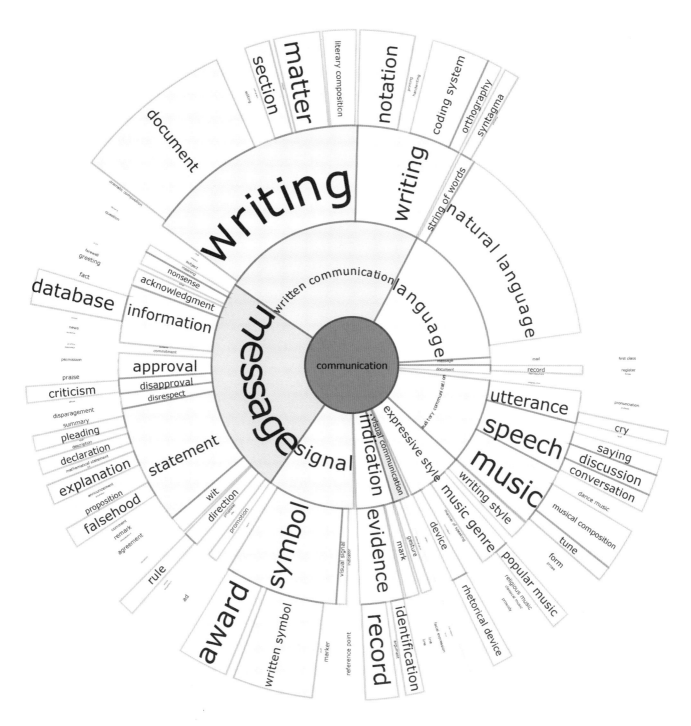

Christopher Collins, Sheelagh Carpendale, and Gerald Penn
DocuBurst
2008

Sunburst visualization of a text document. DocuBurst creates visualizations that analyze the semantic content of a text document by comparing word frequency with a lexical database. It displays the hierarchical structure of hyponyms, specific words or phrases whose semantic meaning is encompassed by that of a common general class (e.g., *bed* is a hyponym of *chair*, since both are part of the higher category "furniture"). The resulting diagrams are overlaid with occurrence counts of words in a given document, providing visual summaries at varying levels of detail. Interactive document analysis is supported by geometric and semantic zooming, the ability to focus on individual words, and links to the source text.

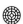

Pop Chart Lab
The Charted Cheese Wheel
2013

A diagram of sixty-five popular cheese varieties, grouped by their texture (soft, semi-soft, semi-hard, hard) and producing animal (cow, sheep, goat, buffalo). Cow cheeses constitute the large majority, with common varieties such as cheddar and Brie.

EDITED
Color Chart
2015

Visualization depicting the fall
2015 season in fashion through
a breakdown of all colors from
each garment shown during
Fashion Week in London,
Milan, Paris, and New York.
EDITED is a fashion analytics
company that helps retailers
identify trends and select
products. It uses proprietary
color-recognition software to
analyze the multitude of colors
shown at fashion shows across
the globe.

Deroy Peraza (Hyperakt)
The Champions Ring
2012

Chart depicting the knockout
stage of the 2010 World
Cup, starting with the sixteen
qualifying teams in the outer
ring, leading to the final
between the Netherlands and
Spain and the ultimate winner,
Spain, at the very center of
the diagram.

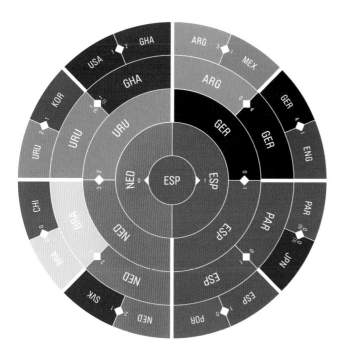

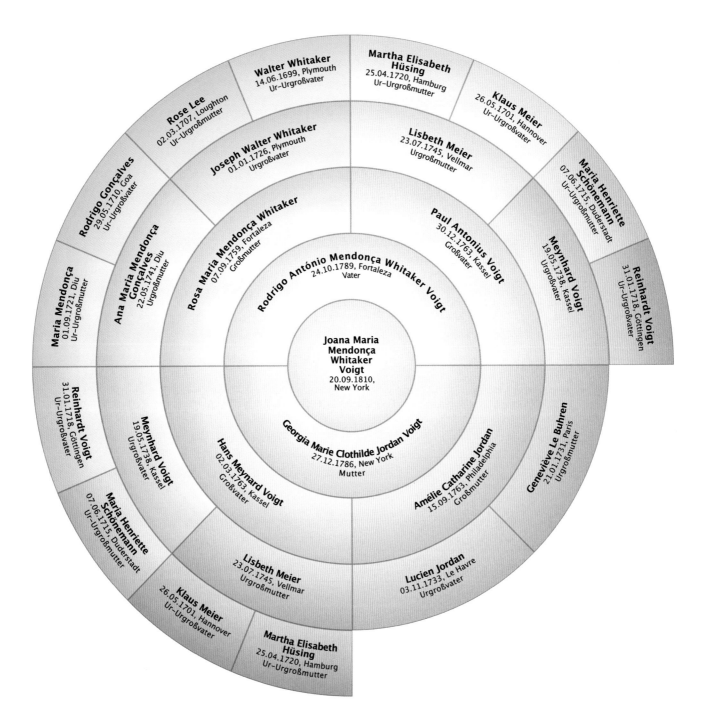

Mendel Kucharzeck and
Stefan Sicurella
MacFamilyTree 6
2010

Sunburst chart showing the
ancestry of Joana Maria
Mendonça Whitaker Voigt
(born September 20, 1810).
Created by Synium Software,

MacFamilyTree is a flexible gen-
ealogy application that allows
users to enter genealogical
data over a span of up to one
hundred generations. The
resulting structures can be dis-
played in a variety of formats,
including descendant charts,
hourglass charts, and sunburst
(fan) charts.

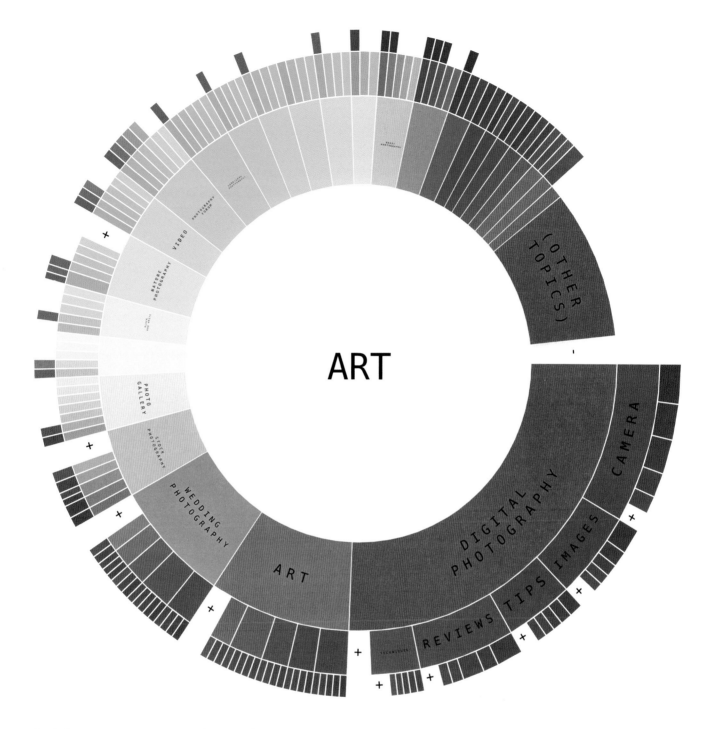

ART

(OTHER TOPICS)

VIDEO

PHOTOGRAPHY FORUM

NATURE PHOTOGRAPHY

PHOTO GALLERY

STOCK PHOTOGRAPHY

WEDDING PHOTOGRAPHY

ART

DIGITAL PHOTOGRAPHY

CAMERA

IMAGES

TIPS

REVIEWS

Marcin Ignac
Carrot² clusters
2008

Part of an interactive sunburst
visualization of search results
from the Carrot² clustering
engine. The chart depicts the
hierarchical structure of clusters
for the searched term *art*. The

innermost ring represents root
clusters or branches, while the
succeeding radial ranks depict
various subclusters. The size of
each cell on a ring indicates the
number of documents in that
cluster or category. Diagrams
are interactive; users can unfold
minor categories and zoom into
clusters to explore deeper levels.

EBBS & FLOWS

Valerio Pellegrini
Magnolia si fà in tanti
(Magnolia is done by many)
2013

Organizational chart of Italian company Arci Magnolia, created to show its hierarchies and competencies in one single view. The center of the circle shows the various skill sets within the organization, which are mapped by color (e.g., administration is represented by purple, communication by orange, and Web services by gray). The numbers in the inner ring represent twenty-six managers, arranged alphabetically in a clockwise fashion, while the outer ring consists of the names of those who report directly to them.

Valerio Pellegrini
Schooling Radar
2014

Map of the education landscape in various African countries. These countries are represented on the outer ring; the size of the circle next to each represents the average number of years spent in school (largest indicating the longest time). Inside this ring is a separate visualization that shows male (light blue) and female (orange) youth literacy rates as a percentage, with 0 percent at the core and 100 percent at the edge of the circular grid. The visualization was created for the *AFRICA—Big Change / Big Chance* event at Triennale di Milano, an exhibition on architecture and changes taking place on the African continent.

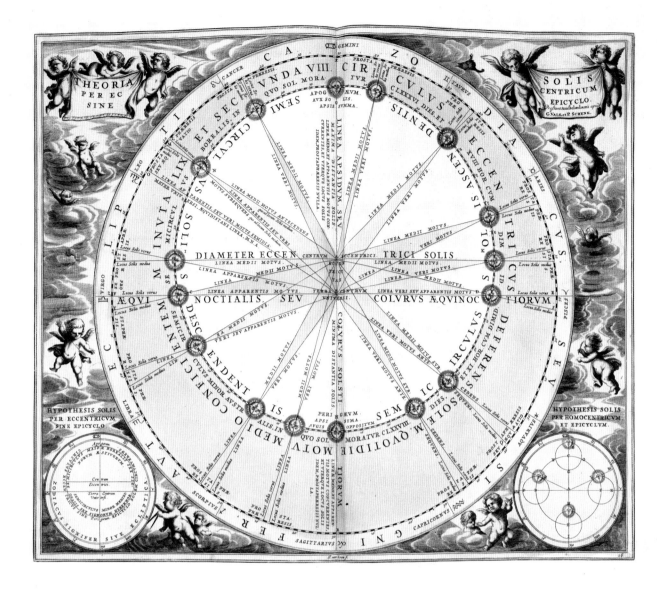

Andreas Cellarius

Theoria Solis Per Eccentricum Sine Epicyclo (Representation of the sun in an eccentric orbit without epicycles)

1660

Map from the *Harmonia Macrocosmica* (1660), a star atlas written by the Dutch-German cartographer Andreas Cellarius. This image illustrates the presumed orbit of the sun around the earth, based on the geocentric world system of Claudius Ptolemy. Plotted within the zodiacal circle, the unconventional off-center orbit of the sun tries to shed light on the difference between the fall-spring equinox interval (187 days) and the spring-fall equinox interval (178 days). Today, we know this discrepancy is due to the inconsistent speed of the earth as it orbits, moving faster when closer to the sun.

Nicolas Flamel
Zodiac chart
ca. 1680

Illustration of the zodiac
in relation to a particular
alchemical process, from a
treatise by Nicolas Flamel
on alchemy and astronomy.
A French alchemist and
manuscript seller, Flamel came
to prominence posthumously
for supposedly uncovering
the philosopher's stone and,
according to legend, attaining
immortality.

Anonymous
Map compass
ca. 1560–64

Compass created by an
unknown Venetian cartographer,
part of the *Isolario* (1560–64),
an atlas that maps the islands
and coastal regions of the
Mediterranean.

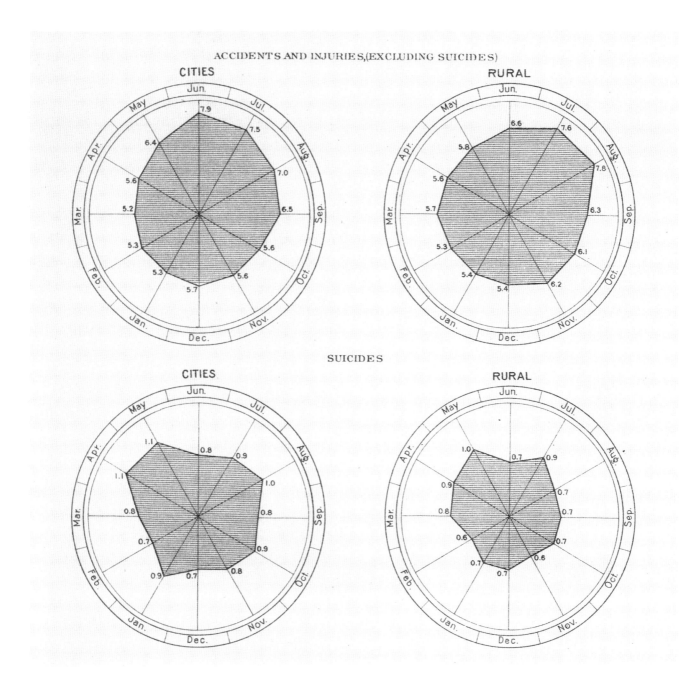

Henry Gannett

Death rates from accidents, injuries, and suicides
1903

Published by the US Census Office at the turn of the twentieth century, a visualization that maps the rate of death by accident and injury (top two charts) and suicide (bottom charts) by month, for cities and rural districts of the registration states in 1900. This diagram is an example of a radar chart, a type of plotting that can show one or more series of values over three or more axes, arranged radially as spokes around a central point.

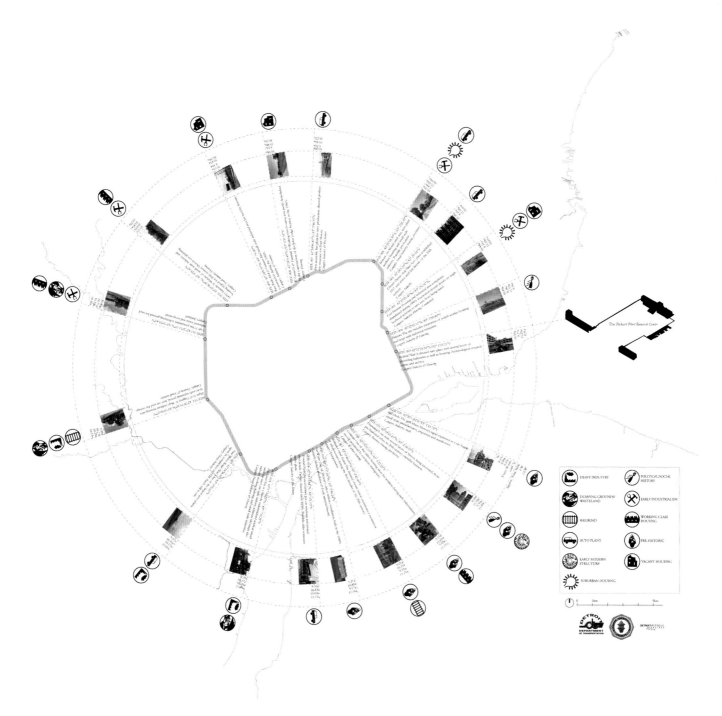

Hannes Frykholm
Detroit Archaeology Train
2012

A project in which the Swedish architect Hannes Frykholm speculated how future generations might uncover and excavate the twentieth century. This visualization maps a number of possible archaeological excavation sites in relation to the existing railway system in Detroit. With help of the legend, viewers can create a themed itinerary for a potential visit suited to their historical interests.

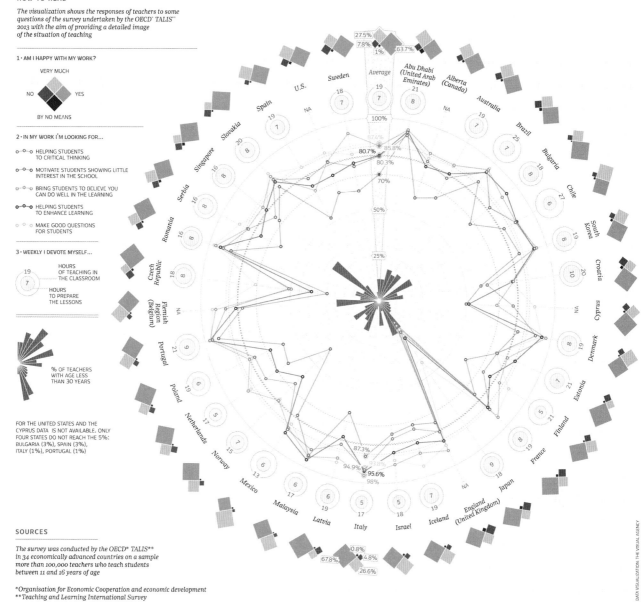

Francesco Roveta and
Benedetta Signaroldi
(The Visual Agency)
Who Are Our Teachers?
2014

Diagram graphing the
responses of more than one
hundred thousand teachers to
a survey on teacher-student
engagement conducted by the

Organisation for Economic
Co-operation and Development.
It charts the happiness levels
(outer ring), hours worked
(inner circles), and motivations
(plotted lines) of teachers
from thirty-four economically
advanced countries. The
central starburst displays the
percentage of respondents
under the age of thirty.

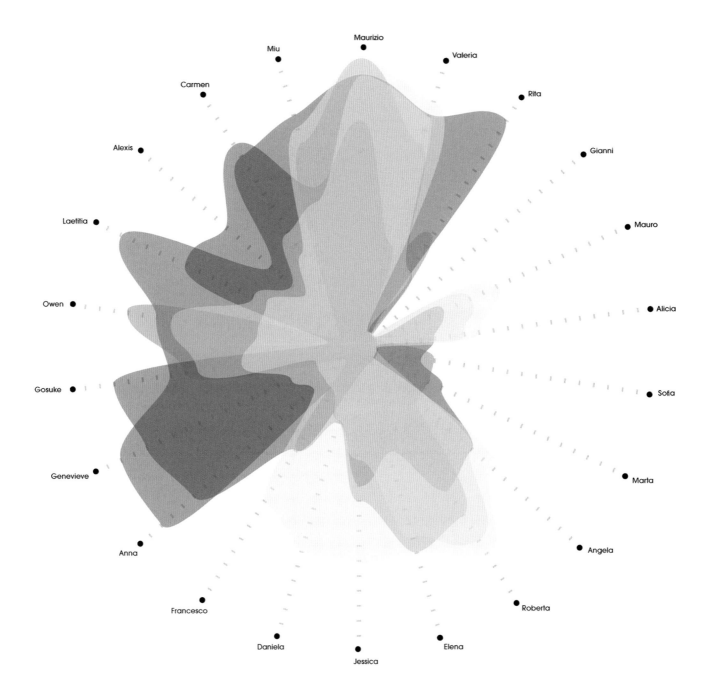

Valentina D'Efilippo
Relationship Matters
2009

Visualization of some of
the more intangible and
unquantifiable qualities of
the life of graphic designer
Valentina D'Efilippo.

This diagram categorizes
conversations D'Efilippo has
had with various people, who
are mapped around the outer
edge of the circle. Topics
are represented by semi-
transparent layers, with different
colors showcasing interesting
overlaps (pink representing

topics involving fashion
and photography; maroon:
university and job; olive: politics
and the economy; dark blue:
design and art; light blue:
movies, books, and music; and
yellow: clubbing, travel, and
entertainment).

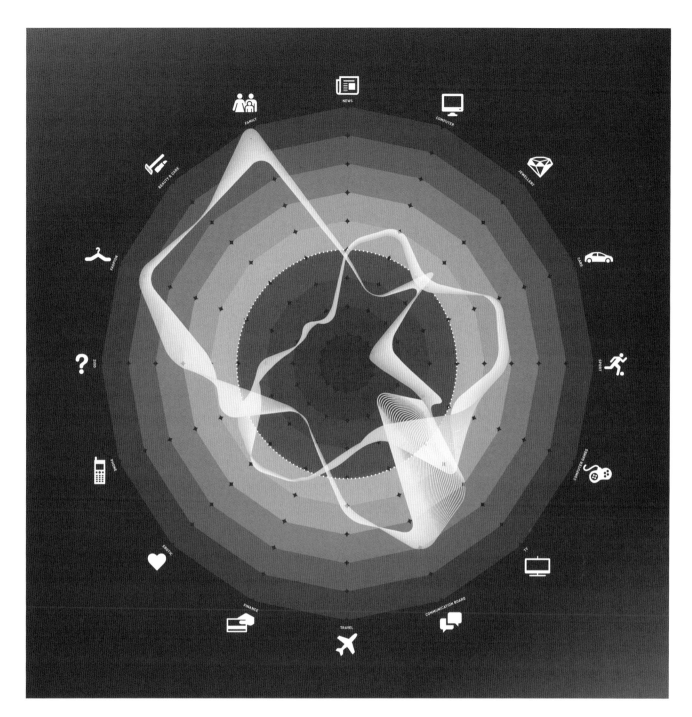

Jan Schwochow (Golden
Section Graphics)
How We Surf
2012

Comparison of online usage
among different audiences,
organized by demographic
categories (e.g., gender, age,
and education level) and
commerce sectors. These vis-
ualizations are built on the
technology and methodology of
the data-management company
nugg.ad.

Katrin Süss
(Richard Wagner's) Lohengrin
by Franz Liszt
2014

Etching, 17 × 17 inches
(43 × 43 centimeters).

Stefanie Posavec and
Dare Digital
MyFry
2010

The mobile app edition of actor
Stephen Fry's autobiography
The Fry Chronicles. It allows
the reader to engage with the
text through a visual index of
key themes: people, subjects,
emotions, and "Fryisms," each
of which is color-coded (e.g.,
love is shown as magenta and
comedy as orange). The overall
structure is visualized through
a circular wheel of spines, each
of which represents a section of
the book.

Henry Lindlahr
Iridiagnosis and Other Diagnostic Methods
1919

Taken from a medical textbook on diagnostic techniques involving the iris, an illustration of the effect on the iris of a variety of illnesses, from arsenic poisoning (figure b) to "acute nervous disorder" (figure e).

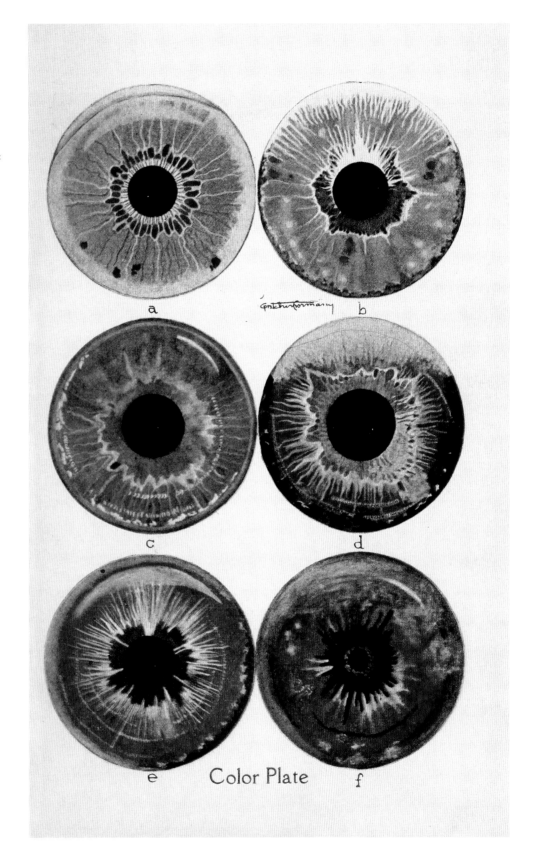

Color Plate

Doug Kanter and D'Arcy Saum
The Healthiest Year of My Life
2012

Created by designer Doug
Kanter to help monitor his type
1 diabetes, a visualization that
shows every diabetes-related
data point he collected in 2012,
including more than ninety
thousand blood-sugar readings
and thousands of insulin doses.

The image is read clockwise,
with each line representing
one day. Blood-sugar readings
are shown by color: low blood
sugar in warmer tones, in-range
readings in white, and high
blood-sugar readings in cooler
colors. Along the outside, black
lines correspond to the distance
the designer ran throughout
the year, which peaked in
November with a marathon.

Thomas Clever, Gert Franke, and Jonas Groot Kormelink (CLEVER°FRANKE)
Weather Chart 2012
2012

Comparison of weather data provided by the Dutch Meteorological Institute and more than 710,000 posts in social media about the weather, to establish whether a correlation exists between the two. The visualization shows a ring of 365 days, on top of which are superimposed graphs of weather elements such as sunshine or rain. The size of the gray bubbles indicates the quantity of social media messages about the weather, and their placement on the line of the day indicates the average sentiment on a scale of one to ten, with ten being the most positive.

Giorgio Uboldi and Michele
Mauri (DensityDesign); Cristina
Perillo and Iolanda Pensa
(lettera27)
*Share Your Knowledge—
Artgate*
2011

A project carried out between
September and November 2011
that encouraged organizations
to create and expand Wikipedia
entries. This visualization poster
shows a number of Wikipedia
pages that were created
and modified as part of the
project, displayed radially in
alphabetical order. The first ring
represents the share of new
pages created and old pages
modified during the project; the
second ring shows the number
of page views for each page.
Finally, a stacked bar chart
represents the number of bytes
edited: red edits are by users
involved in the project, whereas
blue edits are by other users.

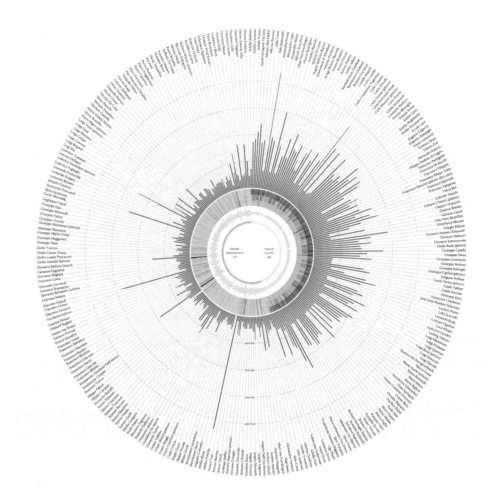

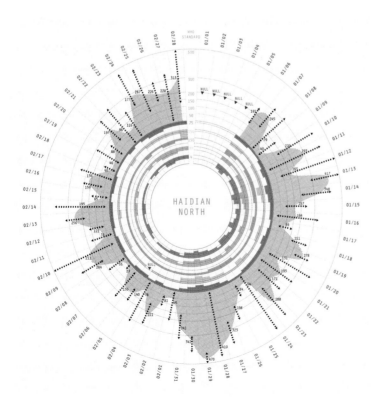

Abby Chen
Air Quality Beijing
2013

Chart recording the air quality
of Beijing over the course of
sixty days. Five principal air
pollutants are represented by
five color-coded inner rings:
PM 2.5 (red), PM 10 (yellow),
sulfur dioxide (brown), nitrogen
dioxide (green), carbon
monoxide (purple). The lined
gray pattern depicts the daily
average of the air quality index,
while the dotted arrows indicate
the air quality index minimum
and maximum values for each day.

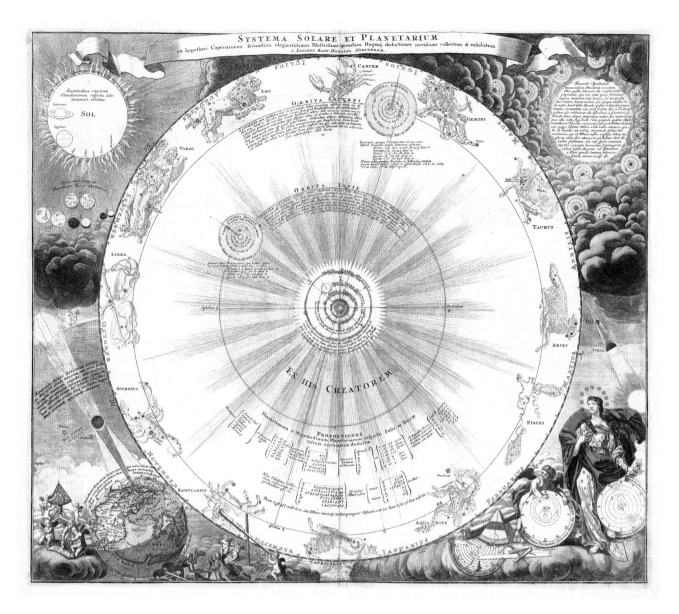

Johann Baptist Homann
Systema Solare et Planetarium
Ex Hypothesi Copernicana
(Solar system and planetarium
according to the Copernican
hypothesis)
1716

Chart showing the Copernican
model of the universe.
Johann Baptist Homann
was a renowned German
cartographer, appointed

Imperial Geographer by the
Holy Roman Emperor Charles
VI in 1715. This map is included
in his masterwork, *Grosser Atlas*
ueber die ganze Welt (Grand
atlas of all the world). At the
center is the sun, orbited by the
known planets, with the twelve
constellations of the zodiac in
the outermost ring. The lower
left-hand corner shows Earth at
the time of the solar eclipse of
May 12, 1706.

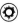

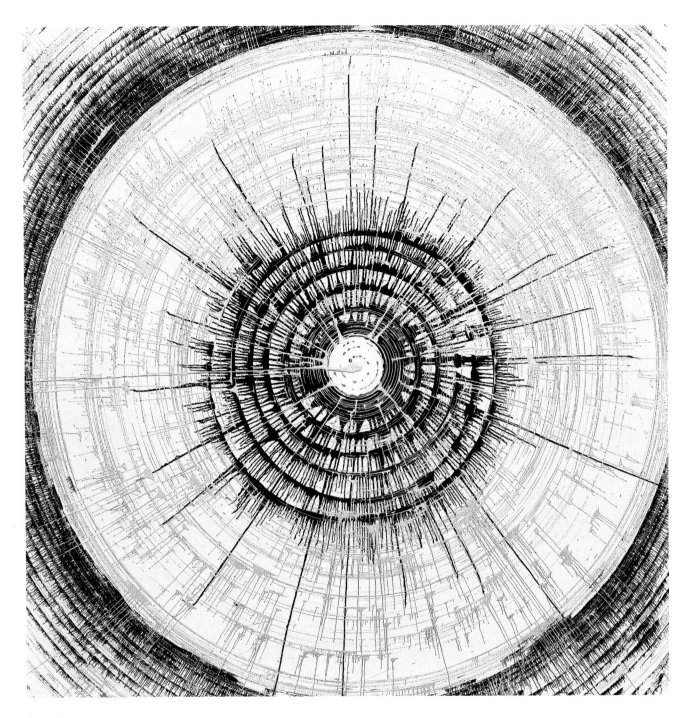

Syma Art
Evil Eye
2012

Oil on canvas, 27.33 × 27.33
inches (69.5 × 69.5 centimeters).

The Luxury of Protest
(Peter Crnokrak)
A_B Peace & Terror etc. The Computational Aesthetics of Love & Hate
2008

Visualization of the ways in which each of the 192 member states of the United Nations contributes to peace and terror in the world. The project is a dual-sided poster: the A side, shown here, displays measures of peace, while the B side shows measures of terror. The graph follows the same format on both sides, with three rings that represent individual quantitative measures obtained from researchers working on geopolitics. Variations in these metrics are represented by line width: thicker lines have higher values.

Marcin Plonka
Typeface classification poster
2009

Radial diagram dividing a selection of font classics into seven major classification groups, listed at the core: Serif Old Style (fonts such as Garamond or Lucida), Serif Modern (Didot or Century), Sans Geometric (Century Gothic or Futura), Slab Serif (Clarendon or Rockwell), Sans Humanist (Optima or Formata), Serif Transitional (Georgia or Baskerville), and Sans Neo-Grotesque (Arial or Helvetica).

Andrea Codolo and
Giacomo Covacich
*Il fiore dell'istruzione. Un
po' appassito* (The education
flower. A little withered)
2012

A visualization of educational
standards in thirty-four countries
across the world, based on
data from the Organisation
for Economic Co-operation
and Development report
Education at a Glance 2012.
The colored petals show level
of education according to age
and diploma type, while the
pistils and stamen show annual
expenditure per student and
the investment in education,
respectively.

Manuel Bortoletti, Daniela
Bracco, Francesca Rossetto,
Paola Santoro, and Erica Zipoli
*Dati inconsci—Un confronto
alla luce del sole* (Unconscious
data—a daylight comparison)
2014

Chart displaying an overview
of sleep patterns through a
single night from data the
designers collected on their
own phones. The four lines,
plotted clockwise, represent
the sleep cycles of the four
participants. The lines fluctuate
on a vertical axis between deep
sleep (low) and light sleep (high)
and are arranged around a circle
comprising eight hours.

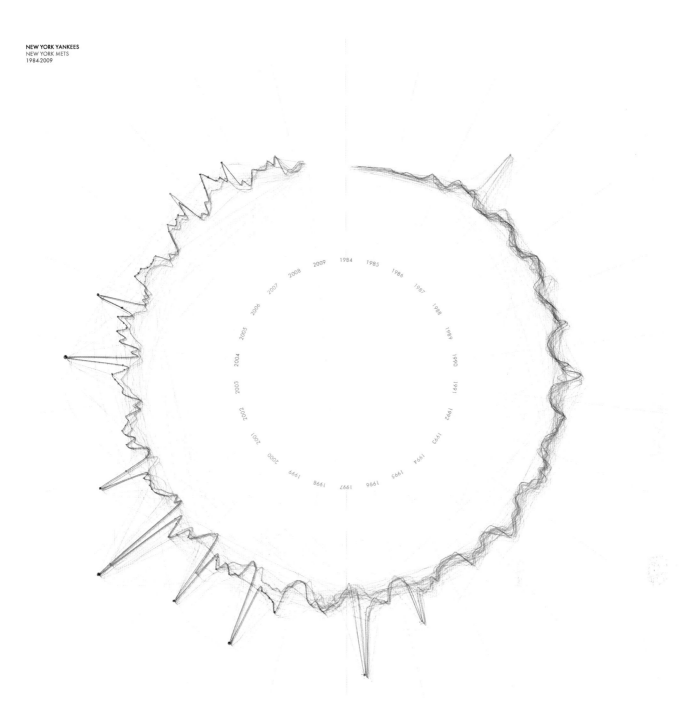

Jer Thorp
New York Times Threads—
Yankees vs. Mets
2009

A chart mapping how often two baseball teams were mentioned in the *New York Times* between 1984 and 2009: the New York

Yankees (blue) and New York Mets (orange). Each line represents an individual story. Color indicates prominence, with the darkest lines representing front-page stories and lighter ones registering mentions in other sections.

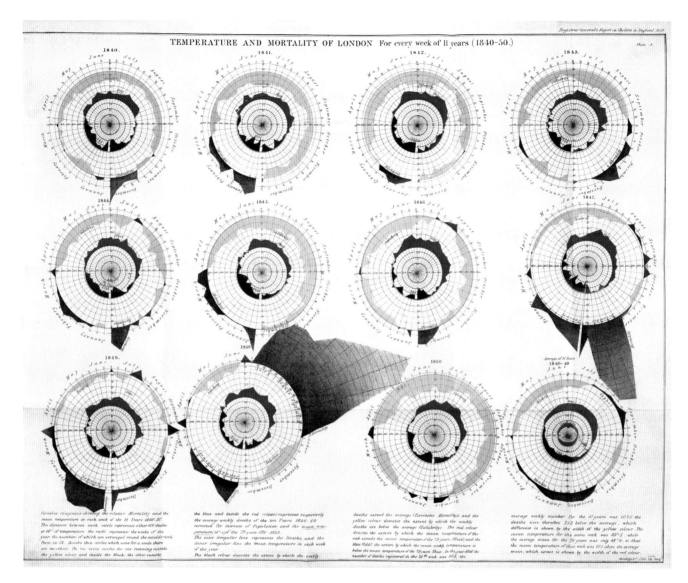

William Farr

*Temperature and Mortality
of London*

1852

Chart by William Farr, a
nineteenth-century British
epidemiologist who is regarded
as one of the founders of
medical statistics. Featured
in *The Report on Mortality of
Cholera in England* (1852), it
displays the temperature and
mortality rate in London for
every week over the course of

eleven years (1840–50). In each
individual chart, black shading
in the outer ring denotes the
amount by which weekly deaths
exceeded the average, yellow
the amount by which they were
below the average. The red
color in the inner ring shows
how much the mean weekly
temperature exceeded the
mean temperature of the years
1771–1849; the solid black
shows how much the mean
weekly temperature was below
that for the same period.

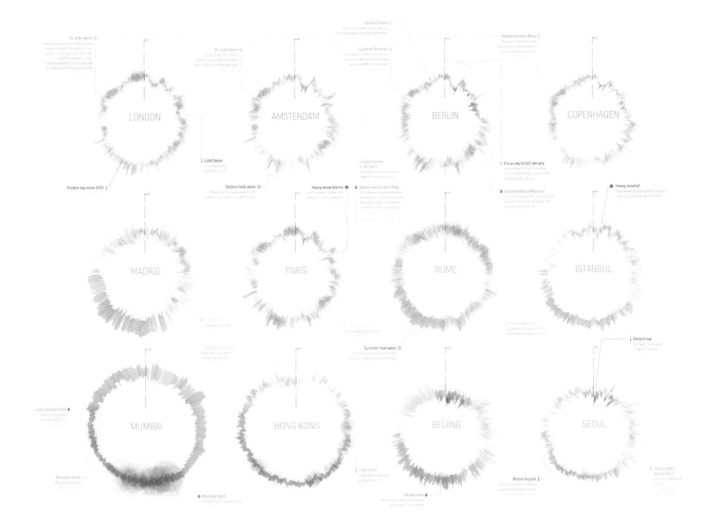

Timm Kekeritz (Raureif)
Weather Radials 2013
2014

Project investigating the impact of heat waves and snowstorms in thirty-five cities around the globe. Each city is presented as a ring, with its climate characteristics visualized so that the viewer can easily spot any unusual weather events.

The closer a temperature line is positioned to the center of the circle, the colder the minimum temperature of each day; similarly, the farther away the line is, the warmer the maximum temperature. Color indicates the daily mean temperature (reds being warm and blues being cold). Precipitation is represented as a circle, with size proportional to amount.

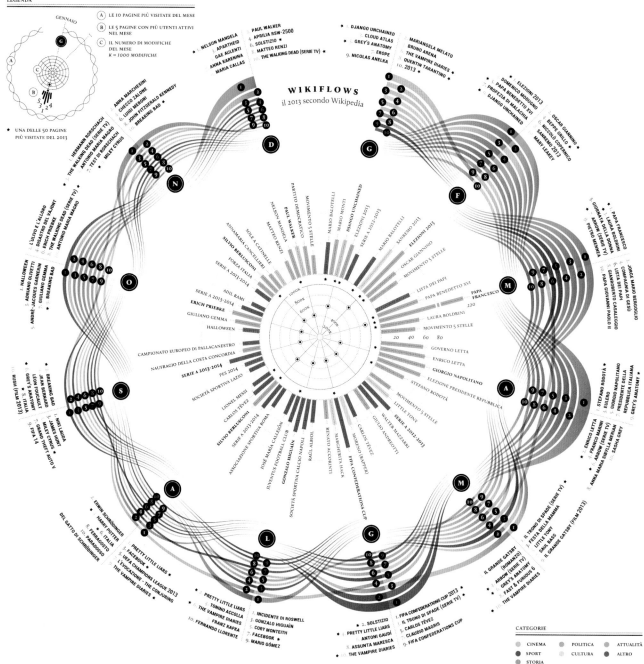

Valerio Pellegrini
Wikiflows—One Year on Wikipedia
2014

Diagram of page views and edits on Italian Wikipedia in 2013, divided into three layers. The center shows overall edits of Wikipedia; the inner ring shows the five pages with the most editors; and the outer ring shows the most-visited pages. The colors represent topic categories: cinema, politics, current events, sports, music and culture, history, and miscellany. Months are radially distributed (the letters refer to the initials of each month in Italian: *G* for January, *D* for December).

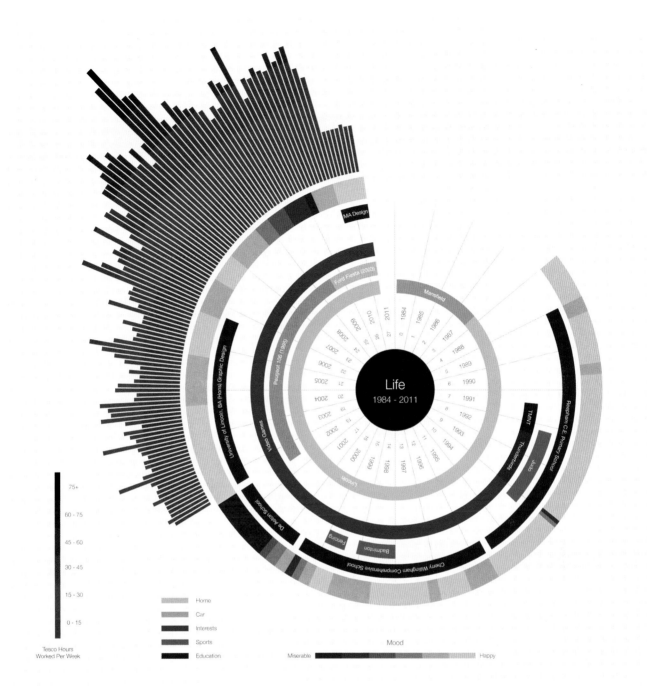

75+

60 - 75

45 - 60

30 - 45

15 - 30

0 - 15

Tesco Hours
Worked Per Week

Home

Car

Interests

Sports

Education

Mood

Miserable Happy

Ben Willers
Life in Data
2011

Self-quantification project
compiling data associated with
the author since birth. Starting
from the center, the rings show
the locations in which he has

lived, his interests, the cars he
has owned, the sports he has
played, and the educational
institutions he has attended.
The outermost ring shows
happiness, while the protruding
lines represent the hours he
worked in the supermarket
Tesco.

Jaeho Lee, Dongjin Kim,
Jaejune Park, and
Kyungwon Lee
*Flow Circle: Circular
Visualization of Wiki Revision
History*
2013

Diagram charting the revision
history of the Wikipedia
page for "gun politics." The
visualization tool Flow Circle
bases revision histories on
snapshots of a page in various
stages of its development
and maps different types of
relationships among authors of
the article.

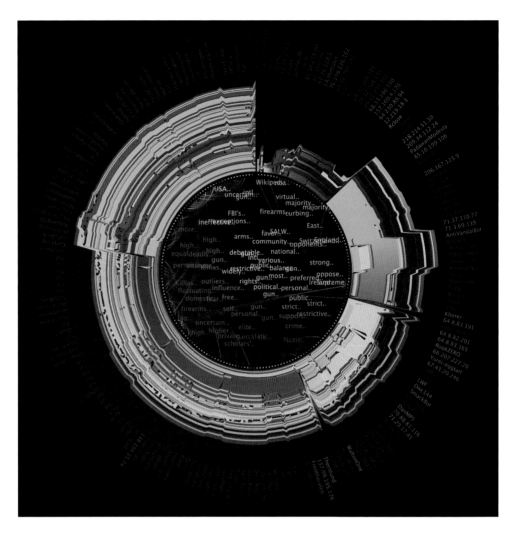

Rayz Ong
37min Busride
2009

Visualization of the
demographic data collected
from a single thirty-seven-
minute journey the designer
took on bus number 174
in Singapore. Information
such as the other riders'
ethnicity (Chinese passengers
represented by green, Indian by
blue, Malay by dark blue, and
"foreigners" by purple), gender
(male by red, female by orange),
and age (adult by yellow, senior
citizen by lime green, and
student by light lime green) is
mapped by individual bars.

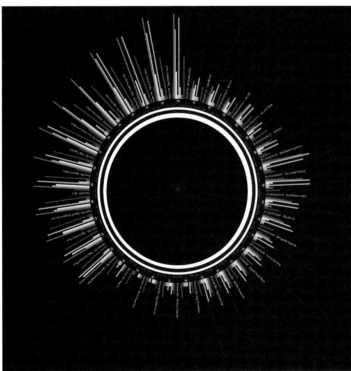

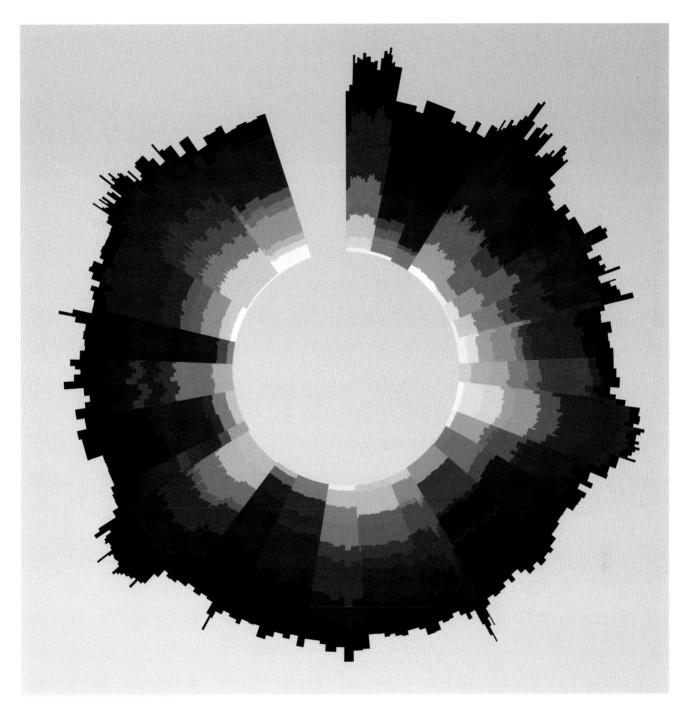

Frederic Brodbeck
Cinemetrics
2011

A project that measures data about a film in order to reveal its visual properties. The author deconstructed several movies into a set of basic components, such as video, audio, chapters, and subtitles, and processed them in order to extract a few specific traits, such as color palette and shot length. The resulting interactive visualization provides what the author calls a movie's "fingerprint." Shown here is the fingerprint for the movie *Quantum of Solace* (2008). Segments are organized in a clockwise fashion, each representing ten shots in the movie; the colored rings match the predominant hues within that segment.

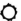

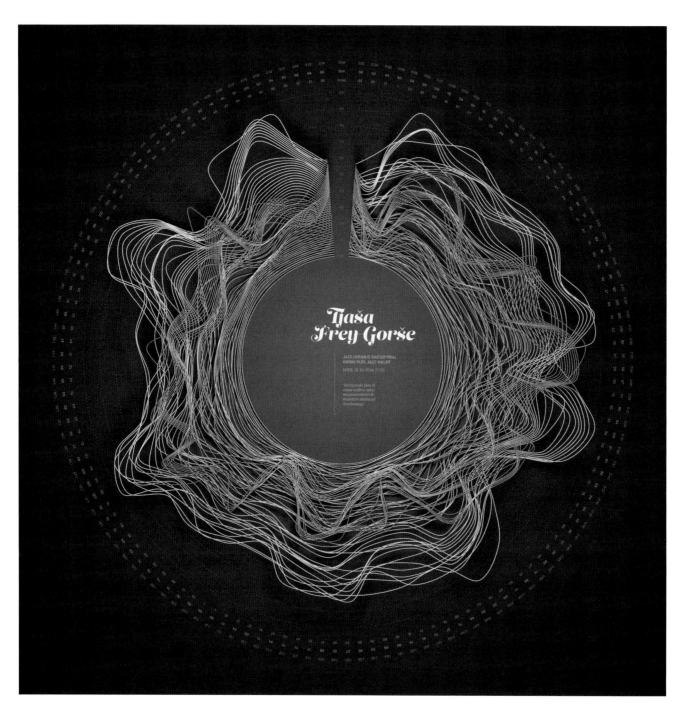

Črtomir Just, Matej Končan,
Manuel Kuran, Luka Zevnik,
Ahac Meden, Ivor Knafelj, and
Gregor Purgaj
Braindance
2014

A neuro-art project that
visualizes the brainwaves of
twenty participants as they
listen to a musical composition
for the first time. The chart
depicts two specific measures:
focus (concentration), in
turquoise; and flow (relaxation),
in orange.

Siori Kitajima and Ravi Prasad
(opposite)
*Sunlight, Fatness, and
Happiness*
2012

A diagram that allows viewers to
search for correlations among
six seemingly disparate metrics
from fifty countries: happiness
ranking, amount of sunlight,
gross domestic product,
obesity rate, murder rate, and
population density.

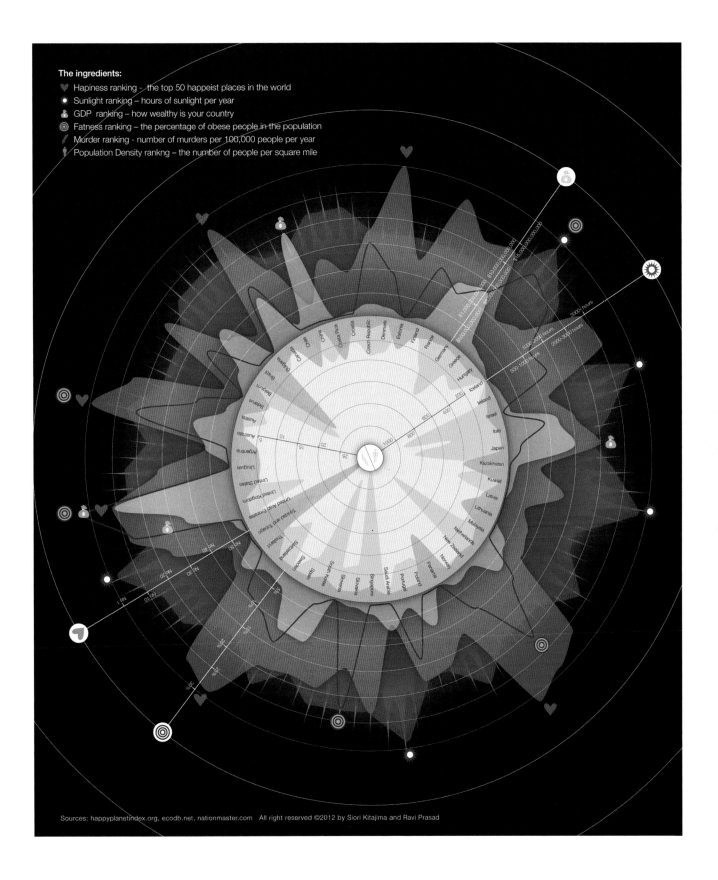

The ingredients:

- Hapiness ranking – the top 50 happeist places in the world
- Sunlight ranking – hours of sunlight per year
- GDP ranking – how wealthy is your country
- Fatness ranking – the percentage of obese people in the population
- Murder ranking - number of murders per 100,000 people per year
- Population Density rankng – the number of people per square mile

SHAPES & BOUNDARIES

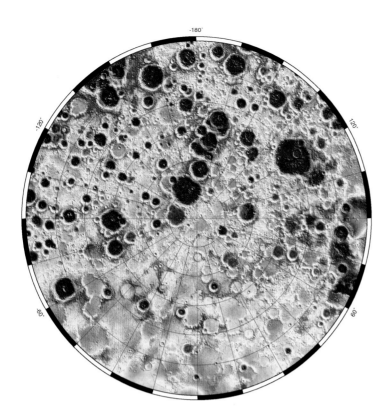

Gravity Recovery and Interior Laboratory (NASA)
Moon's north pole gravity
2012

A stereographic map of the gravity of the polar region of the moon (north of latitude 60), based on data from NASA's 2012 Gravity Recovery and Interior Laboratory mission. Red corresponds to areas of high mass, which create higher local gravity, blue and purple to areas of low mass, which in turn result in lower local gravity.

Matteo Bonera, Giulia De Amicis, Francesco Roveta, and Mir Shahidul Islam (The Visual Agency)
Tutti i voli portano a Londra (All the flights are going to London)
2013

Visualization of the daily flights to Milan (depicted at the core) from all worldwide cities, featured in *La Lettura*. Cities' distance from Milan is proportional to the number of daily connections (the better the city is connected, the closer it appears on the map). The concentric rings represent the average daily number of direct flights from Milan to all international cities. The area of each city's circle is related to its overall airport traffic.

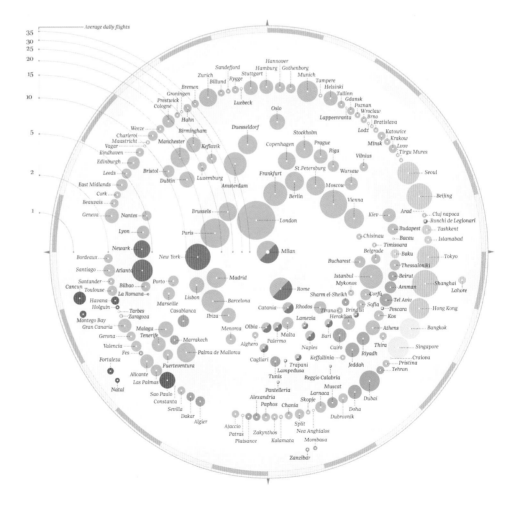

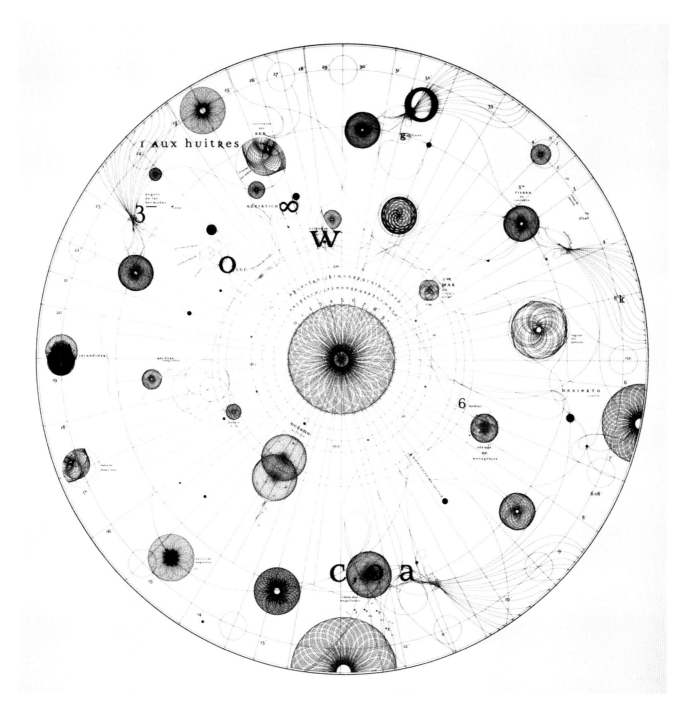

Tania Alvarez Zaldivar
Cartola Specimen
2010

An artistic interpretation of a
map chart showing elements of
Cartola, a typeface designed for
legibility at small point sizes, to
be used in maps.

SHAPES & BOUNDARIES

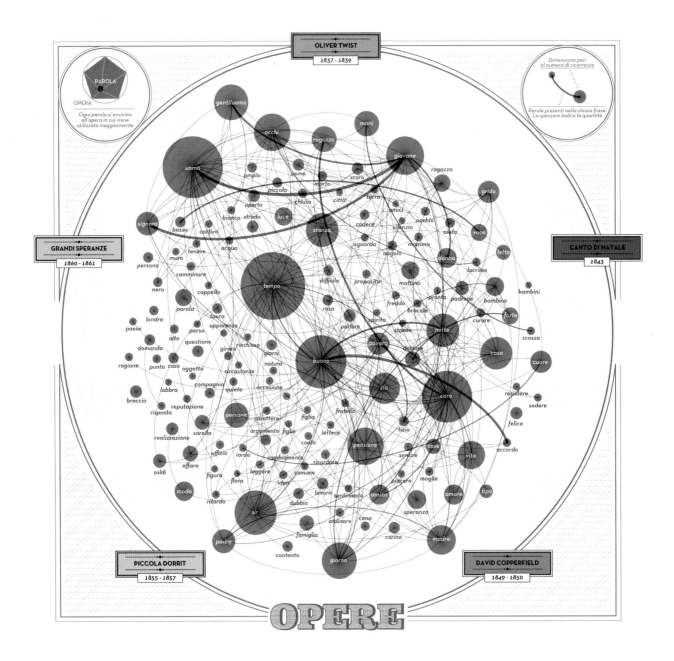

Valerio Pellegrini, Giorgio Caviglia, Giorgio Uboldi, and Michele Mauri (DensityDesign)
Charles Dickens
2012

A graphic breaking down five of Charles Dickens's most famous works to highlight the linguistic relationships among them.

Words are placed nearest to the work in which they are most used; the size of the bubble is proportional to the number of times the word is used in all the analyzed works. The weight of each connecting line indicates how frequently the two words were combined in the same sentence.

Torgeir Husevaag
Meeting Points
2011

Ink on paper, 43 × 43 inches
(109 × 109 centimeters).
Depiction of a set of walking
paths through an unidentified
city, created along with a
companion piece, *Escape
Routes*, for an exhibition in
Oslo. The bands of colored
circles represent the distance
in kilometers from the starting
point (the center of the
diagram) and time walked, from
one minute (in red, close to the
core) to sixty minutes (in light
blue, toward the periphery).

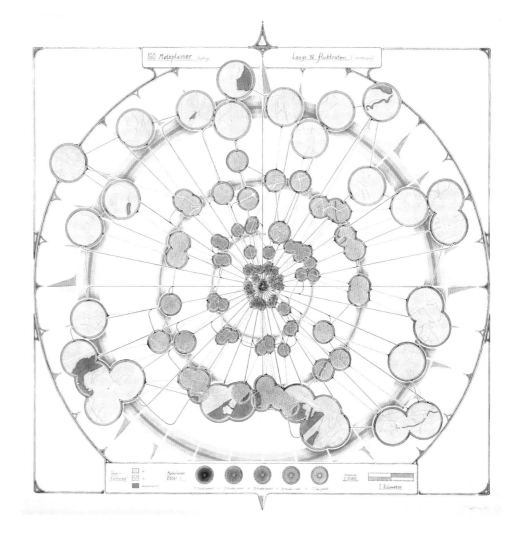

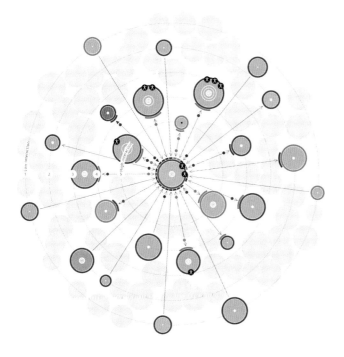

Elizaveta Oreshkina and
Alexander Larionov
*The Egocentric Network
Diagram*
2010

A tool for visualizing employee
work interactions. The assessed
employee is the circle at the
center of the diagram, with
other circles representing
colleagues. The most important
contacts are depicted by
colored circles, less significant
ones by gray circles.

Elias Ashmole
Theatrum Chemicum Britannicum
1652

Alchemical table representing the universe. This engraving is by Elias Ashmole, an English antiquarian and alchemist who was heavily involved in the English Civil War. The four elements at the chart's center are surrounded by the seven spheres and additional annotations that show the "secrets of the treatise both great & small."

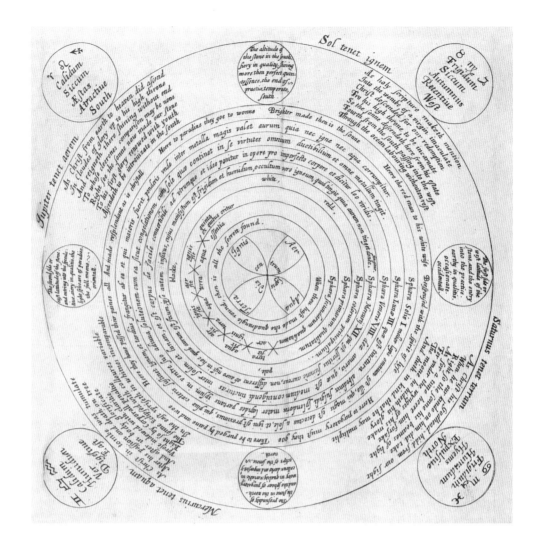

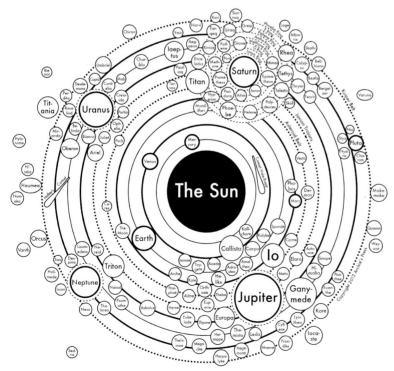

Archie Archambault (Archie's Press)
Solar System
2013

An updated diagram of our solar system, including various natural satellites, asteroids, and other space junk.

Jan Willem Tulp
(TULP interactive)
Close Votes
2012

An interactive visualization
based on the results of the
Dutch national elections in
2012. This diagram compares
various cities' distribution of
votes. Each circle represents a
city; the circle's size indicates its
population. The closer a circle is
to the selected city at the center
of the diagram, the more similar
its distribution of votes.

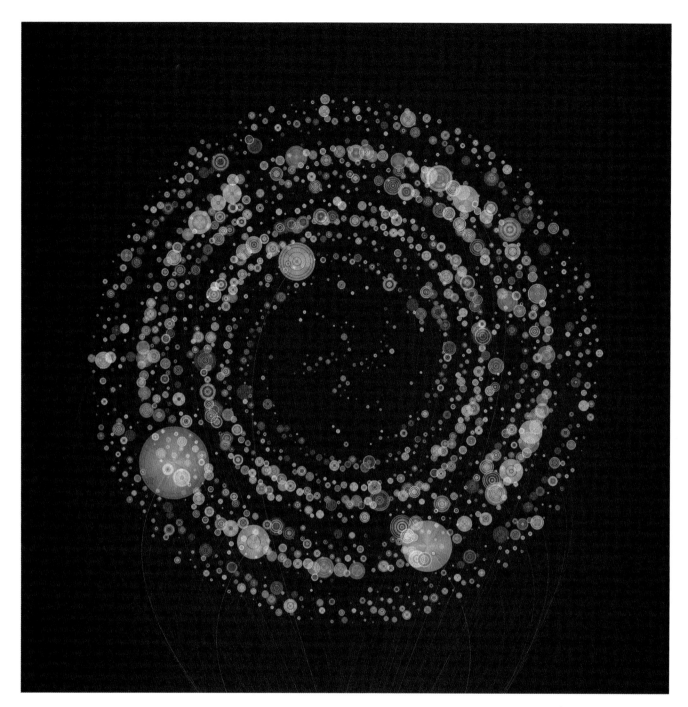

Brendan Dawes
EE—Digital City Portraits
2012

A digital portrait of Liverpool, England, created by analyzing millions of bits of data to determine the topics that people were tweeting about over the course of three days. Twitter data was searched for various keywords such as entertainment, weather, and money in eleven British cities during seventy-two hours. Each circle represents one minute out of 4,320—the number of minutes in three days—with older items at the core of the diagram. Colors indicate topics (e.g., *Strictly Come Dancing* is represented by light turquoise and Liverpool football's Steven Gerrard by red).

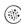

#WAR

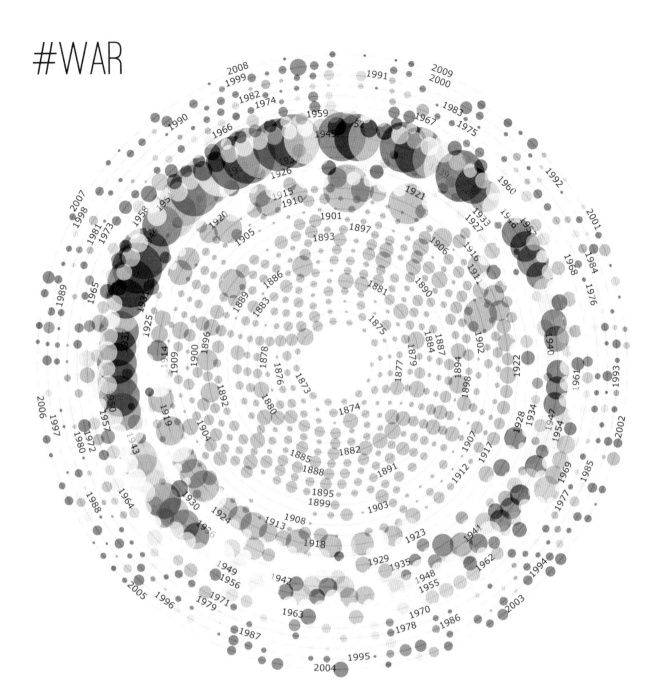

Wesley Grubbs, Nick Yahnke, and Mladen Balog
The Popular Science *Archive Explorer*
2011

Diagram showing how often the word *war* has appeared in *Popular Science* magazine over the course of 130 years. Each dot represents a separate issue of the magazine. Size indicates the frequency of the given keyword, while color indicates the predominant tint in the cover of each monthly issue. *Popular Science* has digitized its archives dating back to 1872, transforming 1,563 issues into minable data. By using this interactive explorer, users can search for any word to see how many times a particular term has been featured in the magazine.

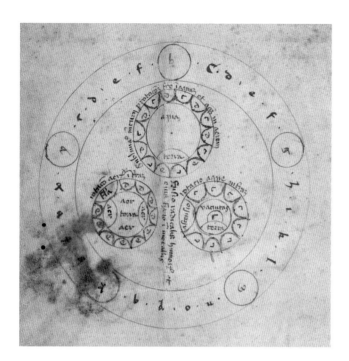

Ramon Llull
Figurae Instrumentales Testamenti (Diagrams and tables related to the *Testamentum*, an alchemical treatise)
ca. fifteenth century

Part of a manuscript that details many alchemical processes, by Ramon Llull, an influential Majorcan philosopher. This diagram shows three different types of worlds composed of the elements, all sitting inside a larger circle.

Robert Fludd (opposite)
Man as Microcosm
1623

Alchemical engraving featured in the title page of English physician Robert Fludd's *Anatomiae Amphitheatrum* (Theater of anatomy). The three large circles and the triangle that links them show how the human, spiritual, and material worlds are interconnected, while the smaller circles provide captions for the alchemy images.

Annibal Barlet
Le vray et methodique cours de la physique resolutive (The true and orderly path of resolutive physics)
1657

Woodcut diagram from a French book about various alchemical processes. The world is broken up into animals, vegetables, minerals, and metals, as well as different geometric shapes.

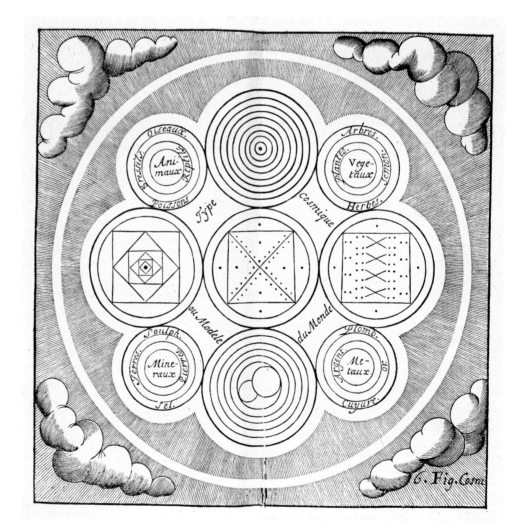

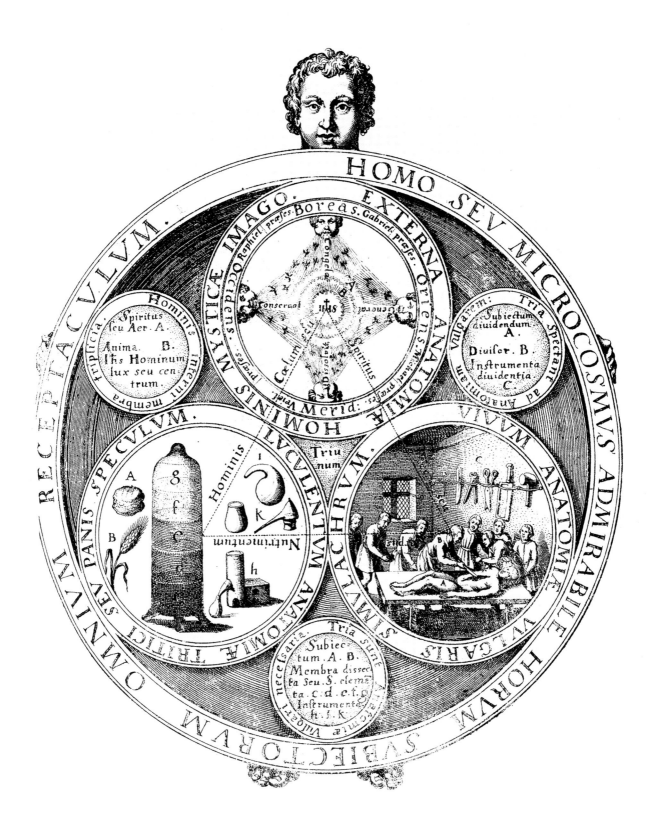

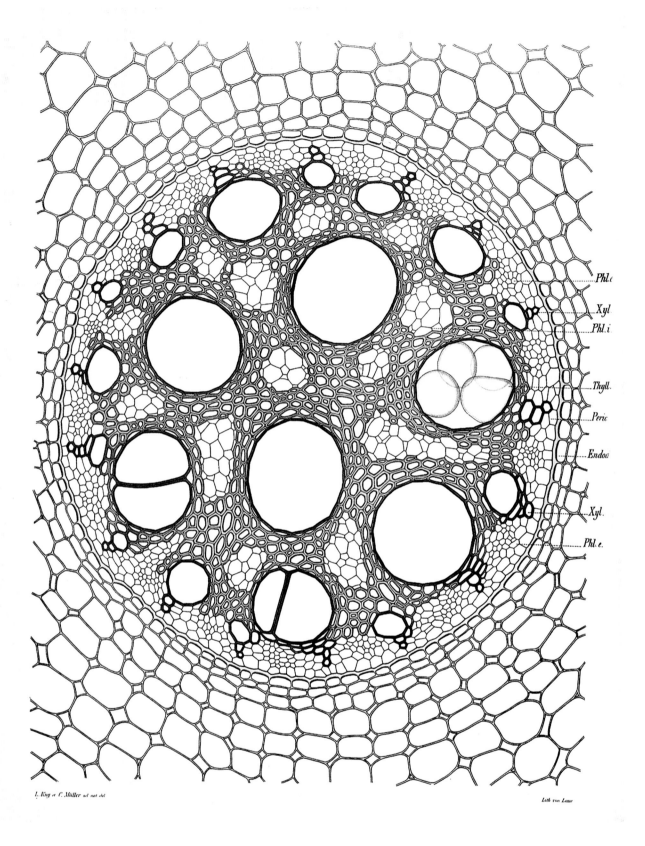

Phl.e

Xyl

Phl.i

Thyll.

Peric

Endo

Xyl.

Phl.e.

L. King et C. Müller ad nat del

Lith von Laue

Arnold and Carolina Dodel-Port
(opposite)
Monocot
1878–83

Part of an atlas of plant systems
that was created by the Swiss
botanist Arnold Dodel-Port
and his wife, Carolina. This
illustration is an extreme close-
up of the root of a monocot (a
type of flowering plant such as
a grass, lily, or palm that has a
single cotyledon in its seed).

Francesco De Comité (right)
Apollonian Gasket
2012

Design based on the Apollonian
gasket, a fractal generated
from groups of three circles,
where each circle is tangent
to two others. This method
generally leaves large empty
spaces inside the circles; the
artist fills these circles using
the same algorithm, changing
some parameters to induce an
element of randomness.

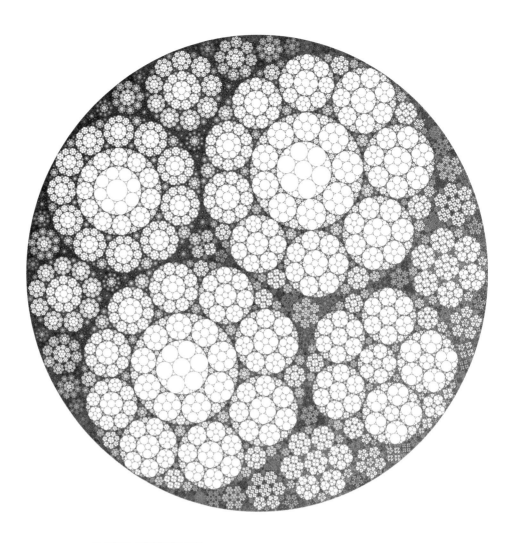

Francesco D'Orazio (left)
**Map of Bank of America's
2014 Super Bowl campaign
against AIDS**
2014

Visualization of how Twitter
accounts drove engagement
in a 2014 fund-raising drive. In
2014, the band U2 gave its song
"Invisible" away on iTunes for
a period of twenty-four hours;
every time it was downloaded
Bank of America donated one
dollar to fight HIV and AIDS.
The campaign raised more than
three million dollars, mainly
due to celebrity endorsement
on Twitter. This network graph
shows how the conversation
around the campaign spread
during the Super Bowl. Each
node represents one post:
blue nodes are tweets, and
yellow nodes are retweets. The
size represents the visibility
generated by the tweet.

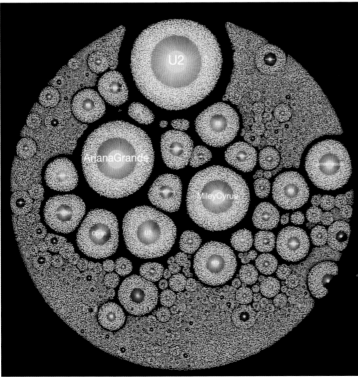

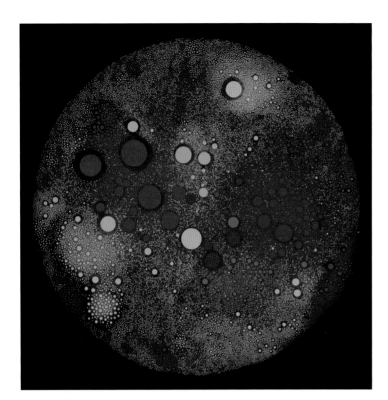

Francesco D'Orazio
*How Video Goes Viral: Dove's
"Real Beauty Sketches"
(Audience Network)*
2013

Graph mapping the communities on Twitter that shared Dove's *Real Beauty Sketches* video. It shows how the users who shared the video are connected to each other on Twitter and the number of communities in the video's audience by looking at the density of mutual connections. Each node represents a user; the color of the node represents the user's community, and the size of the node represents how central the user is to that community.

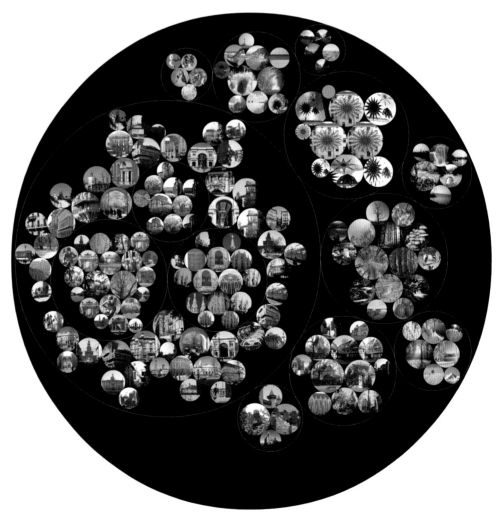

Kai Wetzel
Pebbles
2003

One of the first modern projects to use a nested-circle treemap structure to visualize hierarchical systems. Here this method is applied to a nested directory of digital images; the images themselves appear inside each circle.

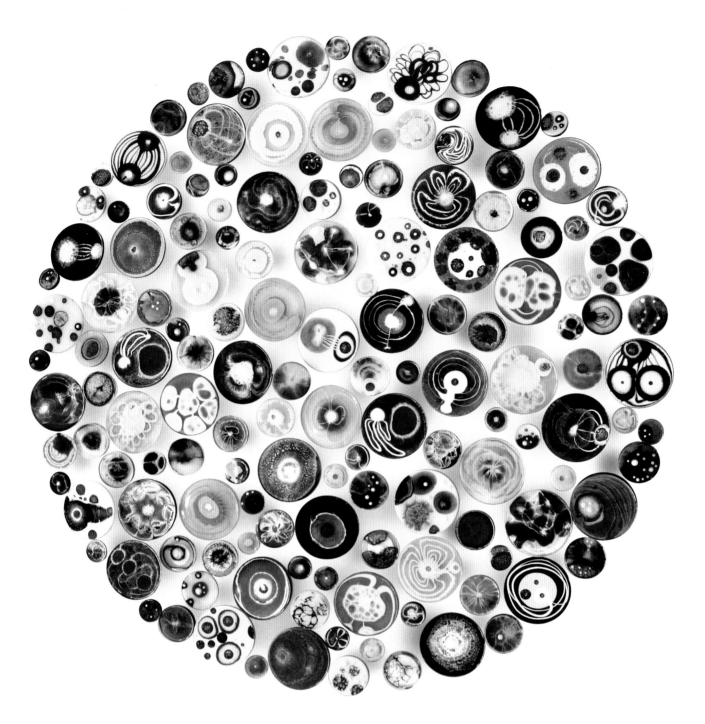

Klari Reis
Hypochondriac
2009–present

Installation of 150 painted petri
dishes, 60 × 60 inches (152.4 ×
152.4 centimeters), depicting
electron-microscope images of
viruses, viscera, and pharma-
ceuticals reacting with the
human body. Biology inspires
artist Klari Reis to create these
paintings inside petri dishes
using reflective epoxy polymer.

Jim Bumgardner
Squared Circle Mosaic
2005

A computer-generated mosaic of all the photos from 2005 in the "Squared Circle" Flickr photo pool—a collection of images of all things circular, from manholes to stickers. By early 2016 the photo pool had more than 160,000 photos. The layout follows a Fibonacci-based phyllotaxis, a common pattern found everywhere in nature, from flower heads to pine cones. At the core of the diagram are low-saturation images, while high-saturation ones grow larger toward the periphery.

Hubble Space Telescope
(NASA/ESA)
Globular star cluster M13
1999–2006

Composite photograph of M13,
one of the 150 known globular
clusters that surround the Milky
Way galaxy. It contains more
than 100,000 stars, is around
25,000 light-years away, and
is 150 light-years across. The
brightest stars are ancient
red giants, dying stars that
have substantially increased
in size and luminosity due to
the thermonuclear fusion of
hydrogen moving toward its
atmosphere and outer shells.
This image is a composite of
images taken in November
1999, April 2000, August 2005,
and April 2006.

divided, according to the theoretical plan, into about sixty-four cells; and making due allowance for the changes which mutual tensions and tractions bring about, increasing in complexity with each succeeding stage, we can see, even at this advanced and

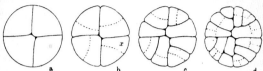

Fig. 242. Theoretical arrangement of successive partitions in a discoid cell; for comparison with Figs. 230 and 241.

complicated stage, a very considerable resemblance between the actual picture and the diagram which we have here constructed in obedience to a few simple rules.

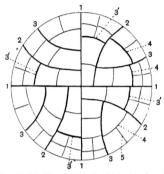

Fig. 243. Theoretical division of a discoid cell into sixty-four chambers: no allowance being made for the mutual tractions of the cell-walls.

In like manner, in the annexed figures representing sections through a young embryo of a moss, we have little difficulty in discerning the successive stages which must have intervened between the two stages shewn: so as to lead from the just divided or dividing quadrants (a), to the stage (b) in which a well-marked epidermal

D'Arcy Wentworth Thompson
Figures from *On Growth and Form*
1945

Two diagrams: the theoretical arrangement of successive partitions in a discoid cell and in eight cells from the dorsal of a frog's egg. Sir D'Arcy Wentworth Thompson was a Scottish biologist and mathematician who pioneered the mathematical representation, treatment, and modeling of biological processes. *On Growth and Form*, first published in 1917, was influential in paving the way for the scientific explanation of how patterns are formed in plants and animals.

again peculiar, and is probably rare, but it is included under the cases considered on p. 491, in which the cells are not in complete fluid contact but are separated by little droplets of extraneous matter; it needs no further comment. But the other four cases are beautiful diagrams of space-partitioning, similar to those we have just been considering, but so exquisitely clear that they need no modification, no "touching-up," to exhibit their mathematical regularity. It will easily be recognised that in Fig. 256, 1 and 2,

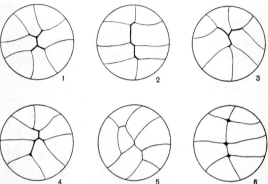

Fig. 256. Various modes of grouping of eight cells, at the dorsal or epiblastic pole of the frog's egg. After Rauber.

we have the arrangements corresponding to l and g, and in 3 and 4 to c in our table on p. 598. One thing stands out as very certain indeed: that the elementary diagram of the frog's segmenting egg given in textbooks of embryology—in which the cells are depicted as uniformly symmetrical and more or less quadrangular bodies—is entirely inaccurate and grossly misleading*.

* Cf. Rauber, Neue Grundlegungen z. K. der Zelle, *Morphol. Jahrb.* VIII, p. 273, 1883: "Ich betone noch, dass unter meinen Figuren diejenige gar nicht enthalten ist, welche zum Typus der Batrachierfurchung gehörig am meisten bekannt ist....Es haben so ausgezeichnete Beobachter sie als vorhanden beschrieben, dass es mir nicht einfallen kann, sie überhaupt nicht anzuerkennen." See also O. Hertwig, Ueber den Werth d. erste Furchungszelle für die Organbildung des Embryo, *Arch. f. Anat.* XLIII, 1893; here O. Hertwig maintains that there is no such thing as "cellular homology."

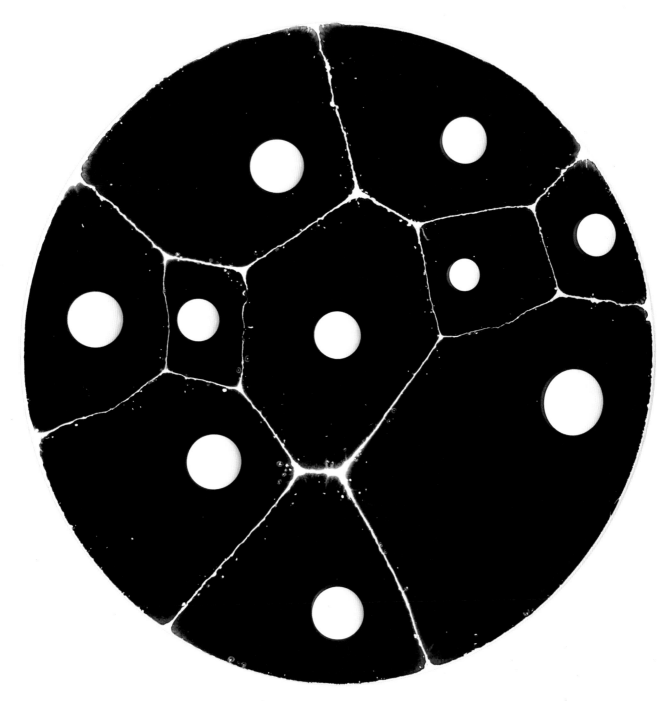

Klari Reis
Petri dish painting details
(*Petri Projects*)
2009–present

Piece from a series for which
the artist produced a painting
a day of a petri dish recalling
microscopic cellular imagery.
The series explores the
boundary between art and
science.

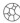

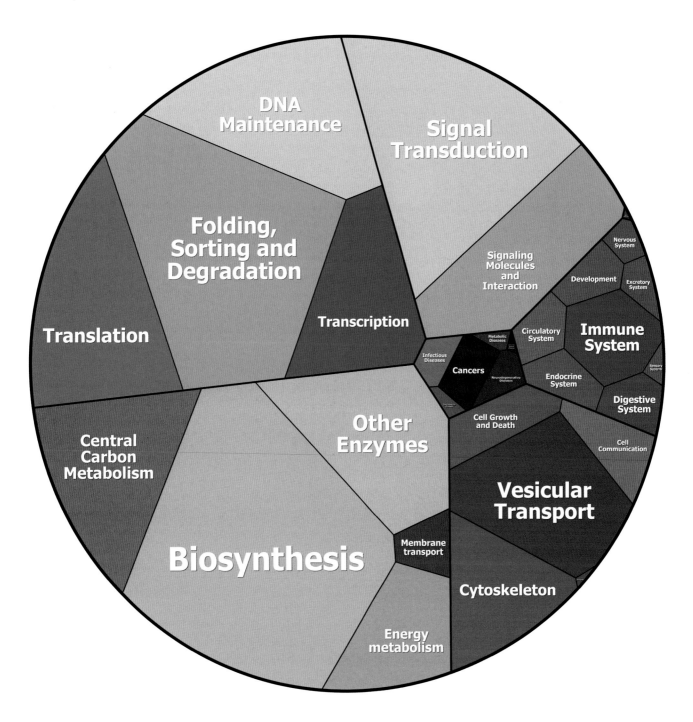

Wolfram Liebermeister, Elad Noor, Dan David, Avi Flamholz, Ron Milo, Katharina Riedel, Henry Mehlan, Julia Schüler, and Jörg Bernhardt
Lab Mouse Proteomap
2014

A circular Voronoi treemap depicting the amount of protein in different mouse tissues, clustered according to function. The size of each polygonal shape (cluster) indicates protein abundance, while functionally related proteins show colors similar in hue, luminance, and saturation.

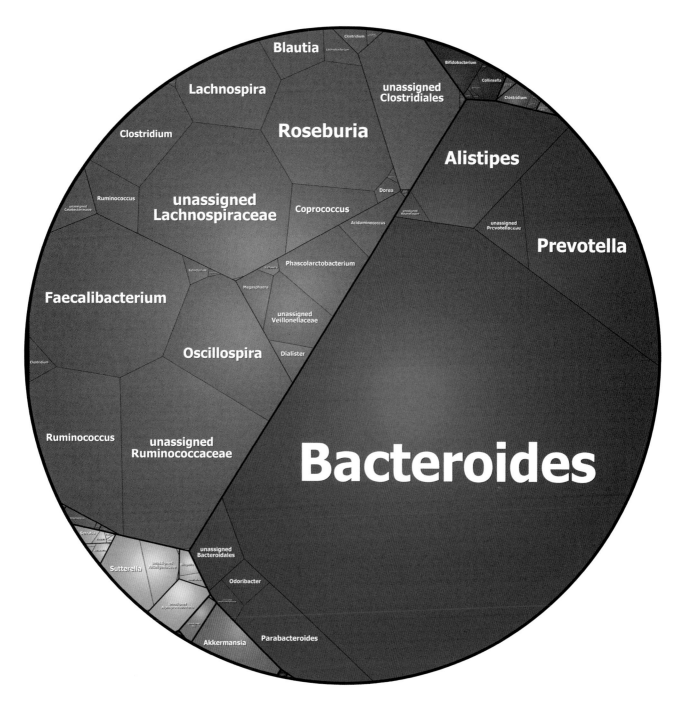

Tanja Verena Maier,
Philippe Schmitt-Kopplin,
and Jörg Bernhardt
Gut microbiome
2014

A circular Voronoi treemap
visualizing the human gut's
operational taxonomic units
(OTUs), which are the species or
groups of species identified by
DNA sequencing.

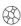

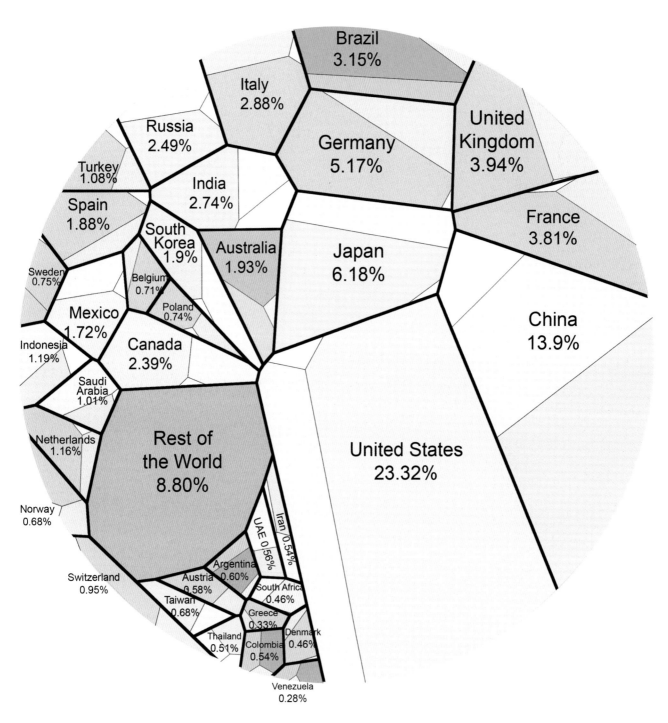

Brazil
3.15%

Italy
2.88%

Russia
2.49%

Germany
5.17%

United
Kingdom
3.94%

Turkey
1.08%

India
2.74%

Spain
1.88%

South
Korea
1.9%

Australia
1.93%

Japan
6.18%

France
3.81%

Sweden
0.75%

Belgium
0.71%

Mexico
1.72%

Poland
0.74%

China
13.9%

Indonesia
1.19%

Canada
2.39%

Saudi
Arabia
1.01%

Netherlands
1.16%

Rest of
the World
8.80%

United States
23.32%

Norway
0.68%

Iran 0.54%

UAE 0.56%

Switzerland
0.95%

Argentina
0.60%

Austria
0.58%

South Africa
0.46%

Taiwan
0.68%

Greece
0.33%

Thailand
0.51%

Denmark
0.46%

Colombia
0.54%

Venezuela
0.28%

Howmuch.net

*The World's Economy Divided
by Area*
2015

A Voronoi diagram representing
the relative size of various
countries' economies in terms
of nominal gross domestic

product: the larger the area,
the larger the economy. Each
country's area is further divided
into three sectors: services
(darkest shade), industrial (mid
tone), and agricultural (lightest).
Data was taken from the CIA's
World Factbook.

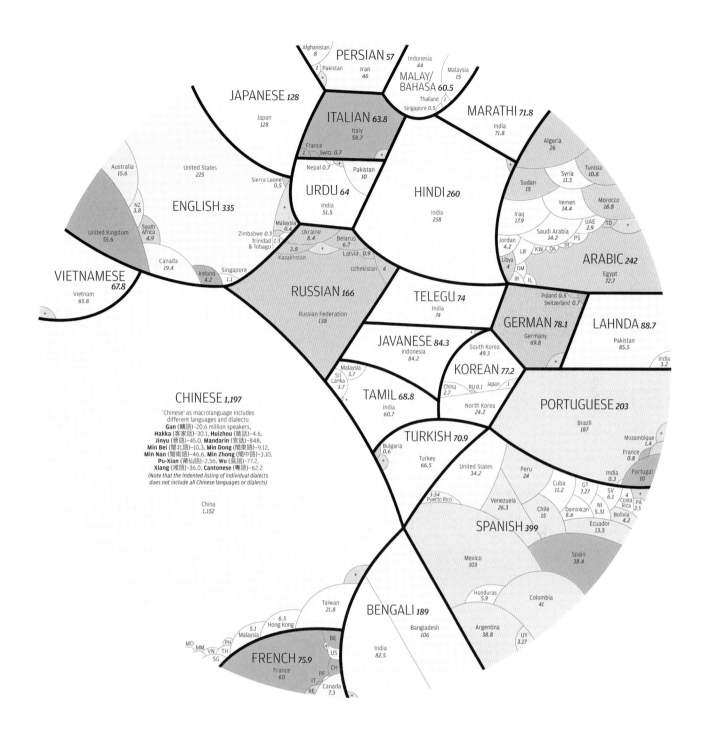

PERSIAN *57*
Afghanistan 8
Pakistan 1
Iran 46

MALAY/ BAHASA *60.5*
Indonesia 44
Malaysia 15
Thailand 1
Singapore 0.5

JAPANESE *128*
Japan 128

ITALIC *63.8*
Italy 58.7
France 1
Switz. 0.7

MARATHI *71.8*
India 71.8

URDU *64*
Nepal 0.7
Pakistan 10
India 51.5

HINDI *260*
India 258

ARABIC *242*
Algeria 26
Syria 11.5
Tunisia 10.8
Sudan 15
Yemen 14.4
Morocco 18.8
Iraq 17.9
Saudi Arabia 14.2
UAE 2.9
TD
Jordan 4.2
LB
KW QA
TR
PS
Libya 4
OM
IR IL
Egypt 72.7

ENGLISH *335*
Australia 15.6
NZ 3.8
United States 225
Sierra Leone 0.5
United Kingdom 55.6
South Africa 4.9
Zimbabwe 0.3
Trinidad & Tobago 1.3
Malaysia 0.4
Canada 19.4
Ireland 4.2
Singapore 1.1

VIETNAMESE *67.8*
Vietnam 65.8

Ukraine 8.4
Belarus 6.7
Latvia 0.9
Kazakhstan 3.8
Uzbekistan 4

RUSSIAN *166*
Russian Federation 138

TELEGU *74*
India 74

Poland 0.5
Switzerland 0.7

GERMAN *78.1*
Germany 69.8

LAHNDA *88.7*
Pakistan 85.5
India 3.2

JAVANESE *84.3*
Indonesia 84.2

South Korea 49.3

KOREAN *77.2*
China 2.7
RU 0.1
Japan 1
North Korea 24.2

CHINESE *1,197*
'Chinese' as macrolanguage includes
different languages and dialects:
Gan (贛語)–20.6 million speakers,
Hakka (客家話)–30.1, **Huizhou** (徽話)–4.6,
Jinyu (晉語)–45.0, **Mandarin** (官話)–848,
Min Bei (閩北語)–10.3, **Min Dong** (閩東語)–9.12,
Min Nan (閩南語)–46.6, **Min Zhong** (閩中語)–3.10,
Pu-Xian (莆仙話)–2.56, **Wu** (吳語)–77.2,
Xiang (湘語)–36.0, **Cantonese** (粵語)–62.2
*(Note that the indented listing of individual dialects
does not include all Chinese languages or dialects)*

China 1,152

Malaysia 3.7
Sri Lanka 3.7

TAMIL *68.8*
India 60.7

PORTUGUESE *203*
Brazil 187
Mozambique 1.4
France 0.8
India 0.3
Portugal 10

TURKISH *70.9*
Bulgaria 0.6
Turkey 66.5
United States 34.2
Peru 24
Cuba 11.2
GT 7.27
SV 6.1
4
Costa Rica
PA 2.5
3.54 Puerto Rico
Venezuela 26.3
Chile 15
Dominican 8.6
NI 5.31
Bolivia 4.2
Ecuador 13.5

SPANISH *399*
Mexico 103
Spain 38.4
Honduras 5.9
Colombia 41
Argentina 38.8
UY 3.17

Taiwan 21.8
6.5 Hong Kong
5.1 Malaysia
MO MM VN PH TH SG

BENGALI *189*
Bangladesh 106
India 82.5

FRENCH *75.9*
France 60
BE
US
PF
CH
IT
RE
Canada 7.3

Alberto Lucas López
A World of Languages
2015

A chart of the major twenty-three languages used in the world today, which are native to 4.1 billion people. Each language is represented by a space within black borders, sized according to overall number of native speakers and then subdivided into the different countries in which the language is spoken. Each country's color indicates its continental region to show how individual languages have taken root in many different areas of the globe: North America (yellow), South America (blue), Western Europe (red), Eastern Europe (brown), Middle East (mint green), Africa (olive green), Asia Major (orange), Asia Minor (beige), Oceania (salmon). The number indicates the quantity of native speakers (in millions) by country or language.

Oliver Deussen
Eclipse Voronoi treemap
2010

A Voronoi treemap of the hierarchical file structure of the multilanguage software-development system Eclipse, showing fifteen thousand classes.

Stanisław Osiński and Dawid Weiss (Carrot)
FoamTree: FT500 Global Voronoi Treemap
2015

Interactive, circular Voronoi treemap created with the JavaScript treemap-visualization library FoamTree. This map depicts the ranking of the largest companies in the world in 2015 by the *Financial Times*. Companies are grouped into sectors, such as banks and retailers; the size of each cell corresponds to market value, with companies like Apple, ExxonMobil, Google, and Walmart immediately noticeable. Color represents the country in which each corporation is based, with predominant ones standing out, such as the United States (red), China and Japan (purples), and the United Kingdom and Switzerland (greens).

Stanisław Osiński and Dawid
Weiss (Carrot)
*FoamTree: FT500 US Voronoi
Treemap*
2015

This interactive Voronoi treemap
depicts the largest companies
in the United States. Color
represents employee turnover,
from highest in red to lowest
in light blue (Walmart clearly
stands out in this regard).

MAPS & BLUEPRINTS

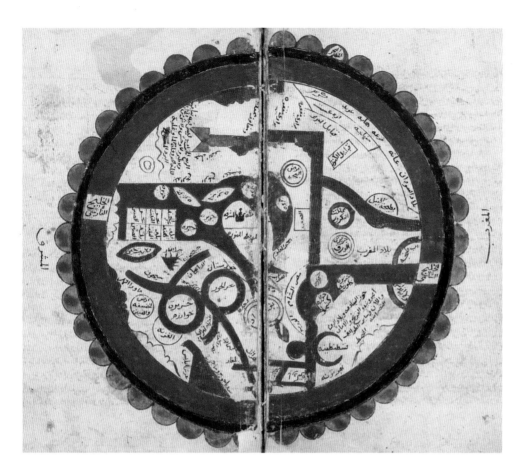

Sirāj al-Dīn Abū Ḥafṣ ʿUmar Ibn al-Wardī
The Perfect Pearl of Wonders and the Precious Pearl of Extraordinary Things
1632

Seventeenth-century Arabic circular map showing the world edged by the *qāf*. These legendary mountains in ancient Muslim tradition represented the end of the known world; here they are represented by semicircles. Located on the map are Mecca and Medina, as well as Constantinople (now Istanbul, shown by a red crescent) and Baghdad.

Isidore of Seville
T-O map
twelfth century

Isidore of Seville was a seventh-century Spanish bishop whose chief work of scholarship, *Etymologiae* (Etymologies), was one of the most popular encyclopedias of the Middle Ages. It has been reprinted, edited, and reproduced by numerous authors over a period of more than a thousand years. This detailed version of the classic T-O map shows the world as known in the twelfth century: the Mediterranean Sea, represented by the capital *T*; the Red Sea, curving out from the top of the *T*; the Nile as a black line running from the right of the circle into the Mediterranean; and the Pyrenees, shown as a row of oval shapes in the bottom left-hand segment. Carthage, Ethiopia, Libya, Mauritania, and the Pillars of Hercules are also labeled.

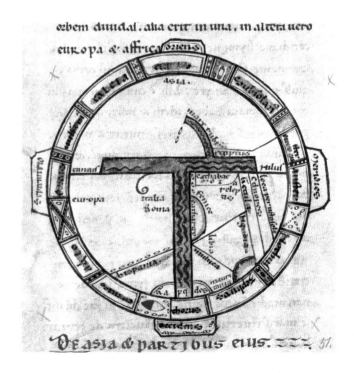

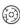

Anonymous
Islamic map of the world
eighteenth century

Map of the world with south at the top and west to the right. The Indian Ocean and the Red Sea can be seen on the left; China, India, and Iran are marked in boxes to the right. Also indicated is the Mediterranean, where Rome and Constantinople (now Istanbul) are shown. The Nile flows from the Mediterranean east, toward a large circle indicating its source in Africa.

Melike Turgut
Process Infograph
2011

A map of the designer's creative process. Turgut created an interlocking diagram to explain the connections among different stages of solving a design problem, with symbols representing strategies such as "explore visual system," "taking calculated risks," and "change of perspective."

QUESTION THE IDEA

QUESTION THE IDEA

smooth path to finish

The elements of my discovery

◇	idea	✕	obstacle	◗ⅼⅼ	work out details
◆	concept	⌒	taking risks	⊕	processing data
◈≡	explore idea, see options	⌒	taking calculated risks	◖	critique
◈⦂	explore visual system	⌣	change of perspective	T	Typography

Mark R Shepherd (opposite)
Map of Sorrow
2012

A digital collage that conveys the emotive spiritual journey of the artist Mark R Shepherd.

Ji Soo Han and Paul Ornsby
Situationist Drawing Device
2010

Chart generated by a backpack-size mechanism that creates a distinctive way for users to "draw" their experience of the landscape. Movement of the body triggers the device to make marks on a drawing board, as shown above. Each drawing is unique and provides a memory map of the place visited.

Plan et Distribution du Comble.

Plan et Distribution du 1.er et 2.e Etage.

George-Louis Le Rouge
Coupe pour la lauteur des planchers (Plan for the author's floors)
1776–90

Plan showing the layout of the three floors of the author's house: the attic (left) and the first and second floors (right). George-Louis Le Rouge was a French architect, cartographer, and geographical engineer for Louis XV. He published an influential book on the art of gardening that popularized the Anglo-Chinese style of garden design that was being developed in England at the time.

Frank Earl Ormsby
First-floor plan of the Pyramid-Cube University
1919

Architectural drawing from Frank Ormsby's *The Sage's Key to Character at Sight*. Ormsby was a specialist in occultism and mysticism and discovered the new "science" of solar magnetics, a quack discipline that applied astronomy to medicine. He attempted to set up the Pyramid-Cube University in Chicago to teach his version of occult studies to believers.

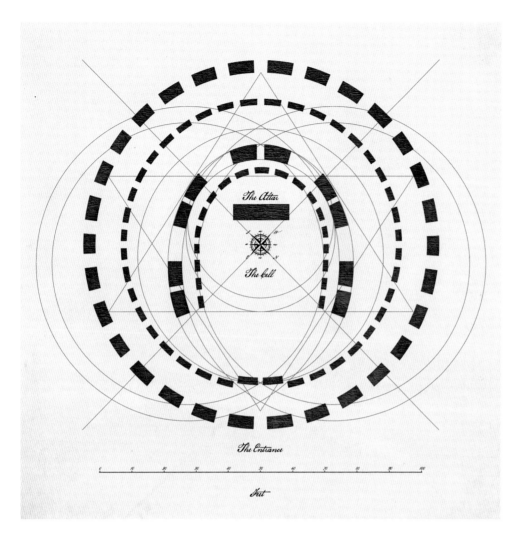

Michael Paukner
Stonehenge Rebuilt
2009

A reconstruction of the original plan of Stonehenge. Australian graphic designer Michael Paukner has reimagined the original site, which now lies in ruins: the top half of the outer circle is almost entirely in ruins; the second inner circle no longer exists; and the inner ellipse is in disarray, particularly on the right-hand side.

Albrecht Dürer
Fortification plan
1527

Plan by the German painter and printmaker Albrecht Dürer., from *Etliche Vnderricht zu Befestigung der Stett Schloss vnd Flecken* (Several instructions for fortifying towns, castles and small cities) Dürer is best known for his woodcuts and engravings; however, he also wrote this treatise on fortification to advise kings and princes on architectural means of defending themselves against new military technologies. As shown here, it contains plans, sections, and elevations for a variety of projects that would increase the security of walls and battlements.

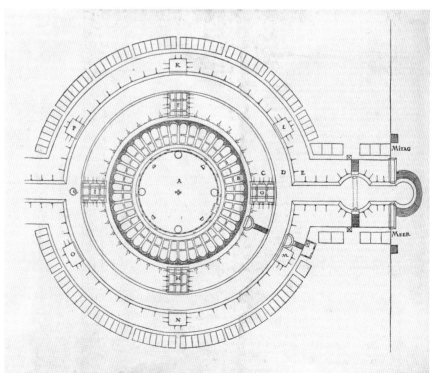

Cedric Kiefer (onformative)
Montblanc Generative Artwork
2011

Part of a generative artwork
created to visualize the
characteristics of a Montblanc
watch, using data involving
size, material, casing type, and
end user. The network of fine
lines in this drawing reflects
the precision of the watch's
movement.

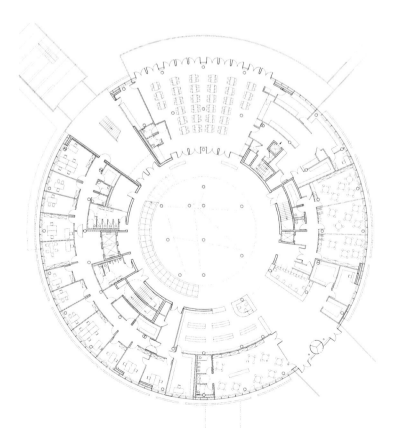

Bernard Tschumi Architects
Plan of Alesia Museum
2012

The first-floor plan for a
museum in Alise-Sainte-Reine,
France. Bernard Tschumi
Architects' structure echoes
the circular battlements and
earthworks that used to exist
there. The cylindrical design
also provides a 360-degree
panoramic view of the valley in
which it is situated.

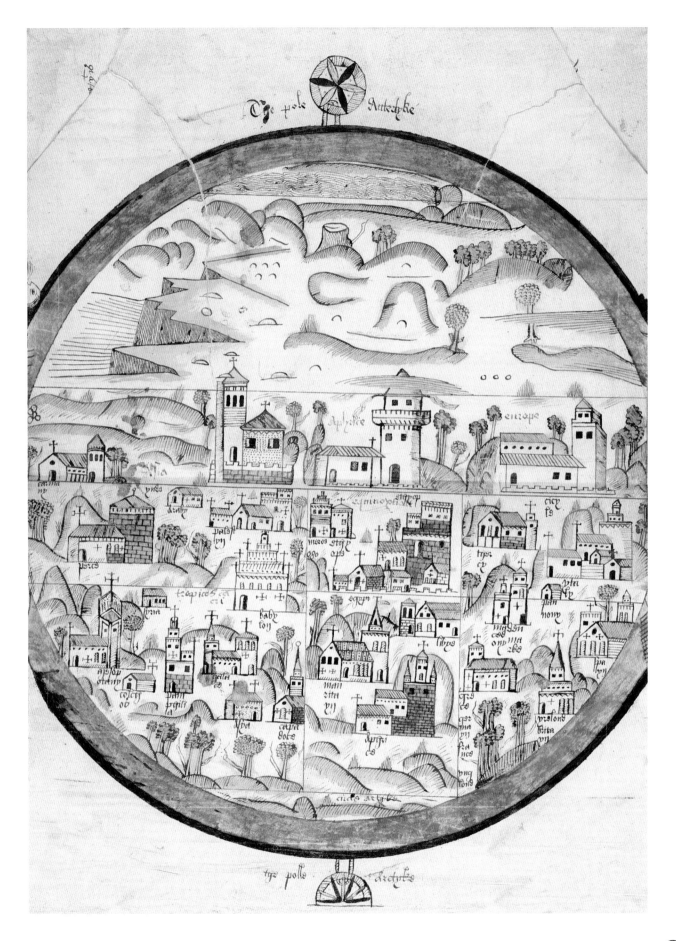

Lucas Brandis
World map
1475

A world map in the *Rudimentum Novitiorum* (Handbook for beginners), showing the known world in terms of continental divisions based on the T-O map: Asia is in the top two quadrants, with Europe and Africa below. Paradise can be found in the Far East, with four rivers flowing from the Garden of Eden (top center) through the Earth. The Holy Land is in the center of the map with the Pillars of Hercules at the bottom. This was not intended for precise geographical navigation; also included are places from biblical history, classical times, and mythology.

Johannes de Sacrobosco and Anthony Askham (opposite)
Map of a medieval city
1526–27

Circular map drawn in a grid, showing the detail of a city, with particular emphasis on religious buildings. Johannes de Sacrobosco's *De Sphaera* (The sphere) was a popular astronomy guide that was reprinted more than eighty times up until the Renaissance. This edition has been supplemented by the English astrologer Anthony Askham and contains nineteen maps.

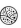

Salottobuono, YellowOffice,
and Jean-Benoit Vetillard
Dreaming Milano
2009

A plan for the potential
regeneration of Milan's
currently disused railway
infrastructure, proposed by
Ferrovie dello Stato, an Italian
railway company. The scheme
pictured here establishes a
new neighborhood that would
attract twenty-five thousand
new inhabitants by 2015,
blurring the city zones and
boundaries.

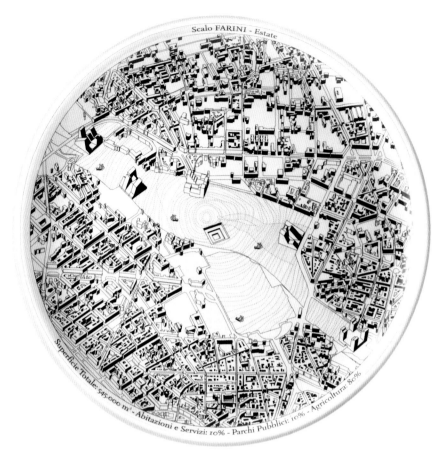

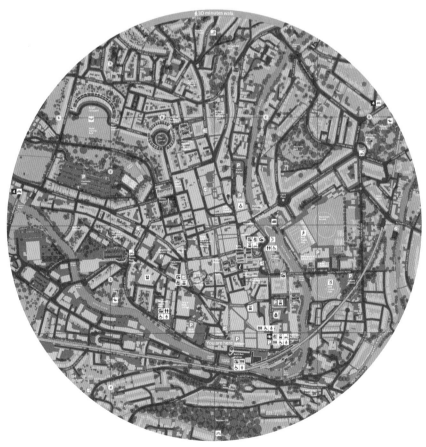

PearsonLloyd, fwdesign,
and City ID
**Wayfinding and signage
strategy for Bath and
Northeast Somerset**
2009

A map indicating a wayfinding
information system for the
historic English city of Bath.

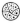

Carlos Romo Melgar (C31913)
Cosmographies
2010

Part of a series of circular
maps inspired by medieval
cartographers. This map of
Madrid shows designer Carlos
Romo Melgar's personal
experiences of the city in terms
of geography and emotions.
The center of the circle contains
experiences that are usually
more complex and personal;
positioned toward the border
are the events and places
to which he feels less of a
connection.

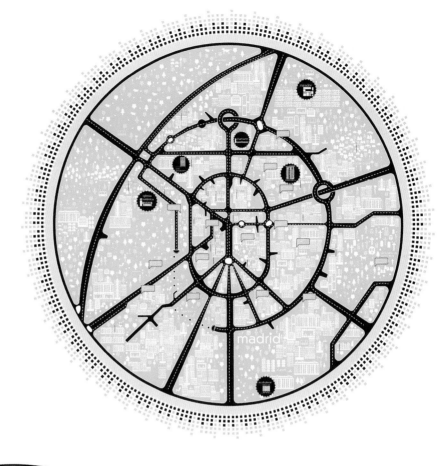

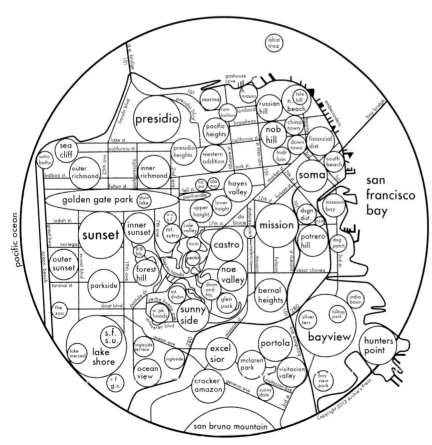

Archie Archambault
(Archie's Press)
San Francisco
2013

Map depicting the landmarks
of San Francisco. Precise
geographical detail is elimi-
nated so that a user can get
a feel for the city. Circles are
used to depict scale, as well
as to create a cohesive visual
language to make information
easier to read. Archambault
creates these maps as an
attempt to end overreliance
on GPS technology and aims
to rekindle the "map from
the mind."

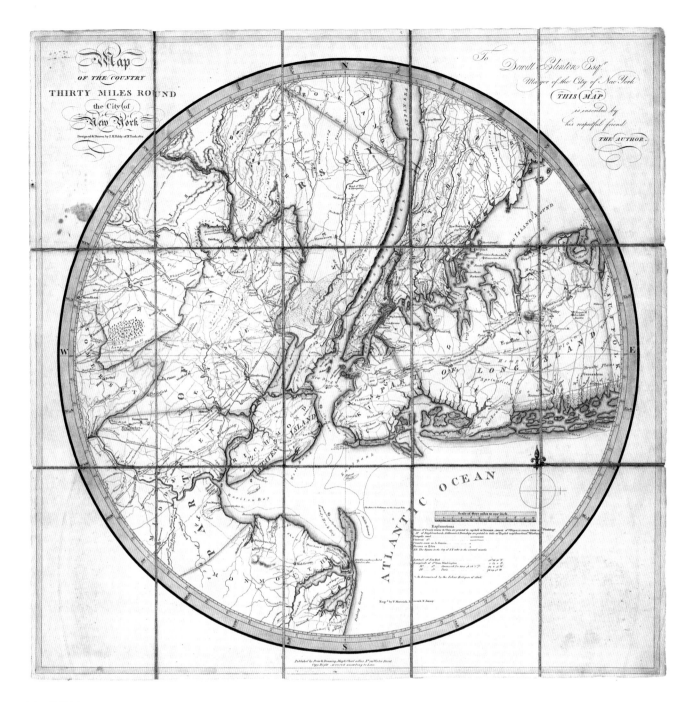

John H. Eddy
*Map of the Country
Thirty Miles Round the
City of New York*
1811

One of the most complete and
accurate early maps of New York
City and the surrounding areas.
It extends north to Tarrytown,
New York; south to Monmouth
County, New Jersey; west to
Somerset, New Jersey; and east
to Suffolk County, Long Island,
New York.

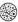

Anonymous
Planisferio antico di Andrea Bianco
(Ancient world map by Andrea Bianco)
1788

A Venetian circular world map placing Jerusalem at the center, which was typical of medieval cartography. In addition to depicting European cities, it shows several mythical places; the phantom island of Antilia, also known as the Isle of Seven Cities, can be seen at the bottom of the map, along with Sanbrandan, and the biblical lands of Magog and Gog. The drawing is based on the original manuscript map from 1436, created by Italian cartographer Andrea Bianco and stored in the Library of San Marco, Italy

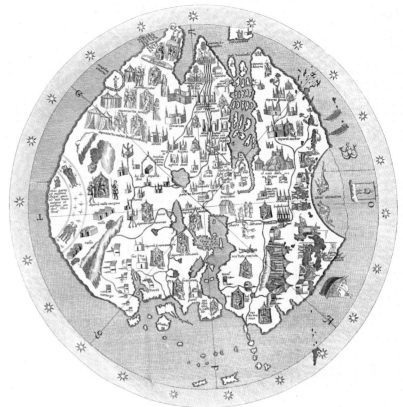

PLANISFERIO ANTICO DI ANDREA BIANCO
Che si conserva in Venezia nella Biblioteca di S. Marco.

Anonymous
Ch'ŏnha chido
(Atlas of the world)
nineteenth century

A copy of a traditional Korean atlas (originally produced around the sixteenth century) showing the Korean peninsula at the core of the map next to neighboring China, Japan, and Ryukyu Islands, and encircled by a ring of mythical lands.

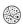

Shannon Rankin
Settlement North
2010

Map, acrylic, adhesive, paper,
20 × 20 inches (51 × 51
centimeters).

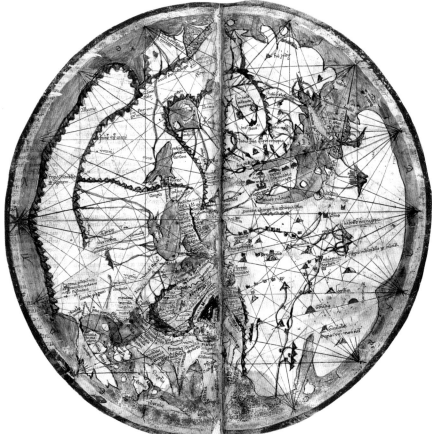

Pietro Vesconte
Mappa mundi (World map)
1320

Map orientated with the
east on top; seas are shown
in green and land as white.
Pietro Vesconte was a Genoese
cartographer and geographer
whose world maps are consid-
ered to be some of the most
geographically accurate of
the time.

US Geological Survey
Geologic map of Venus
1989

Map of part of the northern
hemisphere of Venus. Colors
correspond to surface features,
including volcanoes (light red
and pink), mountains and ridges
(purple, green, and blue), and
plains (yellow and light green).

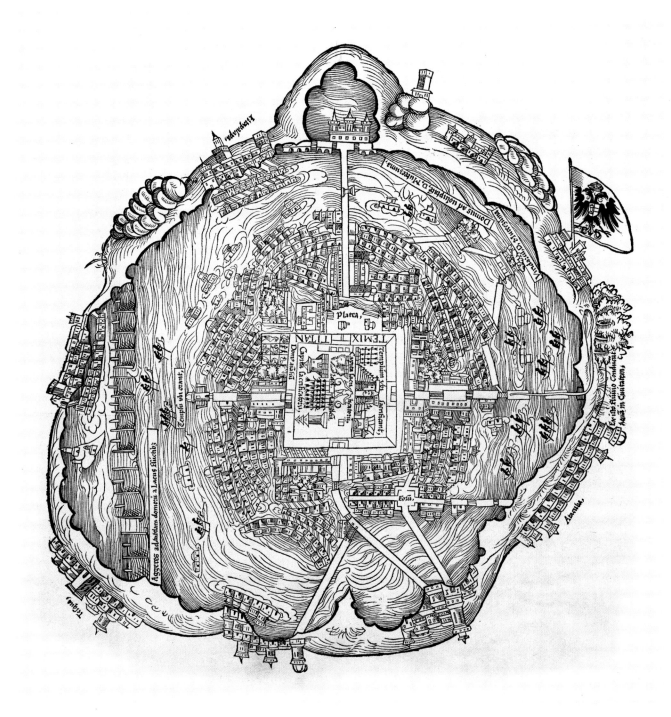

Hernán Cortés
Map of Tenochtitlán
1524

The first European
representation of Tenochtitlán,
the Aztec capital. Hernán Cortés
was a Spanish conquistador who
helped to cause the collapse of
the Aztec Empire and brought
large parts of modern-day

Mexico under Spanish rule.
This woodcut appeared in a
manuscript accompanied by
letters detailing the invasion.
As seen here, the city was built
on an island in a lake and was
connected to neighboring cities
by a series of causeways. The
central square contains the
temple complex that dominated
the city.

Wouter van Buuren
Untitled
2009

Photograph, 47.2 × 47.2 inches
(120 × 120 centimeters), taken
from the roof of a high-rise
building in Shanghai in August
2009.

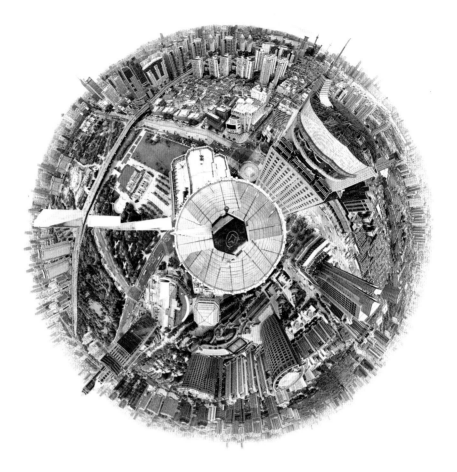

Albert Camesina and
Heinrich Schmidt
*Viennam Austriae cum
Sua Vicinia*
1864

Map published to commemo-
rate the 1683 Battle of Vienna,
which took place after the
city had been besieged by
the Ottoman Empire for two
months. The victory for the
Austrian and European forces
was seen as a turning point
in early modern Europe and
pivotal in the decline of the
Ottoman Empire. The city's
fortifications are clearly visible
in the inner circle, surrounded
by the Viennese countryside.

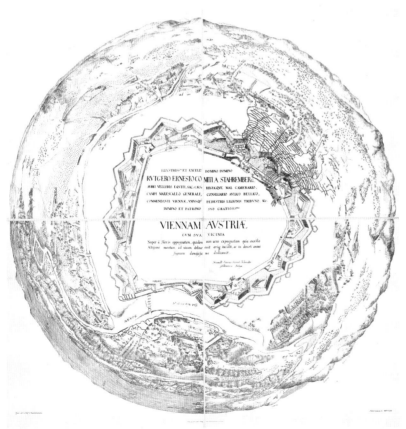

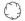

Birds-Eye View from Summit of Mt. Washington; White Mountains, New-Hampshire.

Issued by Passenger Department of Boston & Maine R.R.

Boston and Maine Railroad

*Bird's-Eye View from Summit
of Mt. Washington; White
Mountains, New-Hampshire*

1902

Drawing, 30 × 26.4 inches
(71 × 67 centimeters).

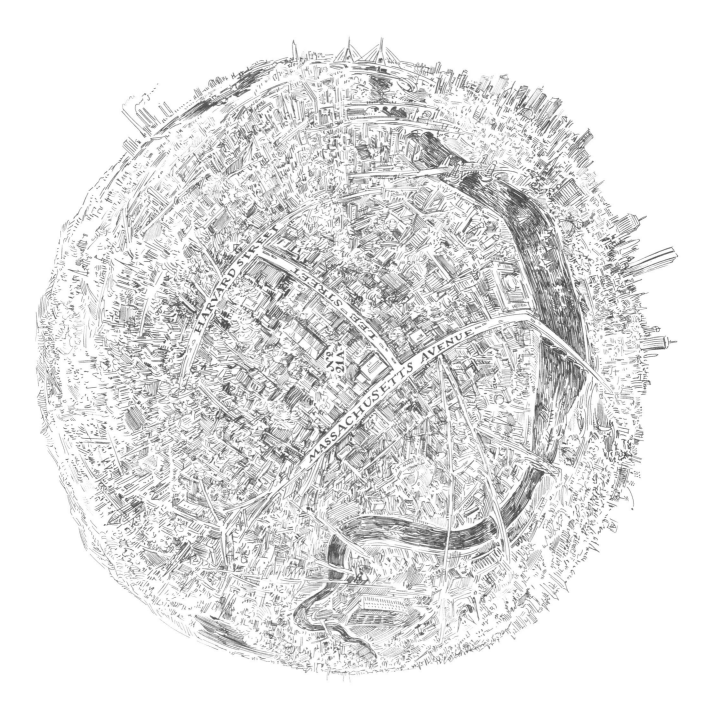

Pier Gustafson
21 Lee Street and Environs
2009

Pen and ink drawing. Bird's-
eye view of a house and the
surrounding area in Cambridge,
Massachusetts. A Harvard boat
crew, sailboats on the Charles
River, a home run being hit out
of Fenway Park, and a couple
jogging along the Harvard
Bridge are all visible in this
hand-drawn map.

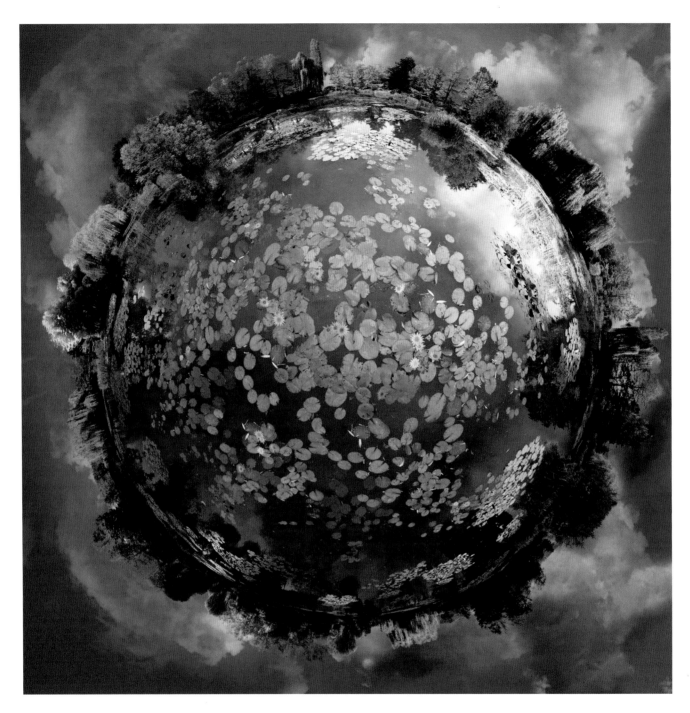

Catherine Nelson
Monet's Garden
2010

Photographic piece, 59 × 59 inches (150 × 150 centimeters), from *Future Memories*, an enticing series of digitally created imaginary globes by Australian visual artist Catherine Nelson. These scenes, with evocative titles such as *Ghent Winter* and *Bourgoyen Spring II*, are depicted at different seasons and under different weather conditions.

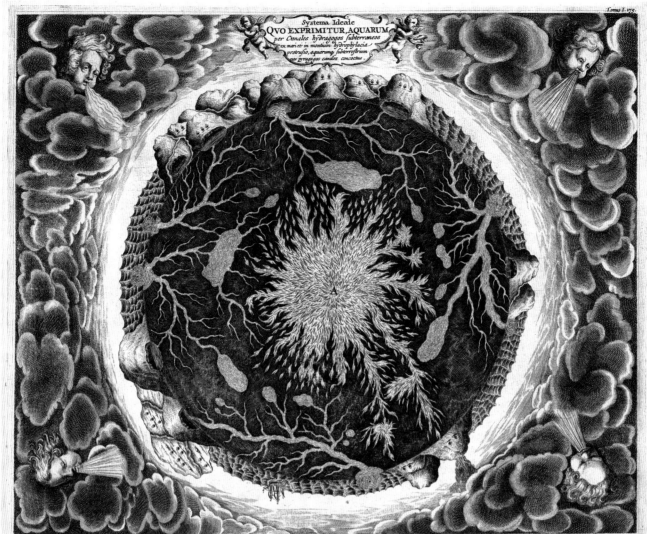

Athanasius Kircher
Systema Ideale Quo Exprimitur Aquarum (Subterranean Aquifers)
1668

Diagram showing the interconnectedness of fire inside the Earth through the various firehouses of *pyrophylacia*.

Mundus Subterraneus in XII Libros Digestus (Underground world in twelve books) is a scientific textbook that depicts the Earth's geography, written by the German polymath Athanasius Kircher. In this image, the large central firehouse is hell (the farthest point from heaven in the geocentric model of the time); it is surrounded by purgatory. Volcanoes along the outer crust of the Earth provide air and an outlet for the fumes of the fires, and the mountains that are shown alongside them provide a secure skeletal structure for the system.

Den Aardkloot van water ontbloot, na twee zyden aante fien.

Thomas Burnet
Den Aardkloot van water ontbloot (The entire planet devoid of water)
1694

An unusual map that shows the world as if the oceans did not exist, created by the British theologian Thomas Burnet. It was part of his argument that the Earth must have originated in the biblical Great Flood; God would have created the world in a perfect sphere, and only a flood could have left it in such a deformed shape. The two halves represent the Eastern and Western hemispheres; California appears as an island off the coast of North America in the bottom image.

Wenzel Jamnitzer
Dodecahedron variations
1568

Engraving showing some of the variations of the dodecahedron, which in medieval cosmological theory represented heaven. Created by German goldsmith and engraver Wenzel Jamnitzer, *Perspectiva Corporum Regularium* (Perspective of regular solids) is a study of how the five platonic solids (tetrahedrons, cubes, octahedrons, dodecahedrons, and icosahedrons) each could be truncated, stellated, and faceted to produce twenty-four variations.

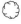

FEEDING THE PLANET, ENERGY FOR LIFE

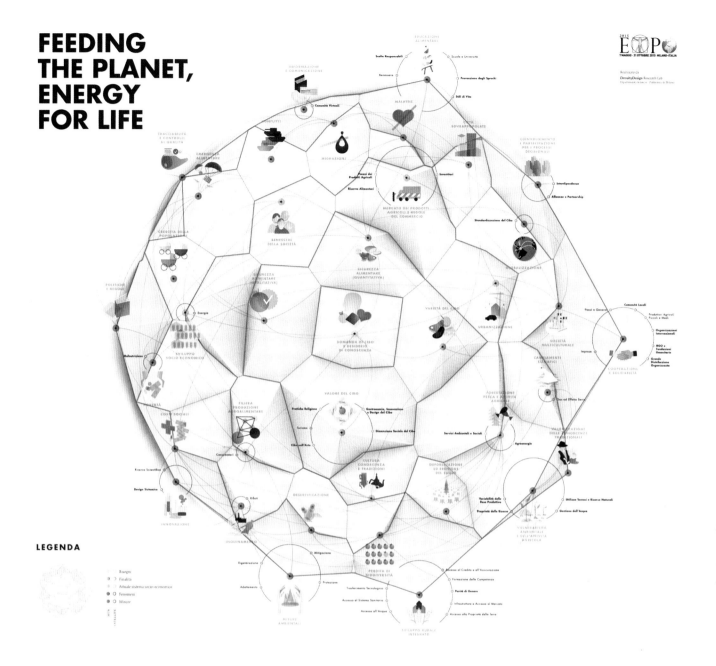

Michele Mauri, Luca Masud, Mario Porpora, Lorenzo Fernandez, Giorgio Caviglia, and Donato Ricci (DensityDesign)
Feeding the Planet, Energy for Life
2011

Visualization in the form of a mind map that communicates the complex relationships among food production and consumption, social and environmental concerns, and technological and sustainability issues. Topics are shown radially on five levels, moving from needs (at the center) through purposes, socioeconomic systems, phenomena, and, finally, actions. Each individual topic is represented by a pictogram, with subtopics grouped around it.

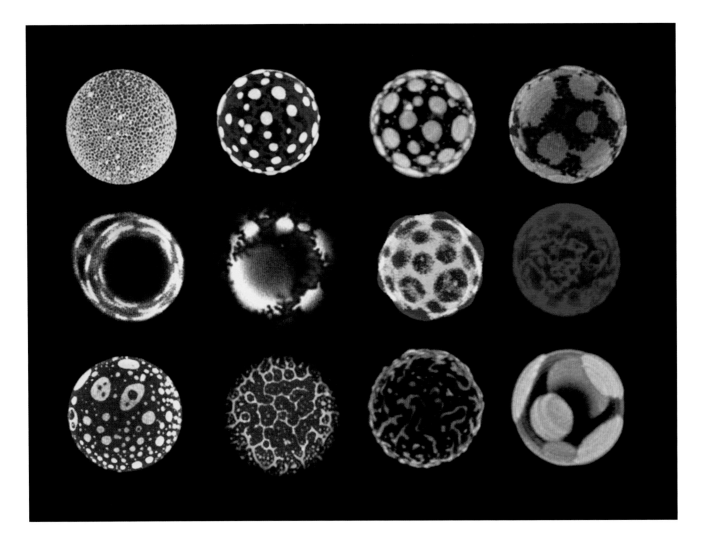

Jorge Bernardino de la Serna
**Giant unilamellar and
multilamellar vesicles
(liposomes)**
2007

Composite photograph of a set
of giant liposomes—spherical
vesicles that contain an aqueous
solution inside their membrane
(unilamellar) or membranes
(multilamellar). Liposomes are
normally used as vehicles to
carry drugs and nutrients into
the tissues. A giant unilamellar
liposome may have a diameter
of up to 100 μm (0.00394 inches
or 1/10 of a millimeter).

(opposite)
**Supernovas and
planetary nebulae**
2004–16

Composite images of
supernovas (dying stars) and
planetary nebulae (clouds of
gas and dust), photographed
over the years by different
NASA telescopes. From left
to right, top to bottom: Tycho
supernova remnant (2008),
Kepler's supernova remnant
(2004), Cassiopeia A supernova
remnant (2014 and 2006), Helix
Nebula (2002), and Eskimo
Nebula (2014).

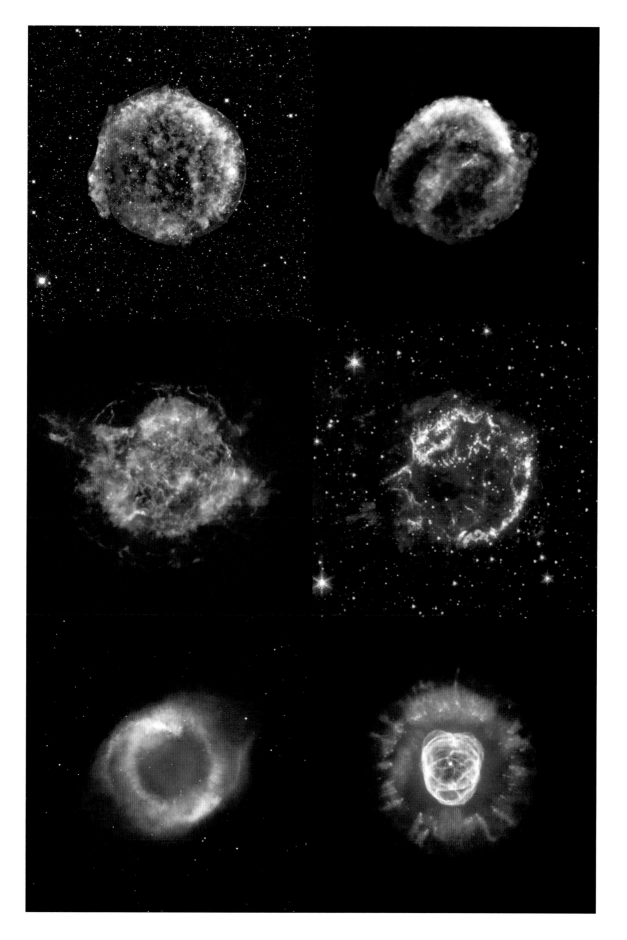

NODES & LINKS

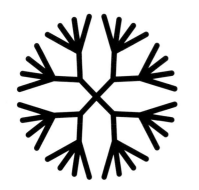

Josh Gowen (Signal Noise)
The Large Hadron Collider:
Mapping the Data
2013

Graphic depicting data
generated by the Large Hadron
Collider (LHC), which creates
collision experiments to test
various physics theories,
including effects on matter
similar to those that might
have occurred after the Big
Bang. Mapped here is the
journey taken by the data
generated by four different
experiments, conveyed by
the colored segments in the
outer ring: the initial particle
collision; the data's drastic
trimming as it is subjected to
two trigger systems; its storage
in a data center; and, finally, its
distribution via the Worldwide
Large Hadron Collider
Computing Grid.

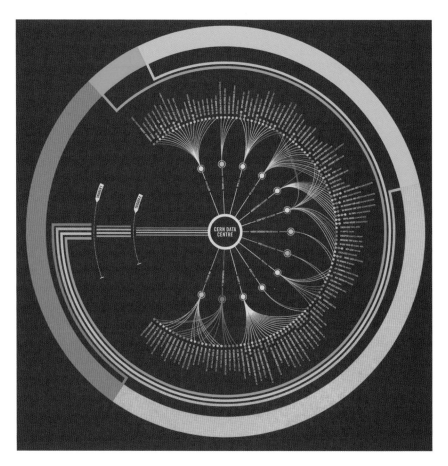

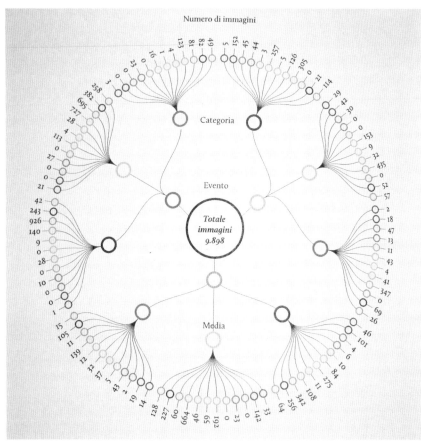

Tiziana Alocci
Intertextuality and
Photojournalism
2014

A circular tree diagram
of a project that analyzed
9,898 journalistic images to
determine which tropes are
particularly resonant with the
Italian public. Starting from
the center, the chart breaks
down the photographs by
event, then further sorts them
by the medium of publication,
followed by individual category.
Categories (e.g., city, landscape,
civilians, rubble) are color-
coded at the outermost ring.
The number indicates how many
images are in each category.

Viviana Ferro, Ilaria Pagin, and Elisa Zamarian
Zeus's Affairs
2012

Graphic that maps Zeus's intricate relationships, using classical authors as source material. Zeus, the ancient Greek god, was renowned for his love affairs, many of them incestuous. The thick black circles represent Zeus's affairs: the inner ring depicts goddesses, the outer one humans. The inner side of each circle displays his lovers, who are connected with colored lines to their children, shown on the outer side. Colors represent mentions by various authors and are chronologically grouped: yellow (BC), brown (between BC and AD), brown (AD), and blue (general). The thin circles in the central part of the diagram represent brotherhoods.

Liam J. Revell
Phylogenetic diagram
2014

Map of the phylogeny (development of a particular group of organisms) of the ancestral states of a group of lizards from the Caribbean. Biologist Liam Revell used a custom package in the computing environment R, called phytools, to generate this chart as part of a chapter he contributed to the book *Modern Phylogenetic Comparative Methods and Their Application in Evolutionary Biology.* The names of the lizards sit on the outer ring; warmer colors indicate smaller lizards, while cooler colors indicate larger ones.

Aristide Lex
Beers of the World
2010

A circular tree diagram organizing 120 beers by geographic provenance. The information branches outward as it narrows in specificity: from continent to country to city to, finally, brand. Each beer has an icon identifying coaster shape, color, and brew style. A radial bar graph in the outer circle shows brand longevity.

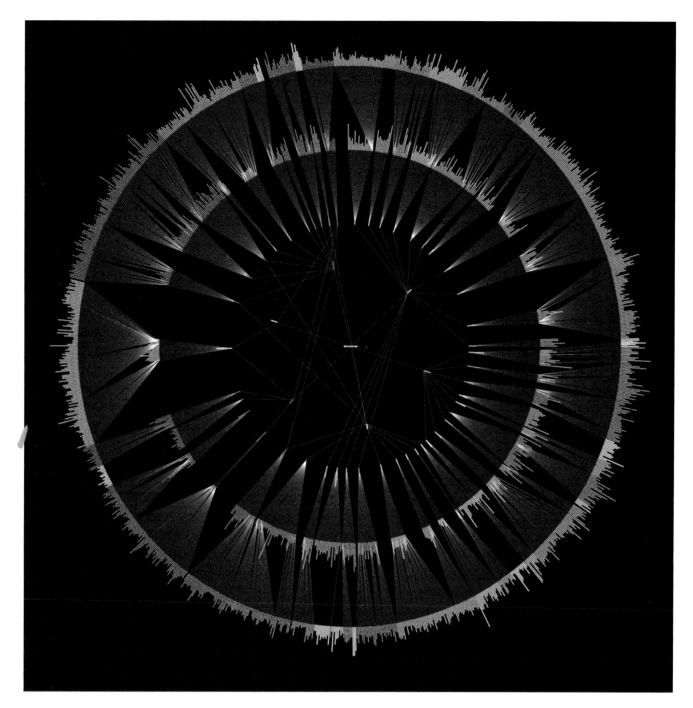

Thomas Clever
(Pre)search Engine
2006

Visualization of the categorization system of the National Library of the Netherlands, from Thomas Clever's research into current and future search capabilities and the categorizations that sit behind them. The center of the diagram instructs the user to choose a category; lines radiate out to different first-level categorizations (e.g., the arts or technology). These groups are then divided further into two additional levels of categorization (theater or linguistics and literature) before the final ring, which shows the most granular search terms (e.g., Danish literature).

Ernst Haeckel
Drawing of an *ophidea*
1904

Lithograph of an *ophidea*, a
type of echinoderm similar
to a starfish. Ernst Haeckel
was a German biologist who
published a series of detailed
lithographs, *Kunstformen der
Natur* (Art forms of nature), over
the course of five years. These
images of microscopic biology
have been hugely influential on
both the arts and science.

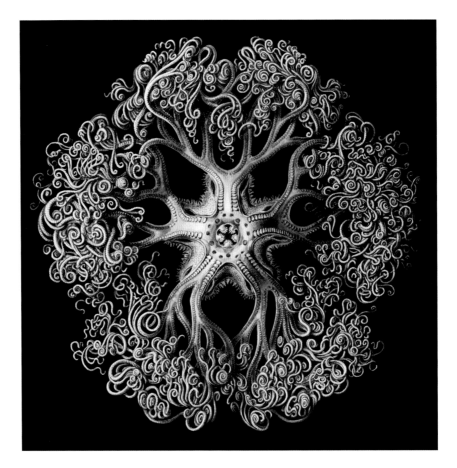

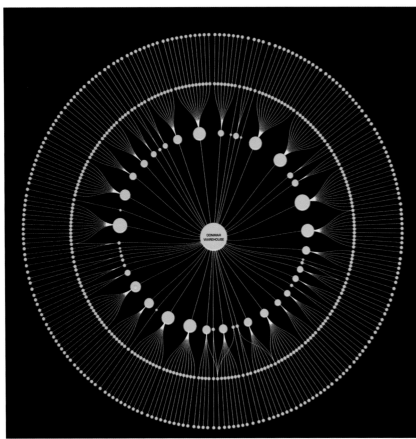

Valentina D'Efilippo
Privacy
2014

A visualization projected as
part of the set design of James
Graham's play *Privacy*, in
collaboration with the Donmar
Warehouse theater in London.
Inspired by Edward Snowden's
leak of intelligence material, the
piece exposes a hierarchy of
personal data to demonstrate
the vulnerability of a person's
online digital record.

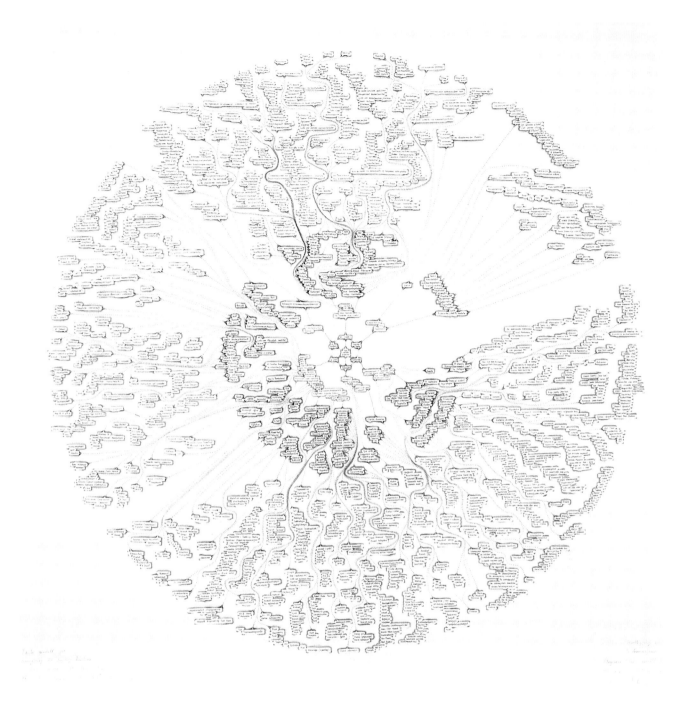

Torgeir Husevaag
Directive Network
2011

A drawing generated by
following links from a
Wikipedia article about
Datalagringsdirektivet (the
Norwegian Privacy Data
Retention Directive), which
is a controversial European
Union directive concerning
storage of metadata.

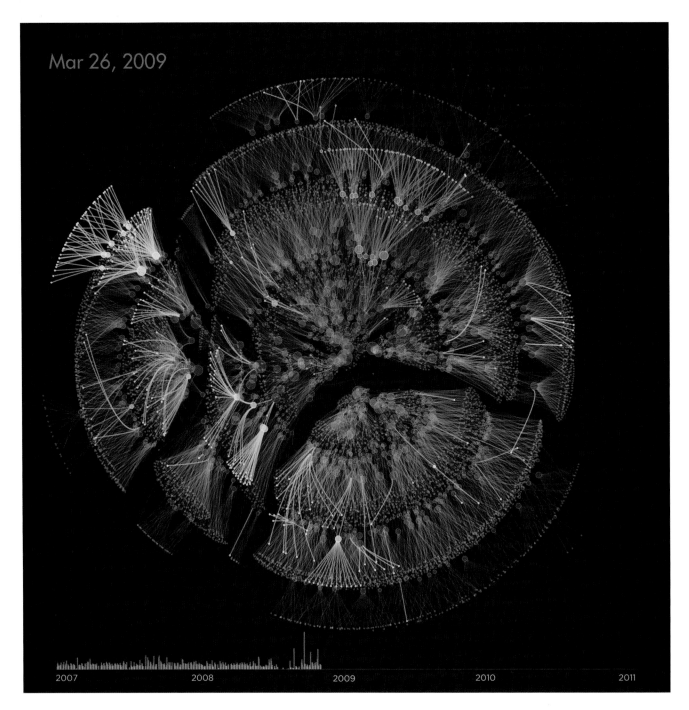

Mar 26, 2009

2007 2008 2009 2010 2011

Justin Matejka and George
Fitzmaurice (Autodesk Research)
*OrgOrgChart: The Evolution of
an Organization*
2012

A diagram of the entire
organizational hierarchy of
the Autodesk company as it
existed on March 26, 2009.
The OrgOrgChart (Organic
Organization Chart) project

explores the evolution of
corporate structures. Data
on Autodesk's hierarchy was
collected each day between
May 2007 and June 2011. Each
employee is represented by a
circle, with a line connecting
each employee with his or
her manager. Larger circles
represent managers overseeing
more employees.

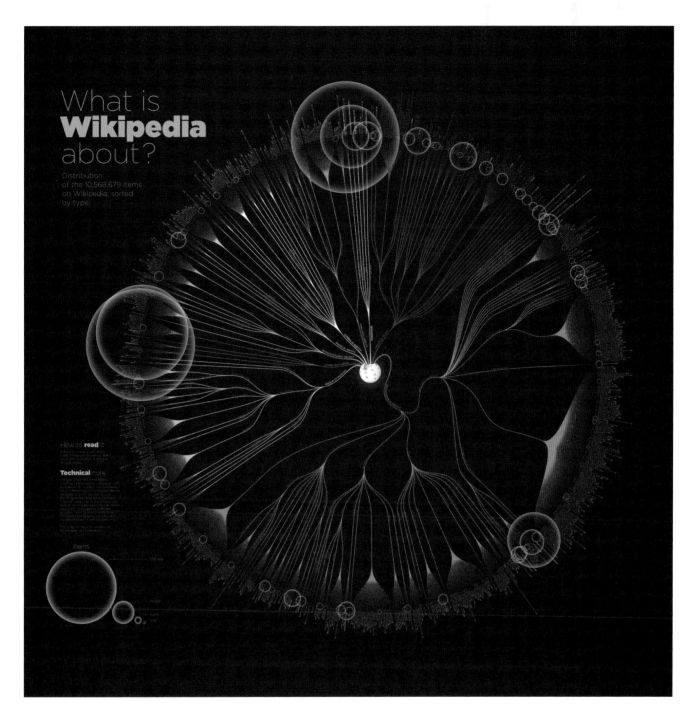

What is **Wikipedia** about?

Distribution
of the 10,568,679 items
on Wikipedia, sorted
by type.

How to **read** it

Technical note

Items

Paul-Antoine Chevalier and
Arnaud Picandet (Ask Media)
What Is Wikipedia About?
2014

A radial tree that sorts
10,568,679 items on Wikipedia
by type. The size of the circles
is proportional to the number

of entries in Wikipedia related
to each concept, and the
branches represent the main
categories associated with that
concept (such as creative work,
physical unit, living organism,
or the largest of all groups,
geographical entity).

 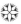

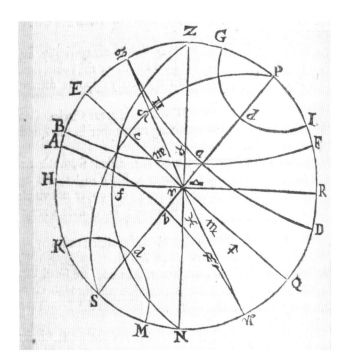

Henry Gellibrand and
William Fisher
Navigation diagram
1680

A diagram indicating how to
calculate the longitude of a
star using an Aries eclipse,
a method invented by the
renowned mathematician
Henry Gellibrand. Based on
Gellibrand's equations, *An
Epitome of Navigation* was
written by William Fisher to aid
sailors and navigators.

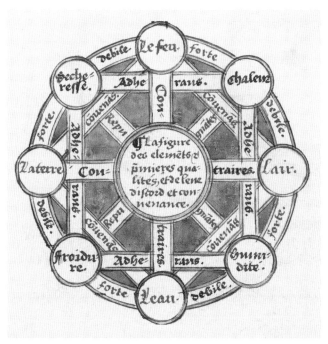

Oronce Finé
The four elements
1549

From French mathematician
Oronce Finé's *Le Sphere du
Monde* (The sphere of the
world), an illustration describing
the interactions between the
four classical, or Hellenic, ele-
ments (earth, fire, air, and water)
and their various properties
(hot, dry, cold, and wet).

Ramon Llull
Prima figura (First figure)
1305

The first of several figures
expressing Ramon Llull's
combinatorial system in *Ars
Magna* (General art). Written
as an encyclopedia of various
religious and philosophical
ideas, the book served partly
as a debating tool for using
logic and reason, allowing the
reader to combine various ideas
and generate a logically sound

argument with its illustrations.
On the edge of this diagram's
outer disc, the nine absolute
principles are shown, and on the
edge of the inner disc the same
terms are repeated, with the
addition of a few new concepts.
The rotation of these discs
could produce any argument
needed. Inside the circle, lines
connect the different principles
to show the relationships
among them.

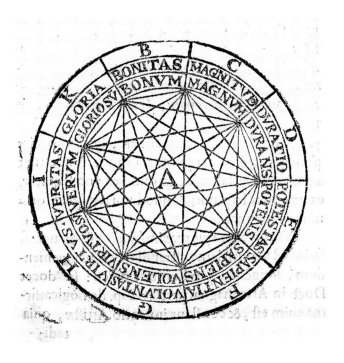

Martin Krzywinski
Human-dog Homology
2007

Radial diagram created using the software package Circos. Featured on the cover of the September-October 2007 edition of *American Scientist*, this illustration depicts the genomic overlap between dogs and humans. Chromosomes are rendered around the outer circle, belonging to either human (in blue) or dog (in orange). Connections between chromosomes convey dog-human homology, shared similarities from common ancestry.

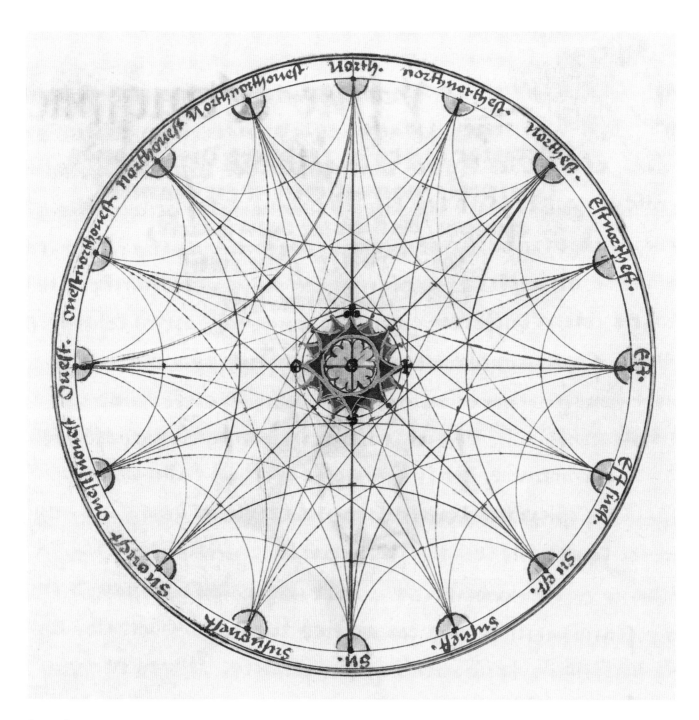

Oronce Finé
Compass
1549

A detailed compass taken from
Oronce Finé's *Le Sphere du
Monde*. Finé's illustrated book
on cartography is notable for its
innovations in projection and
description of the Arctic and
Antarctic Circles.

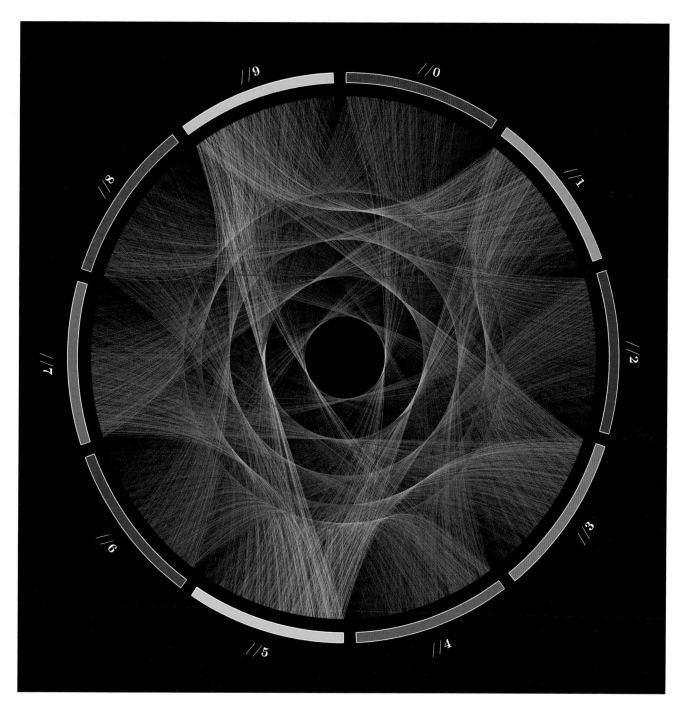

Cristian Ilies Vasile
Pi as Links
2012

Image created with Circos connecting each digit of pi to its successive digit. The outer ring is divided into segments that represent the numbers 0 to 9, each of which has its own color. The connecting lines show links to the positions of the numerically corresponding segments. For example, the "14" in "3.14…" is drawn as a link between segment 1 at position 2 and segment 4 at position 3.

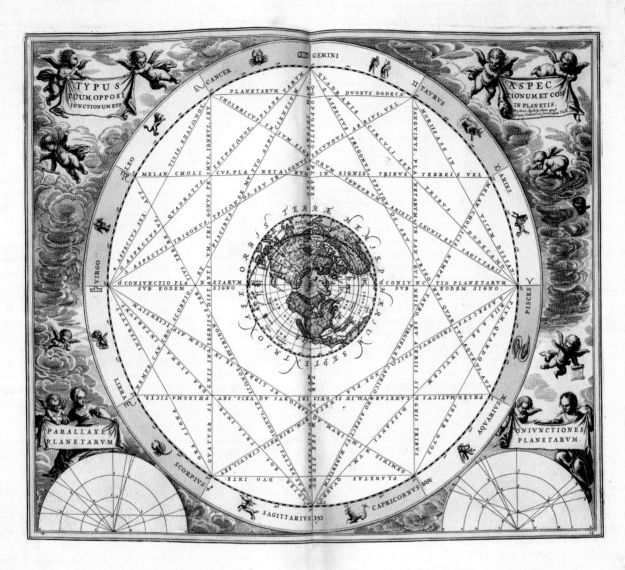

Andreas Cellarius

Typus Aspectum, Oppositionum et Coniunctionum etz in Planetis (The astrological aspects, such as opposition, conjunction, et cetera, among the planets)
1660

Engraving from the *Harmonia Macrocosmica*, a star atlas of twenty-nine maps. This illustration is part of an overview of the history of astrology; it shows how the zodiac (represented on the outer ring) affects the reading of planets.

In astrology, the angle between planets, when measured in degrees viewed from Earth (as seen here), is called an aspect. Aspects were thought to indicate the timing of important events and transitions in people's lives.

Anonymous
Instructional diagram for bloodletting
ca. 1420–30

An ink and watercolor drawing of a bloodletting man in the center of the circle of the zodiac, with lines showing the influence of the zodiac signs and planets on various procedures. Dating back to at least ancient Egypt, bloodletting was an ancient medical procedure that removed blood from the body by means of different instruments, from leeches to sharp sticks, in order to restore health. During the medieval period, charts like this one were common and showed specific bleeding sites on the body in relation to the alignment of the planets and zodiacs (e.g., those born under Sagittarius should avoid incisions in the thighs and fingers).

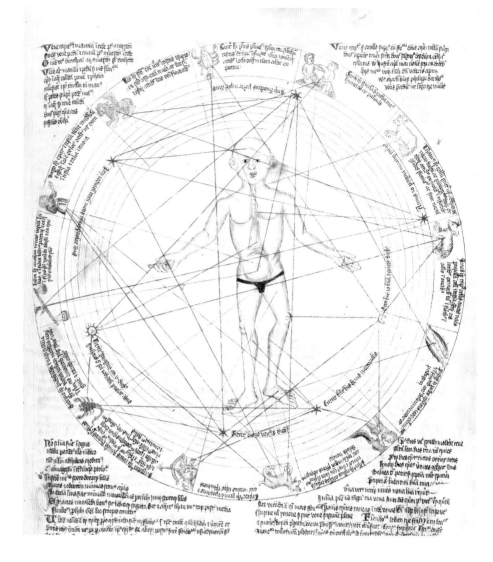

Marin Mersenne
Mersenne star
1636

Diagram that shows the harmonies and disharmonies between intervals of a twelve-tone scale arranged as a circle. Marin Mersenne was a French mathematician and philosopher credited with pioneering the theory behind acoustics, among other accomplishments. His interest in music was primarily a result of his work in mathematics and physics. This diagram, from his *Harmonicorum Libri XII*, is similar to a modern circle of fifths. Each of the twelve points around the circle is assigned a specific pitch value.

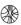

Gregor Aisch
German Party Donations
2010

Chart of donations of more
than €50.000 to German
political parties. Each donation
is represented by a line that
runs from a donor in the lower
semicircle to a party in the
upper semicircle. The line
width depends on the amount
of the donation, and the color
represents the receiving party.

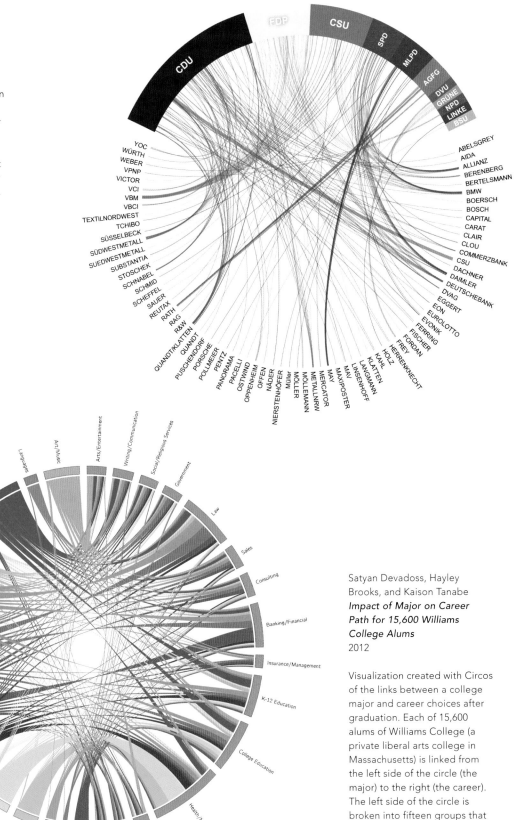

Satyan Devadoss, Hayley
Brooks, and Kaison Tanabe
*Impact of Major on Career
Path for 15,600 Williams
College Alums*
2012

Visualization created with Circos
of the links between a college
major and career choices after
graduation. Each of 15,600
alums of Williams College (a
private liberal arts college in
Massachusetts) is linked from
the left side of the circle (the
major) to the right (the career).
The left side of the circle is
broken into fifteen groups that
encompass all majors available
at Williams, while the right side
is similarly broken into fifteen
parts, each representing a
career sector.

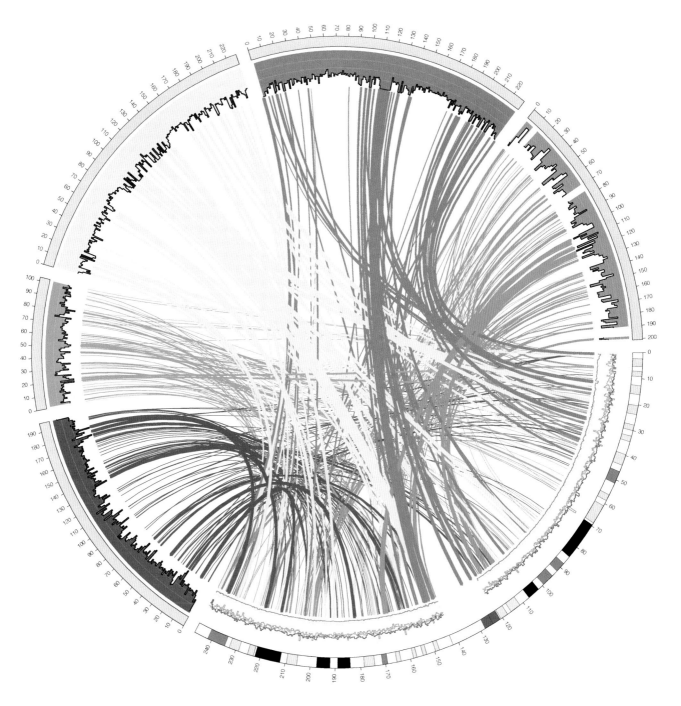

Martin Krzywinski
Comparing Chromosomes
2007

A circular diagram created using Circos, depicting similarities among the first chromosome of five different species. The five sequenced genomes are laid out along the outer ring of the circle in a clockwise fashion: mouse (red), rhesus monkey (yellow), chimp (brown), chicken (blue), and human (remaining section). Connections among chromosomes of each species indicate similarity from shared ancestry.

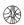

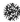

Wang Yingming
Star map
1646

Chart originally created by Wang Yingming, from his posthumously published *General Introduction to* *Calendrical Astronomy* (1646), which is thought to be the first documented work of a Chinese scholar influenced by Western learning. It shows a complete map of the stars and graphical representations of Chinese astronomical alignments.

Anonymous (opposite)
Kujang ch'ŏnsang yŏlch'a punya chido (Old sky chart showing rank and distribution of stars)
1777

An eighteenth-century reprint of a Korean star chart originally engraved in a stone slab in 1395. It is thought that the chart depicts a star alignment that occurred between 100 BC and AD 600.

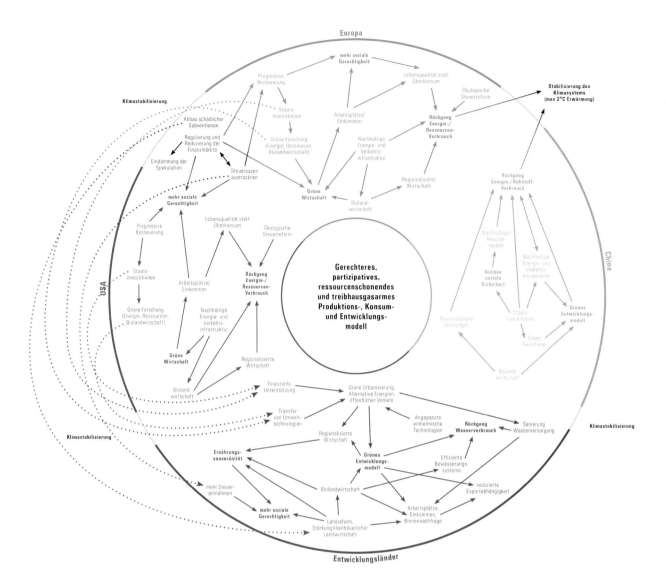

Barbara Hahn and
Christine Zimmermann
(Hahn+Zimmermann)
Green New Deal
2009

Diagram that explores the
effects of various actions and
policies related to climate
change within our global
system. The circle is color-
coded by region or nation:
Europe (green), China (yellow),
developing countries (red),

and the United States (blue). A
small segment of gray (top left)
represents climate stabilization.
Each region's policies on climate
change are shown, along with
interrelated individual factors
that reveal regional and global
interdependencies.

René Descartes
Illustration from *Principia*
philosophiae **(Principles of**
philosophy)
1692

A three-part classification of
principal kinds of terrestrial
particles. René Descartes
was a French philosopher,
mathematician, and scientist
who is credited with the
formation of modern Western
philosophy. This illustration is
part of his work on describing
basic laws of physics and the
Earth's structure.

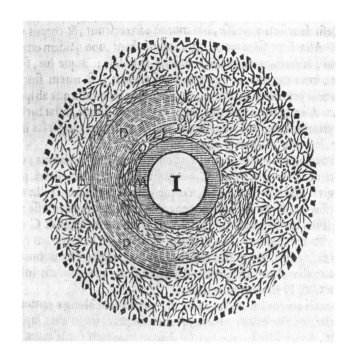

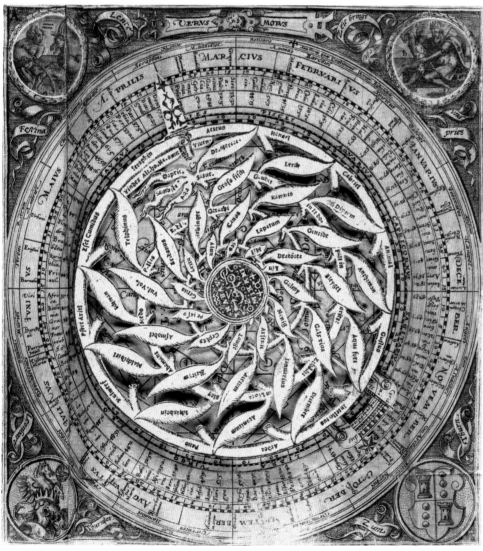

Jost Amman
Verus Motus Saturni **(Actual**
movement of Saturn)
sixteenth century

Volvelle created by the Swiss-
German etcher and woodcutter
Jost Amman, taken from
Leonhard Thurneisser zum
Thurn's *Archidoxa*. Thurneisser
was a multitalented man,
having served as a soldier,
doctor, scientist, and scholar.
His book *Archidoxa* contained
an astrolabe and tables of
the planets. Each of the eight
tables was illustrated with an
interactive disc mechanism that
was meant to be used to predict
luck, misfortune, and natural
phenomena, in this case the
movement of Saturn.

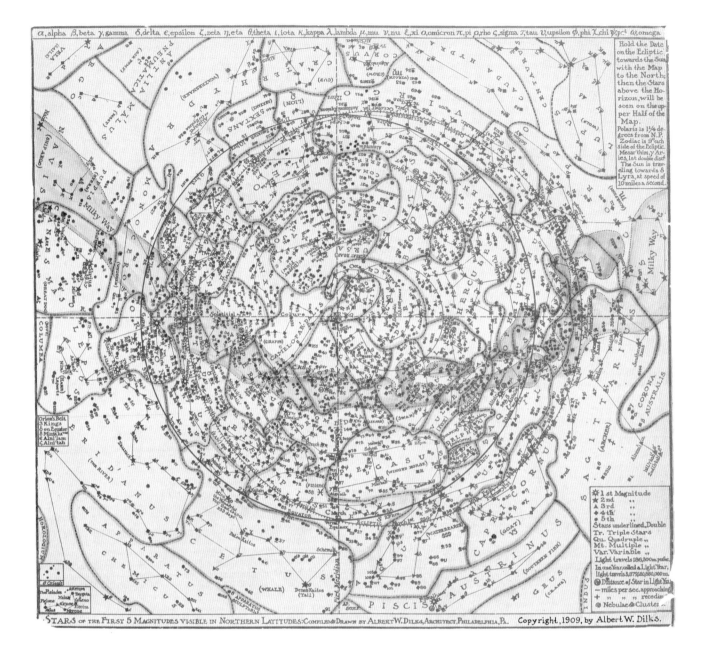

Albert W. Dilks
*Stars of the First 5 Magnitudes
Visible in Northern Latitudes*
1909

A star chart by the American
architect and amateur
astronomer Albert W. Dilks. It
shows the first five magnitudes
(a relative measure of
brightness) of stars visible in
northern latitudes. The lines
represent the boundaries of the
constellations; the blue band
represents the Milky Way and
the stars of our galaxy.

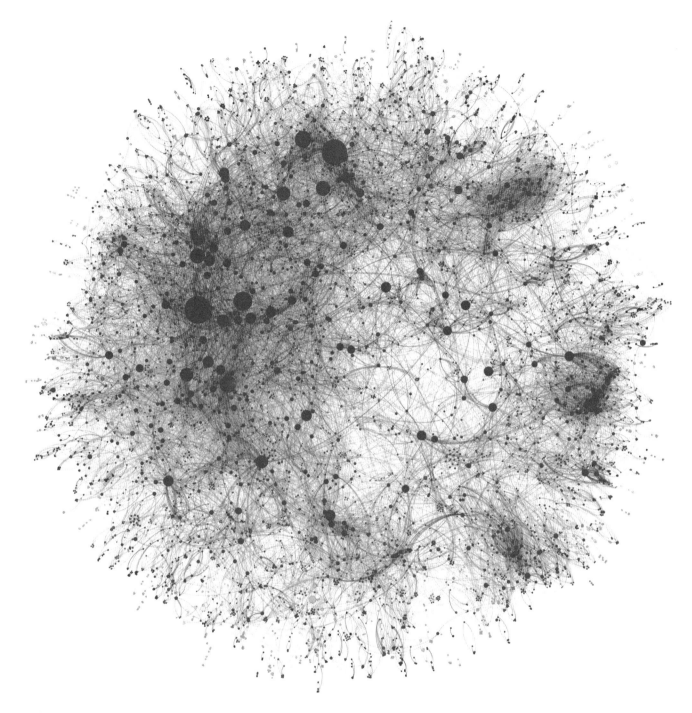

Andrew Lamb
Co-authorship relationships between physicians publishing on hepatitis C, 2008–2012
2012

Image of the network of collaboration among authors of research papers about the hepatitis C virus. Each of the 8,500 circles is a single author; the lines between spots represent co-authorship on scientific papers. Large circles indicate authors who are well connected and have authored multiple papers with different people. The project used data from MEDLINE (an online database containing more than twenty-six million records from academic journals on various life sciences and biomedical disciplines).

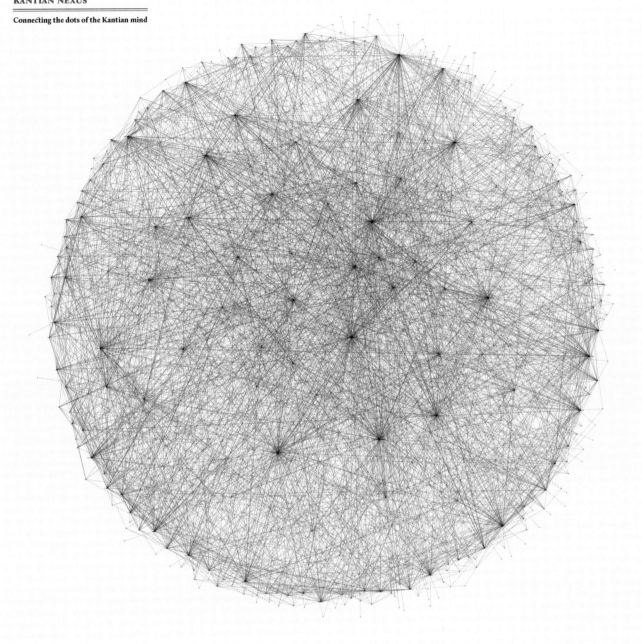

Valerio Pellegrini and
Luca Valzesi
*Kantian Nexus: Connecting the
Dots of the Kantian Mind*
2013

A network visualization of the
most important words used by
Immanuel Kant throughout his
philosophical production (58
works, 4,500 pages). Each word
is connected to the works in
which it appears. The diagram
was created using Minerva,
a tool that can visualize the
evolution of an author's lexicon
across all of that author's works.

Barbara Hahn and
Christine Zimmermann
(Hahn+Zimmermann)
World Economy
2012

Visualization revealing an
interdependent network of
147 firms that control nearly
40 percent of the entire wealth
of transnational companies.
Each of the 147 companies is
represented by a circle. The
color indicates the country
where each is headquartered
(the United States in blue, Great
Britain orange, France purple,
Canada cyan). The size of the
circle is proportional to the
profit of the firm, and the arrows
indicate minority interests in
other companies. The numbers
inside the circles indicate a
company's rank among the top
fifty companies.

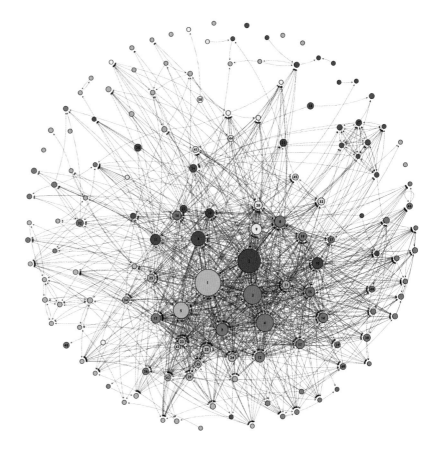

Marcos Montané
Structure #17
2011

A computer-generated sketch
made by playing with different
math functions, then translating
the results into a physical form
using wire. Marcos Montané
is an Argentinian artist who
creates generative graphics and
wire sculptures.

Dorothy Hodgkin
Insulin Map
ca. 1972

A hand-drawn sketch of an insulin molecule by the Nobel Prize–winning British chemist Dorothy Hodgkin. In 1969 she determined the 3-D structure of insulin by using the x-ray crystallographic method, a hugely important contribution to the understanding of the hormone's chemical and biological properties. In addition to making revolutionary discoveries in crystallography, she was heavily involved in initiatives that combined science with modern design. The Festival Pattern Group (formed as part of the 1951 Festival of Britain) used scientific images such as this to produce lace, wallpaper, and furnishing fabrics.

Giuseppe Randazzo
Vague Affinities
2011

A generative sculpture created using Vector3 and Java that explores notions of affinity and difference. One hundred agents were given a color value, chosen from a palette with a continuous gradient. Agents were programmed to move toward those with a smaller chromatic difference and away from those with a larger one.

BIBLIOGRAPHY

Alexander, Christopher. *Notes on the Synthesis of Form*. Cambridge, MA: Harvard University Press, 1964.

Alighieri, Dante, and Mark Musa. *Dante Alighieri's Divine Comedy: Inferno*. Bloomington: Indiana University Press, 2004.

Amir, Ori, Irving Biederman, and Kenneth J. Hayworth. "The Neural Basis for Shape Preferences." *Vision Research* 51 (2011): 2198–206.

Arnheim, Rudolf. *Art and Visual Perception: A Psychology of the Creative Eye*. Berkeley: University of California Press, 1954.

———. *Visual Thinking*. Berkeley: University of California Press, 2004.

Bar, Moshe, and Maital Neta. "Humans Prefer Curved Visual Objects." *Psychological Science* 17 (2006): 645–48.

———. "Visual Elements of Subjective Preference Modulate Amygdala Activation." *Neuropsychologia* 45 (2007): 2191–200.

Bassili, John N. "Facial Motion in the Perception of Faces and Emotional Expression." *Journal of Experimental Psychology, Human Perception and Performance* 4, no. 3 (1978): 373–79.

Batra, Rajeev, Colleen M. Seifert, and Diann Brei. *The Psychology of Design: Creating Consumer Appeal*. London: Routledge, 2016.

Batty, Michael, and Paul Longley. *Fractal Cities: A Geometry of Form and Function*. Cambridge, MA: Academic Press, 1994.

Begby, Adrian, and J. Peder Zane. *Design in Nature: How the Constructal Law Governs Evolution in Biology, Physics, Technology, and Social Organizations*. New York: Anchor Books, 2013.

Bertin, Jacques. *Semiology of Graphics: Diagrams, Networks, and Maps*. Translated by William J. Berg. Madison: University of Wisconsin Press, 1984.

Blair, Ann M. *Too Much to Know: Managing Scholarly Information before the Modern Age*. New Haven, CT: Yale University Press, 2011.

Börner, Katy. *Atlas of Knowledge: Anyone Can Map*. Cambridge, MA: MIT Press, 2015.

Brinton, Willard C. *Graphic Methods for Presenting Facts*. New York: Engineering Magazine Company, 1914.

———. *Graphic Presentation*. New York: Brinton Associates, 1939.

Bruce-Mitford, Miranda. *Signs and Symbols*. London: DK Publishing, 2008.

Carruthers, Mary. *The Book of Memory: A Study of Memory in Medieval Culture*. Cambridge: Cambridge University Press, 2008.

———, and Jan M. Ziolkowski. *The Medieval Craft of Memory: An Anthology of Texts and Pictures*. Philadelphia: University of Pennsylvania Press, 2003.

Changizi, Mark. *The Vision Revolution: How the Latest Research Overturns Everything We Thought We Knew about Human Vision*. Dallas: BenBella, 2010.

Chi, E. H. *A Framework for Visualizing Information*. New York: Springer, 2002.

Christianson, Scott. *100 Diagrams that Changed the World: From the Earliest Cave Paintings to the Innovation of the iPod*. New York: Plume, 2012.

Cohen, I. Bernard. *From Leonardo to Lavoisier, 1450–1800*. Album of Science. Vol. 2. New York: Scribner, 1980.

Cooper, J. C. *An Illustrated Encyclopedia of Traditional Symbols*. London: Thames & Hudson, 1987.

Crane, Walter. *Line & Form*. London: George Bell & Sons, 1900.

Crosby, Alfred W. *The Measure of Reality: Quantification and Western Society, 1250–1600*. Cambridge: Cambridge University Press, 1997.

Dackerman, Susan, Claudia Swan, Suzanne Karr Schmidt, and Katharine Park. *Prints and the Pursuit of Knowledge in Early Modern Europe*. Cambridge, MA: Harvard Art Museums, 2011.

Dazkir, Sibel S., and Marilyn A. Read. "Furniture Forms and Their Influence on Our Emotional Responses toward Interior Environments." *Environment and Behavior* 44 (2012): 722–32.

de Waal, Frans. *The Bonobo and the Atheist: In Search of Humanism Among the Primates*. New York: Norton, 2013.

Diamond, Jared. *Guns, Germs, and Steel: The Fates of Human Societies*. New York: Norton, 1999.

Doczi, Gyorgy. *The Power of Limits: Proportional Harmonies in Nature, Art, and Architecture*. Boulder, CO: Shambhala, 2005.

Dondis, Donis A. *A Primer of Visual Literacy*. Cambridge, MA: MIT Press, 1973.

Drucker, Johanna. *Graphesis: Visual Forms of Knowledge Production*. Cambridge, MA: Harvard University Press, 2014.

Dutton, Denis. *The Art Instinct: Beauty, Pleasure, and Human Evolution*. New York: Bloomsbury, 2010.

Edson, Evelyn. *Mapping Time and Space: How Medieval Mapmakers Viewed Their World*. The British Library Studies in Map History. Vol. 1. London: British Library Board, 1998.

Emerson, Ralph Waldo. *Essays*. Boston: Osgood, 1876.

Franklin-Brown, Mary. *Reading the World: Encyclopedic Writing in the Scholastic Age*. Chicago: University of Chicago Press, 2012.

Friendly, Michael. "Milestones in the History of Thematic Cartography, Statistical Graphics, and Data Visualization." Last modified August 24, 2009. http://www.math.yorku.ca/SCS/Gallery/milestone/milestone.pdf.

Gil, Bryan Nash. *Woodcut*. New York: Princeton Architectural Press, 2012.

Glassie, John. *A Man of Misconceptions: The Life of an Eccentric in an Age of Change*. New York: Riverhead, 2012.

Godwin, Joscelyn. *Athanasius Kircher's Theatre of the World: The Life and Work of the Last Man to Search for Universal Knowledge*. Rochester, VT: Inner Traditions, 2009.

———. *Robert Fludd: Hermetic Philosopher and Surveyor of Two Worlds*. Grand Rapids, MI: Phanes, 1991.

Gombrich, E. H. *The Image and the Eye: Further Studies in the Psychology of Pictorial Representation*. London: Phaidon, 1994.

Gordon, Kate. *Esthetics*. New York: Henry Holt, 1909.

Granoff, Phyllis. *Victorious Ones: Jain Images of Perfection*. New York: Rubin Museum of Art, 2010.

Guénon, René. *Symbols of Sacred Science*. Hillsdale, NY: Sophia Perennis, 2004.

Harmon, Katharine. *You Are Here: Personal Geographies and Other Maps of the Imagination*. New York: Princeton Architectural Press, 2003.

Harris, Robert L. *Information Graphics: A Comprehensive Illustrated Reference*. Oxford: Oxford University Press, 2000.

Harwood, Jeremy, and A. Sarah Bendall. *To the Ends of the Earth: 100 Maps that Changed the World*. Newton Abbot, UK: David & Charles, 2006.

Helfand, Jessica. *Reinventing the Wheel*. New York: Princeton Architectural Press, 2006.

Hosey, Lance. "Why We Love Beautiful Things." *New York Times*. February 15, 2013.

Hyland, Angus, and Steven Bateman. *Symbol*. London: Laurence King, 2011.

Jefferies, John Richard. *Story of My Heart: My Autobiography*. London: Longmans, Green, 1901.

Jung, Carl Gustav. *Man and His Symbols*. New York: Dell, 1968.

Kemp, Martin. *Visualizations: The Nature Book of Art and Science*. Oakland: University of California Press, 2001.

Lakoff, George, and Mark Johnson. *Metaphors We Live By*. Chicago: University of Chicago Press, 2003.

Lapidos, Juliet. "Atomic Priesthoods, Thorn Landscapes, and Munchian Pictograms: How to Communicate the Dangers of Nuclear Waste to Future Civilizations." *Slate*, November 16, 2009. http://www.slate.com/articles/health_and_science/green_room/2009/11/aomic_priesthoods_thorn_landscapes_and_munchian_pictograms.html.

Larson, Christine, Joel Aronoff, and Elizabeth Steuer. "Simple Geometric Shapes Are Implicitly Associated with Affective Value." *Motivation & Emotion* 36, no. 3 (2012): 404–13.

Larson, Christine, Joel Aronoff, I. C. Sarinopoulos, and D. C. Zhu. "Recognizing Threat: A Simple Geometric Shape Activates Neural Circuitry for Threat Detection." *Journal of Cognitive Neuroscience* 21, no. 8 (2009): 1523–35.

Lidwell, William, Kritina Holden, and Jill Butler. *Universal Principles of Design: 100 Ways to Enhance Usability, Influence Perception, Increase Appeal, Make Better Design Decisions, and Teach Through Design*. Beverly, MA: Rockport, 2003.

Lynch, Kevin. *The Image of the City*. Cambridge, MA: MIT Press, 1960.

MacGregor, Neil. *A History of the World in 100 Objects*. London: Penguin, 2012.

Makuchowska, Ludmila. *Scientific Discourse in John Donne's Eschatological Poetry*. Newcastle upon Tyne, UK: Cambridge Scholars Publishing, 2014.

Mansell, Chris. *Ancient British Rock Art: A Guide to Indigenous Stone Carvings*. London: Wooden Books, 2007.

Meirelles, Isabel. *Design for Information: An Introduction to the Histories, Theories, and Best Practices Behind Effective Information Visualizations*. Beverly, MA: Rockport, 2013.

Milligan, Max, and Aubrey Burl. *Circles of Stone: The Prehistoric Rings of Britain and Ireland*. London: Harvill, 1999.

Moreland, Carl, and David Bannister. *Antique Maps*. London: Phaidon, 1994.

Mullin, Glenn H., and Heather Stoddard. *Buddha in Paradise: A Celebration in Himalayan Art*. New York: Rubin Museum of Art, 2007.

Munari, Bruno. *Bruno Munari: Square, Circle, Triangle*. New York: Princeton Architectural Press, 2015.

———. *Design as Art*. London: Penguin, 2008.

Murdoch, John Emery. *Antiquity and the Middle Ages*. Album of Science. Vol. 5. New York: Scribner, 1984.

Neurath, Otto, Matthew Eve, and Christopher Burke. *From Hieroglyphics to Isotype: A Visual Autobiography*. London: Hyphen Press, 2010.

Padovan, Richard. *Proportion: Science, Philosophy, Architecture*. London: Taylor & Francis, 1999.

Pascal, Blaise. *Pensées*. London: Penguin Classics, 1995.

Pietsch, Theodore W. *Trees of Life: A Visual History of Evolution*. Baltimore: Johns Hopkins University Press, 2012.

Playfair, William, Howard Wainer, and Ian Spence. *The Commercial and Political Atlas and Statistical Breviary*. Cambridge: Cambridge University Press, 2005.

Pombo, Olga. *O Círculo dos Saberes* (The circle of knowledge). Lisbon, Portugal: Universidade de Lisboa, 2012.

———. *Unidade da Ciência: Programas, Figuras e Metáforas* (Unity of science: programs, figures, and metaphors). Lisbon, Portugal: Edições Duarte Reis, 2006.

Rendgen, Sandra, Julius Wiedemann, Paolo Ciuccarelli, Richard Saul Wurman, Simon Rogers, and Nigel Holmes. *Information Graphics*. Cologne, Germany: Taschen, 2012.

Rosenberg, Daniel, and Anthony Grafton. *Cartographies of Time: A History of the Timeline*. New York: Princeton Architectural Press, 2010.

Rhie, Marilyn M., and Robert Thurman. *Worlds of Transformation: Tibetan Art of Wisdom and Compassion*. New York: Tibet House, 1999.

Scafi, Alessandro. *Maps of Paradise*. Chicago: University of Chicago Press, 2013.

Schmandt-Besserat, Denise. *How Writing Came About*. Austin: University of Texas Press, 1996.

Seife, Charles. *Zero: The Biography of a Dangerous Idea*. New York: Penguin, 2000.

Seo, Audrey Yoshiko, and John Daido Loori. *Ensō: Zen Circles of Enlightenment*. Boston: Weatherhill, 2007.

Silvia, Paul, and Christopher Barona. "Do People Prefer Curved Objects? Angularity, Expertise, and Aesthetic Preference." *Empirical Studies of the Arts* 27, no.1 (2009): 25–42.

Staley, David J. *Computers, Visualization, and History: How New Technology Will Transform Our Understanding of the Past*. Armonk, NY: M. E. Sharpe, 2003.

Stephenson, David, Victoria Hammond, and Keith F. Davis. *Visions of Heaven: The Dome in European Architecture*. New York: Princeton Architectural Press, 2005.

't Hart, Bernard Marius, Tilman Gerrit, Jakob Abresch, and Wolfgang Einhäuser. "Faces in Places: Humans and Machines Make Similar Face Detection Errors." *PLoS One* 6, no. 10 (2011).

Turchi, Peter. *Maps of the Imagination: The Writer as Cartographer*. San Antonio, TX: Trinity University Press, 2007.

Vartanian, Oshin, Gorka Navarrete, Anjan Chatterjee, Lars Brorson Fich, Helmut Leder, Cristián Modroño, Marcos Nadal, Nicolai Rostrup, and Martin Skov. "Impact of Contour on Aesthetic Judgments and Approach Avoidance Decisions in Architecture." *Proceedings of the National Academy of Sciences of the United States of America* 110, supplement 2 (2013): 10446–53.

Wade, David. *Symmetry: The Ordering Principle*. Glastonbury, UK: Wooden Books, 2006.

Wilkinson, Leland. *The Grammar of Graphics*. New York: Springer, 2005.

Yates, Frances. *The Art of Memory*. London: Random House UK, 2014.

IMAGE CREDITS

PAGE 1
Wellcome Library, London. Copyrighted work available under Creative Commons attribution-only license CC BY 4.0

2
Library of Congress

3
Harvard University and the Biodiversity Heritage Library

4
Library of Congress

15
Wellcome Library, London. Copyrighted work available under Creative Commons attribution-only license CC BY 4.0

16
McGregor Museum, School of Biological Sciences at the University of Auckland

17
Courtesy of Gina Kiss. From Bryan Nash Gill, *Woodcut* (New York: Princeton Architectural Press, 2012), 51

18
Wellcome Library, London. Copyrighted work available under Creative Commons attribution-only license CC BY 4.0

19 top
Library of Congress

19 bottom
Library of Congress

20
Courtesy of David Stephenson. From David Stephenson, *Visions of Heaven* (New York: Princeton Architectural Press, 2005), 93

21
© 2008 CERN, for the benefit of the CMS Collaboration

23 top
Beinecke Rare Book and Manuscript Library, Yale University

23 bottom
Wikimedia Commons

24 left
Wikimedia Commons

24 right
Beinecke Rare Book and Manuscript Library, Yale University

25 top left
Beinecke Rare Book and Manuscript Library, Yale University

25 top right
Wikimedia Commons. Shared under a Creative Commons attribution-share alike 2.0 Germany license

25 bottom
Beinecke Rare Book and Manuscript Library, Yale University

26
Beinecke Rare Book and Manuscript Library, Yale University

27
Beinecke Rare Book and Manuscript Library, Yale University

28 top left and right
From Chris Mansell, *Ancient British Rock Art: A Guide to Indigenous Stone Carvings* (London: Wooden Books, 2007)

28 bottom
Courtesy of Denise Schmandt-Besserat and the University of Texas Press. From Denise Schmandt-Besserat, *How Writing Came About* (Austin: University of Texas Press, 1996). Copyright © 1992

30 top
Diagram by the author

30 bottom
Wikimedia Commons

31 top
Wikimedia Commons

31 bottom
Wikimedia Commons

33 top
Biblioteca Nazionale Centrale di Firenze

33 bottom
Beinecke Rare Book and Manuscript Library, Yale University

34
Beinecke Rare Book and Manuscript Library, Yale University.

36 top
Walters Art Museum

36 bottom
Beinecke Rare Book and Manuscript Library, Yale University

37 top
Astrid Fitzgerald

37 bottom
Giuseppe Randazzo

38 top
© The Trustees of the British Museum

38 bottom
Wikimedia Commons

39 top
Library of Congress

39 bottom
Wikimedia Commons

41 top
Library of Congress

41 bottom
Wellcome Library, London. Copyrighted work available under Creative Commons attribution-only licence CC BY 4.0

42 top and bottom
Beinecke Rare Book and Manuscript Library, Yale University

43
Wellcome Library, London. Copyrighted work available under Creative Commons attribution-only licence CC BY 4.0

44 top
Beinecke Rare Book and Manuscript Library, Yale University

44 bottom
Beinecke Rare Book and Manuscript Library, Yale University

45
David Rumsey Map Collection (davidrumsey.com)

47 top
Wikimedia Commons

47 bottom
Kazuaki Tanahashi

48 top
© The Trustees of the British Museum

48 bottom
Stellavie

49 top
Library of Congress

49 bottom
David Rumsey Map Collection (davidrumsey.com)

50
Library of Congress

52, 54, 56, 59–63
Diagrams by the author

66 top
Beinecke Rare Book and Manuscript Library, Yale University

66 bottom
Martin Krzywinski

67
Klari Reis

68 top
Beinecke Rare Book and Manuscript Library, Yale University

68 bottom
Houghton Library, Harvard University

69
Dave Bowker

70 top
Carlos Simpson

70 bottom
Valentina D'Efilippo

71
Jon Millward (JonMillward.com/blog)

72
NASA/JPL/Space Science Institute

73 top
Amy Keeling

73 bottom
Jax de León

74 top
Wellcome Library, London.
Copyrighted work available
under Creative Commons
attribution-only license
CC BY 4.0

74 bottom
Alex Murrell

75
Omid Kashan

76 top
Library of Congress, Rare Book
and Special Collections Division,
The Hans P. Kraus Collection of
Sir Francis Drake

76 bottom
IIB Studio

77
Courtesy of Matt Dalby

78 top
Piero Zagami

78 bottom
Vladimir Guculak

79
Carolina Andreoli

80
Nicholas Felton

81
Courtesy of Emma Hitchens

82 top
Courtesy of Gareth Owens

82 bottom
David Rumsey Map Collection
(davidrumsey.com)

83
Ross Racine

84 top
Courtesy of Christian Tominski

84 bottom
Courtesy of S. Blair Hedges. From
S. B. Hedges et al., "Tree of Life
Reveals Clock-Like Speciation and
Diversification," *Molecular Biology*

and Evolution 32, no. 4 (2015):
835–45

85
Xiaoji Chen

86
Martin Krzywinski

87 top
Matt DesLauriers

87 bottom
Nicholas Rougeux

88
Peter Crnokrak

89
Pop Chart Lab

92
Courtesy of David Stephenson.
From Stephenson, *Visions of
Heaven*, 45

93 top
NASA

93 bottom
Biodiversity Heritage Library

94
Beinecke Rare Book
and Manuscript Library,
Yale University

95 top
Cara Barer

95 middle
Brookhaven National
Laboratory, STAR Collaboration

95 bottom
Cristian Ilies Vasile

96 top and bottom
Valerio Pellegrini

97
Oliver Uberti

98
Kim Albrecht

99
Biodiversity Heritage Library

100 top and bottom
Beinecke Rare Book
and Manuscript Library,
Yale University

101 top
Nicholas Felton

101 bottom
Library of Congress, Rare Book
and Special Collections Division,
The Hans P. Kraus Collection of
Sir Francis Drake

102
David Rumsey Map Collection
(davidrumsey.com)

103
David Rumsey Map Collection
(davidrumsey.com)

104–5
David Rumsey Map Collection
(davidrumsey.com)

106
David Eaton

107
The British Library

108
Anna Filipova

109
Peter Crnokrak

110
Courtesy of Giacomo Covacich

111 top
Software FX

111 bottom
Courtesy of Erik Jacobsen

112
Hahn+Zimmermann

113 top
Wellcome Library, London.
Copyrighted work available
under Creative Commons
attribution-only license
CC BY 4.0

113 bottom
Hahn+Zimmermann

114
Débora Nogueira de França
Santos

115
Ask Media (askmedia.fr)

116 top
Richard Garrison

116 bottom
Courtesy of Hannes von Döhren

117
Jess3

120 top
Wellcome Library, London.
Copyrighted work available under
Creative Commons attribution-
only license CC BY 4.0

120 bottom
Library of Congress

121
Beinecke Rare Book
and Manuscript Library,
Yale University

122
Beinecke Rare Book
and Manuscript Library,
Yale University

123 top
Wellcome Library, London.
Copyrighted work available
under Creative Commons
attribution-only license
CC BY 4.0

123 bottom
Royal Academy of Arts

124
Geographicus Rare Antique Maps

125
Courtesy of David Stephenson.
From Stephenson, *Visions of
Heaven*, 102

126
Martin Krzywinski

127
David Farrell

128
Alberto Lucas López

129
David Rumsey Map Collection
(davidrumsey.com)

130 top
Beinecke Rare Book
and Manuscript Library,
Yale University

130 bottom
Wellcome Library, London.
Copyrighted work available
under Creative Commons
attribution-only license
CC BY 4.0

131
Houghton Library,
Harvard University

132
Lawrence J. Schoenberg
Collection of Manuscripts, Kislak
Center for Special Collections,
Rare Books and Manuscripts,
University of Pennsylvania Libraries

133 top
Beinecke Rare Book
and Manuscript Library,
Yale University

133 bottom
Library of Congress, Rare
Book and Special Collections
Division, Hans P. Kraus
Collection of Sir Francis Drake

134
Courtesy of Jussi Ängeslevä

135
Andrew Kuo

136 top
Martin Krzywinski

136 bottom
Joshua Kirsch

137
Courtesy of Lola Migas

138 top and bottom
Wellcome Library, London.
Copyrighted work available
under Creative Commons
attribution-only license
CC BY 4.0

139
Courtesy of Bryan Boyer

140 top
US Department of Agriculture,
National Agricultural Library

140 bottom
Library of Congress

141
Courtesy of Christopher Collins

142
Pop Chart Lab

143 top
Courtesy of EDITED

143 bottom
Deroy Peraza

144
Courtesy of Johannes Eichler

145
Marcin Ignac

148 top and bottom
Valerio Pellegrini

149
Library of Congress

150 top and bottom
Beinecke Rare Book
and Manuscript Library,
Yale University

151
David Rumsey Map Collection
(davidrumsey.com)

152
Hannes Frykholm

153
Courtesy of Francesco Roveta

154
Valentina D'Efilippo

155
Jan Schwochow,
Golden Section Graphics

156 top
Katrin Süss (katrinsuess.com).
Photographer: Sven Helemann

156 bottom
Courtesy of Stefanie Posavec

157
Library of Congress

158
Courtesy of Doug Kanter

159
Courtesy of Thomas Clever

160 top
Courtesy of Michele Mauri

160 bottom
Abby Chen

161
Library of Congress

162
Courtesy of Siavash Amini

163 top
Peter Crnokrak

163 bottom
Marcin Plonka

164 top
Courtesy of Giacomo Covacich

164 bottom
Courtesy of Erica Zipoli

165
Jer Thorp

166
Wellcome Library, London.
Copyrighted work available
under Creative Commons
attribution-only license
CC BY 4.0

167
Timm Kekeritz

168
Valerio Pellegrini

169
Ben Willers

170 top
Courtesy of Jaeho Lee

170 bottom
Rayz Ong

171
Frederic Brodbeck

172
Courtesy of Črtomir Just

173
Courtesy of Siori Kitajima

176 top
NASA/MIT/JPL/GSFC/GRAIL

176 bottom
Courtesy of Francesco Roveta

177
Tania Alvarez Zaldivar

178
Courtesy of Valerio Pellegrini

179 top
Torgeir Husevaag. Photographs:
Vegard Kleven

179 bottom
Courtesy of Elizaveta Oreshkina

180 top
Beinecke Rare Book and Manu-
script Library, Yale University

180 bottom
Archie Archambault

181
Jan Willem Tulp

182
Brendan Dawes

183
Courtesy of Wesley Grubbs

184 top and bottom
Beinecke Rare Book
and Manuscript Library,
Yale University

185
Wellcome Library, London.
Copyrighted work available
under Creative Commons
attribution-only license
CC BY 4.0

186
McGregor Museum, School
of Biological Sciences at the
University of Auckland

187 top
Francesco De Comité

187 bottom
Francesco D'Orazio

188 top
Francesco D'Orazio

188 bottom
Kai Wetzel

189
Klari Reis

190
Jim Bumgardner

191
NASA/ESA/Hubble Heritage Team
(STScI/AURA)

192
Biodiversity Heritage Library

193
Klari Reis

194
Courtesy of Jörg Bernhardt

195
Courtesy of Jörg Bernhardt

196
Howmuch.net

197
Alberto Lucas López

198 top
Oliver Deussen

INDEX

A Fellow of the Royal Society of Arts and nominated by *Creativity* magazine as "one of the 50 most creative and influential minds of 2009," Manuel Lima is the founder of VisualComplexity.com, Design Lead at Google, and a regular teacher of data visualization at Parsons School of Design.

Lima is a leading voice on information visualization and has spoken at numerous conferences, universities, and festivals around the world, including TED, Lift, OFFF, Eyeo, Ars Electronica, IxDA Interaction, Harvard, MIT, Yale, the Royal College of Art, NYU Tisch School of the Arts, ENSAD Paris, the University of Amsterdam, and MediaLab-Prado Madrid. He has also been featured in various magazines and newspapers, such as *Wired*, the *New York Times*, *Science*, *Nature*, *Businessweek*, *Creative Review*, *Fast Company*, *Forbes*, *Grafik*, *SEED*, *étapes*, and *El País*.

His first book, *Visual Complexity: Mapping Patterns of Information*, has been translated into French, Chinese, and Japanese. His second, *The Book of Trees: Visualizing Branches of Knowledge*, covers eight hundred years of human culture through the lens of the tree figure, from its entrenched roots in religious medieval exegesis to its contemporary, secular digital themes.

With more than twelve years of experience designing digital products, Lima has worked for Codecademy, Microsoft, Nokia, R/GA, and Kontrapunkt. He holds a BFA in Industrial Design and an MFA in Design & Technology from Parsons School of Design. During the course of his MFA program, Lima worked for Siemens Corporate Research Center, the American Museum of the Moving Image, and Parsons Institute for Information Mapping in research projects for the National Geospatial-Intelligence Agency.

He lives in New York City with his wife, Joana, and daughter, Chloe.

Published by
Princeton Architectural Press
A McEvoy Group company
37 East Seventh Street, New York, NY 10003
202 Warren Street, Hudson, NY 12534
Visit our website at www.papress.com

© 2017 Princeton Architectural Press
All rights reserved
Printed and bound in China
20 19 18 17 4 3 2 1 First edition

ISBN: 978-1-61689-528-0

Editor: Sara Stemen
Designer: Jan Haux

Special thanks to: Janet Behning, Nicola Brower, Abby Bussel, Erin Cain, Tom Cho, Barbara Darko, Benjamin English, Jenny Florence, Jan Cigliano Hartman, Lia Hunt, Mia Johnson, Valerie Kamen, Simone Kaplan-Senchak, Diane Levinson, Jennifer Lippert, Kristy Maier, Sara McKay, Eliana Miller, Jaime Nelson Noven, Esme Savage, Rob Shaeffer, Paul Wagner, and Joseph Weston of Princeton Architectural Press
—Kevin C. Lippert, publisher

Library of Congress Cataloging-in-Publication Data is available on request from the publisher.

Front cover, left: Christoph Weigel, *Discus Chronologicus in quo Omnes Imperatores et Reges Orbis Europaei* (Chronological disc of all the emperors and kings of Europe), 1730. Courtesy of David Rumsey Map Collection (davidrumsey.com).
Front cover, right: Dave Bowker, *One Week of the Guardian: Wednesday*, 2008. Courtesy of Dave Bowker.
Back cover, left: Jan Janssonius, *Tabula Anemographica seu Pyxis* (Map of the winds), 1650. Courtesy of Geographicus Rare Antique Maps.
Back cover, right: Siori Kitajima and Ravi Prasad, *Sunlight, Fatness, and Happiness*, 2012. Courtesy of Siori Kitajima.